THE WATERCOLORIST'S
GUIDE TO PAINTING
SKIES

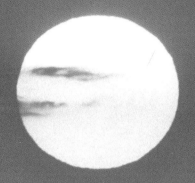

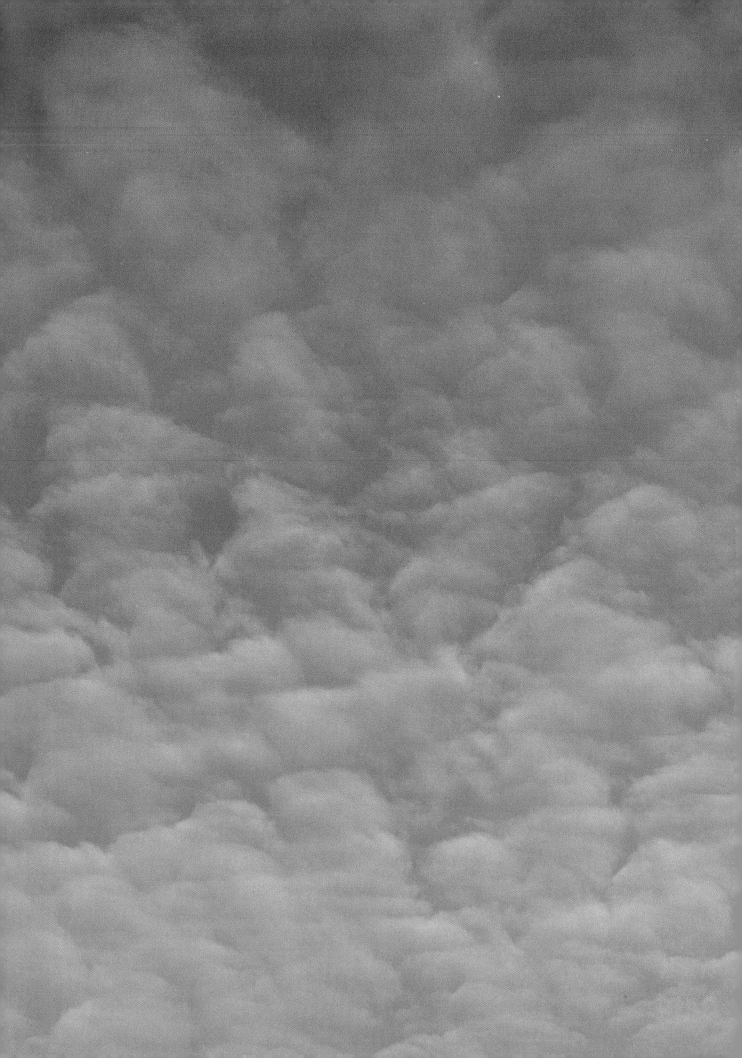

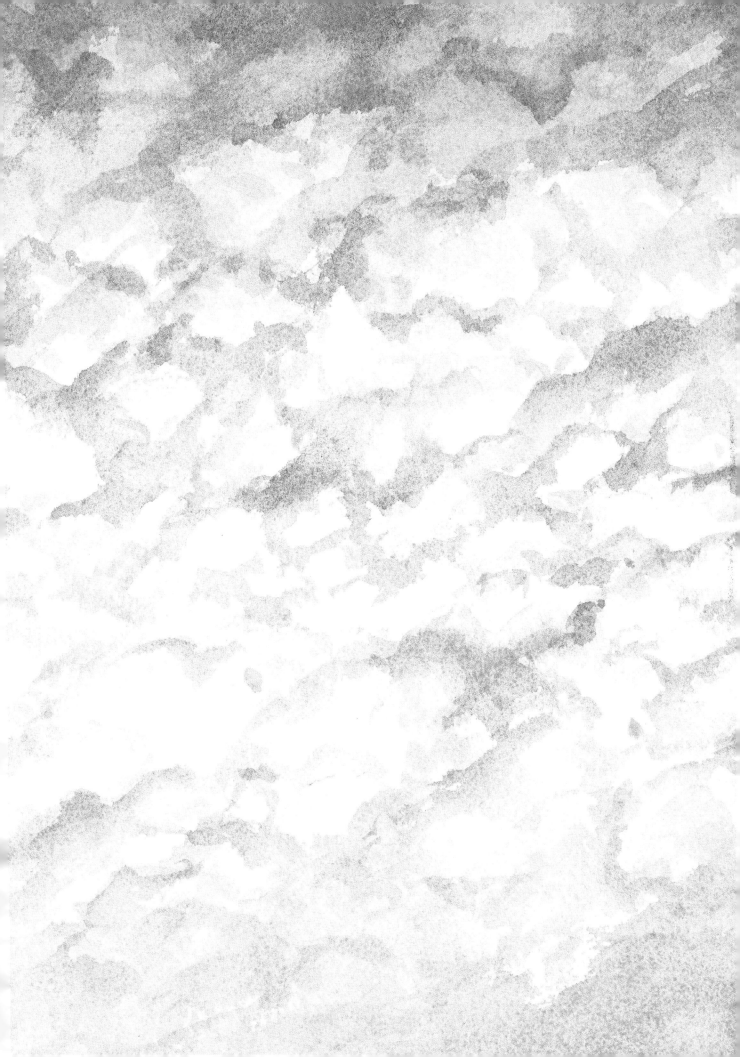

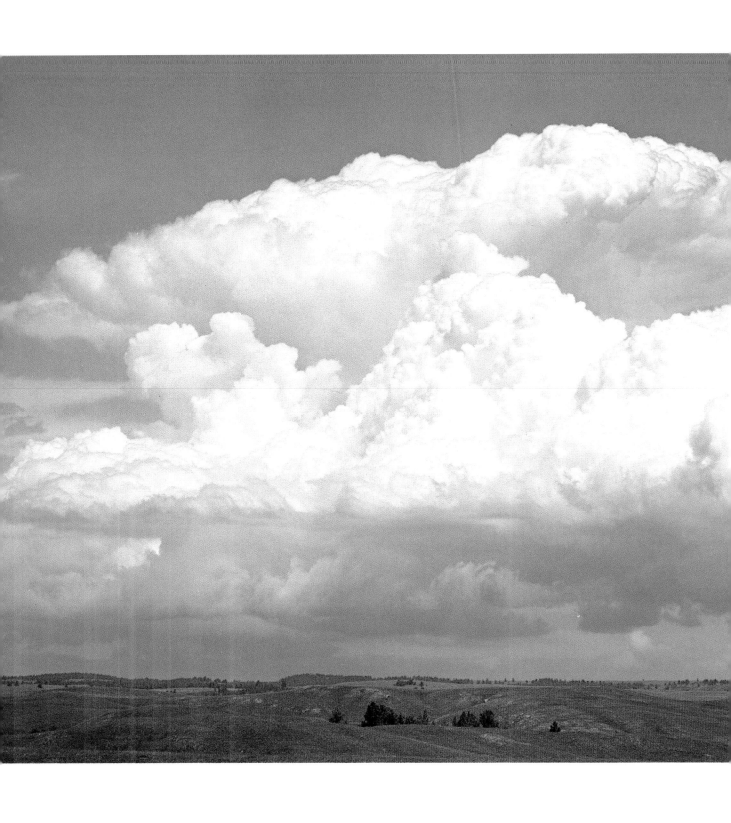

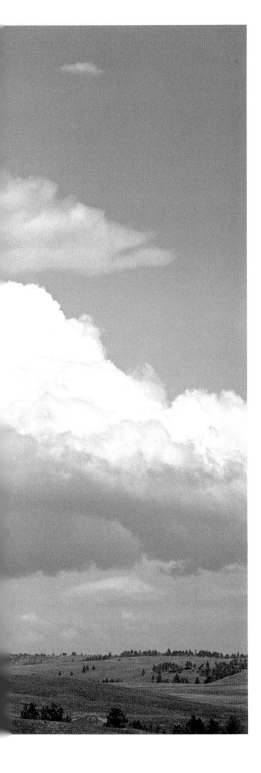

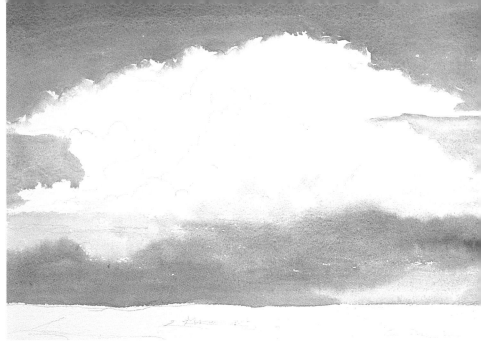

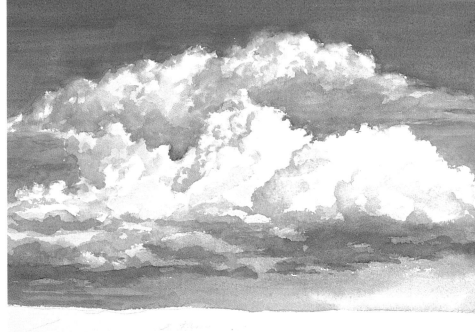

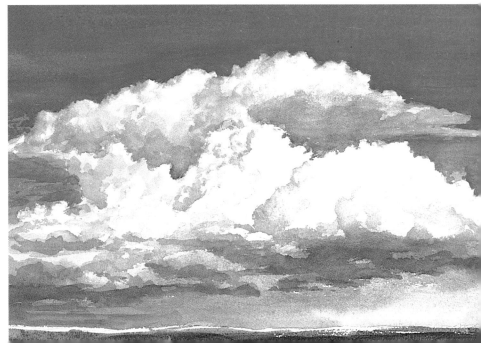

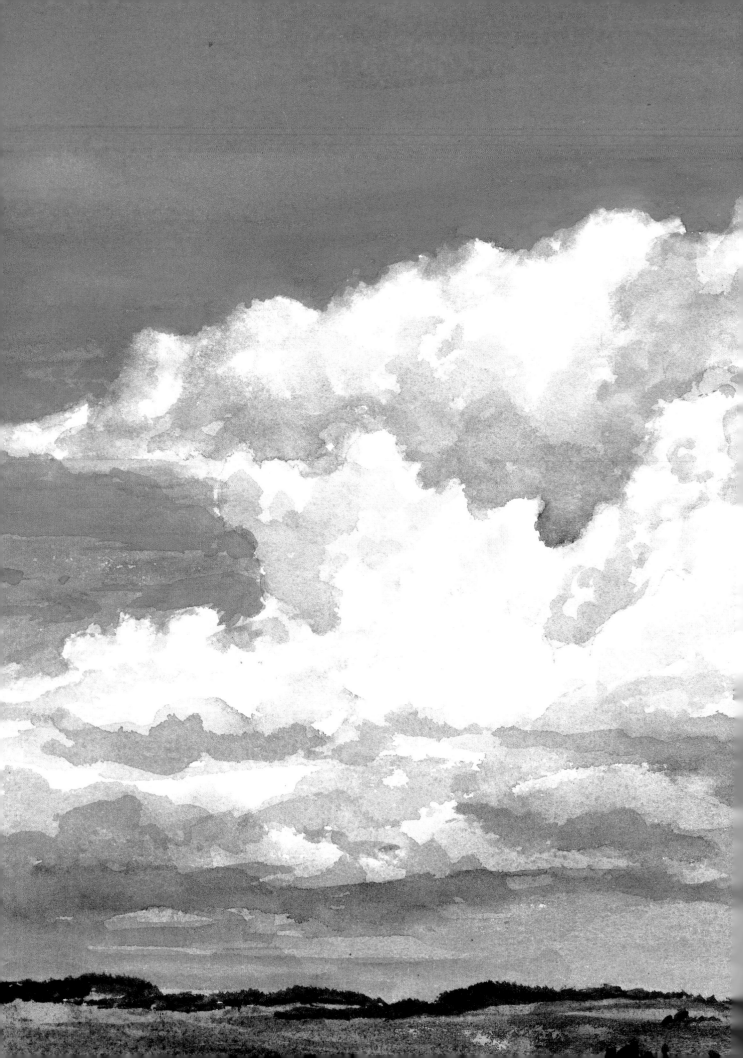

THE WATERCOLORIST'S GUIDE TO PAINTING

SKIES

PAINTINGS BY FERDINAND PETRIE
Photographs by John Shaw

Watson-Guptill Publications/New York

 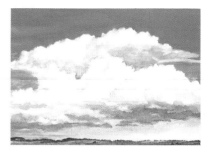

PAGES 2-3

A thick, rich layer of pale altocumulus clouds fills the sky.

When you approach a subject like this one, you're really dealing with a mass of abstract shapes. And since the shapes move constantly as the clouds are carried across the sky, it's vital that you paint quickly.

Before you start to paint, mix pools of the washes you'll need—cerulean blue, ultramarine, mauve, alizarin crimson, and Payne's gray.

Now look at the sky, noting the general pattern that the clouds create; then start to paint. Work all over the paper, first laying in the lightest areas, then gradually introducing the medium tones. Let the colors mix gently together—you don't want any harsh lines.

Finally, use your darkest color, ultramarine, to pick out and define the contours of some of the clouds.

PAGES 4-7.

Masses of soft, downy clouds explode against a deep blue sky.

Knowing how to sculpt out the structure of the clouds is the key to executing a successful painting.

Start by painting the sky around the cloud formation. The blue you lay down will establish a strong medium value against which you can gauge the values within the cloud formation. To capture the feel of the clouds themselves, work with pale washes of color, softening any harsh edges with clear water.

The very first step is to sketch in the horizon line and the overall shape of the cloud mass; then lightly indicate the surfaces of the clouds—where they swell out and where they move back. Now, on dry paper, begin the sky. Working from the top of the sheet, carefully apply a cerulean blue wash around the clouds. Toward the horizon line add a bit of yellow ocher to the blue; even closer to the horizon, lay in a touch of alizarin crimson. Both those colors soften and warm the

blue. Use a mixture of the three colors to begin the shadowy area at the base of the clouds.

Now the real challenge begins: as you continue to paint the shadowy areas throughout the clouds, remember that each stroke you apply has to look soft and ephemeral. You can achieve this effect by working with a brush dipped in clear water. Every time you render a purplish area, go back and soften its edges with the moistened brush. Don't get too much water on the paper—the aim is to let the paint bleed a little bit, not to let it run all over. Use ultramarine and cerulean blue, tempered again with yellow ocher and alizarin.

While the sky is drying, lay in the foreground. Begin with a flat wash of olive green, and then add slightly deeper shades of green to pick out the rolling hills.

All that's left now are the dark green details in the foreground. Mix Hooker's green with a bit of gray and work in the trees that lie along the horizon and jut out of the plain.

First published 1984 in the United States and Canada by Watson-Guptill Publications, a division of Billboard Publications, Inc., 1515 Broadway, New York, N.Y. 10036

Library of Congress Cataloging in Publication Data
Main entry under title:
The Watercolorist's guide to painting skies.
 Includes index.
 1. Skies in art. 2. Watercolor painting—Technique.
I. Petrie, Ferdinand, 1925- II. Shaw, John, 1944-
ND2240.W37 1984 751.42'2436 84-13052
ISBN 0-8230-5691-0

Distributed in the United Kingdom by Phaidon Press Ltd., Littlegate House, St. Ebbe's St., Oxford

Manufactured in Japan.

First Printing, 1984
1 2 3 4 5 6 7 8 9 10/89 88 87 86 85 84

Contents

Introduction

What sets the mood of a landscape painting? The answer isn't simple, because many things matter—a painting's composition, color scheme, and execution, for a start. But more than any other single factor, how the sky is rendered determines a painting's impact.

Picture a pond surrounded by lush summer foliage, drenched in pure, hot summer air; above the water, a strong, clear blue sky shines down on the scene. Now imagine the same setting, at the same time of year, but instead of a clear blue sky, there is an approaching storm. The blue sky has turned to gray, clouds are gathering, and the rush of warm greens and blues on the ground gives way to cool tones. Nothing physical has happened to the water, grass, or trees, yet everything is somehow very different.

Despite their importance in landscape painting, skies aren't always given much attention by beginning watercolorists. Instead of concentrating on atmospheric conditions—things like clouds or haze—beginners tend to belabor every concrete thing they see; they concentrate on trees, flowers, the ground, or even on buildings and animals.

Why is it that the sky is so often taken for granted? Mostly because people look at it in a preconceived way. On a bright, clear day, for example, you may be tempted to lay in a flat blue wash to indicate the sky. Yet even the clearest and bluest of skies usually changes in warmth or value as it nears the horizon. Using a subtle graded wash instead of a flat blue one will give your painting extra impact.

Or consider clouds. Think about the way they are so often handled. In painting after painting,

you see rows of pure white shapes parading across the paper. But clouds aren't always white; in fact, they rarely are. Instead, their color is usually a rich blend of blues, grays, reds, or even yellows.

The lessons in this book will help you get rid of any preconceived notions you have about skies. As you watch how the subjects are interpreted, you'll learn how to analyze the colors found in nature. More than that, you'll discover effective ways to deal with the extraordinary ways that light and atmosphere so often interact.

WHO THIS BOOK IS FOR

This volume is geared toward the intermediate painter—someone who is familiar with basic watercolor techniques. But even if you are a beginner, you'll find the book's problem-and-solution format a big help as you start to master the art of painting in watercolor. Spend a little time becoming familiar with the vocabulary we use and, more important, learn how to handle a brush and paints, then try your hand at some of the lessons.

No matter what your level of expertise, this book will do more than simply teach you "how to" paint skies. As you work through the lessons, you'll discover how to analyze real problems you encounter in landscape painting and you'll learn practical ways to unravel their difficulties. Once you've found a logical way to begin a painting, you'll see that it's often easy to work through to its end.

HOW THIS BOOK IS ORGANIZED

This book contains fifty lessons. Each concentrates on a concrete problem that you are likely to encounter when you begin to paint skies. First the challenges that each situation presents are ana-

lyzed; then a working procedure is outlined.

You'll find that many of the situations have more than one problem, and you'll see, too, that most have more than one possible solution. As you read through the lessons, you'll come to understand how and why decisions are made as an actual painting is executed.

Each lesson explains all the steps of the painting process, clearly pointing out what is done and how it is accomplished. Many of the lessons have step-by-step demonstrations that make it easy for you to understand how the painting evolved.

Supplementary assignments run through the book, either elaborating on a point covered in the lesson or branching out in a new direction. All of the lessons are designed to get you involved with painting in watercolor and in taking you beyond the limits of the illustrated demonstrations.

Feel free to turn to any lesson; they need not be read in particular order. However, since some of the assignments are based on lessons, it may be helpful to read the corresponding lesson before you tackle an assignment.

ABOUT THE PHOTOGRAPHS

Unlike many painting books, this volume includes the actual photographs the artist worked from as he executed his works. These photographs are an invaluable aid in understanding how to translate the world around you into effective paintings. Spend a little time looking at the photograph and the finished painting before you read the lesson, and you'll start to understand how the artist interpreted what he saw.

These superb photographs can help you discover new subject matter and new ways of composing your paintings. As you study a photograph, note how the photographer composed the scene—the angle he used, the way he framed his subject, the light that he captured, and any unusual effects that he achieved. Then, when you are outdoors, try to apply what you've learned as you search out new ways of seeing the world around you. Your most important discovery may well be that the sky isn't just a backdrop—its changing face can occupy you for days, weeks, months, or even a lifetime.

TRANSPARENT AND OPAQUE WATERCOLOR

When you conjure up a mental image of a watercolor painting, the chances are that you picture a shimmering mass of clear color laid over a white surface. And often that's the effect you'll want. But watercolor isn't always clear and transparent. Gouache, an opaque medium, is watercolor, too. At times you'll find that its properties can be an immense help in giving you the control that you need. Because it's opaque, it can be applied over layers of transparent watercolor—even over dark hues—giving you the freedom to paint light areas last.

White gouache is especially handy for the painter who concentrates on skies. It can be dropped into wet transparent watercolor to create a variety of effects. Where it remains thick and pure, it will have the hard, solid feel characteristic of some clouds, while as it merges with the blue it will appear soft and wispy.

Gouache has other uses, too, uses that you'll discover as you explore the lessons in this book. If you are unfamiliar with gouache, experiment with it before you start to use it in your paintings. You'll find that it han-

dles much like transparent watercolor and, with a little experience, you'll discover the dimension that it can add to your work.

SELECTING YOUR PALETTE

All of the paintings in this book were completed using the following seventeen colors. In most of the paintings, only six or seven colors came into play:

> Ultramarine blue
> Cerulean blue
> Antwerp blue
> Prussian blue
> Mauve
> Alizarin crimson
> Cadmium red
> Cadmium orange
> New gamboge
> Yellow ocher
> Cadmium yellow
> Lemon yellow
> Hooker's green
> Sepia
> Burnt sienna
> Davy's gray
> Payne's gray

Using this basic palette, you'll soon discover how you can mix an astounding number of hues.

Every lesson lists each color that's used in the painting. You'll probably be surprised to see how often unexpected colors appear—clouds, for example, are often rendered with grays, blues, or even purples. You'll see, too, how subtle changes in the color of the sky often rely on reds or yellows for their impact. Don't get caught up in what you think the colors should be. The lessons can help you learn how to experiment with color, and what you discover may be just what you need to add drama and excitement to your paintings.

THE RIGHT BRUSHES

If you're a fairly accomplished watercolorist, you know the brushes that you are comfortable using. But if you're just starting to paint, or if you're not happy with the results you're getting, if may help

to think through what you expect in a brush.

The first step in many paintings calls for wetting the paper, either with a sponge or a brush. If you choose to use a brush, try a flat one, an inch or more wide. Its broad surface is ideal for carrying water rapidly over the paper. When it comes to actually laying in the pigment, round brushes are invaluable. The broad side can be moved across the paper to lay in bold areas of color, while the tip is perfect for finishing smaller details.

Synthetic brushes are much more popular today than those made of sable—and with good reason. The sable brushes are astronomically expensive, and few people can afford them. Good synthetics mimic the feel of sable; they are excellent substitutes for those made of animal hair.

MISCELLANEOUS MATERIALS

Sponges come in handy in at least two situations—moistening your paper with water before you begin to paint and washing paint off your paper when your paintings have run aground. You'll find that a natural sponge is much more gentle than a synthetic one. It won't disturb the surface of the paper the way artificial ones do. You can also use your sponge or paper towels for blotting up paint if the paper buckles and forms depressions or if you lay in too much pigment all at once.

Masking solution is invaluable when you want to keep one portion of your painting pure white as you paint around it. It looks and handles much like rubber cement. When you are ready to paint the area that you've masked out, just peel the solution off and go to work.

You'll be surprised at the number of tools you have on hand without even knowing it. We've already mentioned sponges and

paper towels. Razor blades are handy, too, for pulling brilliant highlights out of wet paint. Or try using the tip of a brush handle to scratch details out of a moist surface. Don't stop there. Experiment blending paint with your fingers, or try spattering water onto a wet surface to see what effect it creates.

Finally, an eraser is helpful when you want to depict sunbeams. After you've painted the scene and the surface is thoroughly dry, you can pick up pigment with an eraser. When you use one, work gently. You don't want to tear the paper or damage its surface.

CHOOSING THE RIGHT PAPER
The heavier the paper, the less likely it is to buckle and form depressions as you paint. Of course, you can always stretch lightweight paper before you begin to work on it, but for most situations you'll find that heavier paper can save you a lot of extra work.

All the paintings in this book were executed on 140- to 300-pound paper. When you are working with a lot of water—and you frequently are when you paint skies—the heavier 300-pound stock is probably your best bet. It's the preferred paper, too, when you know that you'll be sponging the surface often or working over it with razors or an eraser.

Size matters, too. If you are just starting to paint, don't get overly ambitious. Try working on moderately large pieces of paper rather than gigantic ones. And don't let the paper get too small. Small surfaces (less than 10 inches or 12 inches square) are fine for quick studies but don't give you as much freedom as the larger surfaces do. The paintings in this book were all done on paper 12 inches by 16 inches, a size suitable for most painting situations.

SELECTING YOUR SUBJECT
If skies intrigue you, you shouldn't have any trouble finding something to paint. The sky is constantly changing, and all you need to do is keep your eyes open; you'll find plenty of interesting scenes around you. At first choose skies that are clear or those that have just a few simple clouds. Gradually build up to the point where you can handle skies that are filled with masses of cloud formations. Keep your eyes open, too, for interesting atmospheric conditions—fog, haze, rain, or snow.

When you turn to a sky filled with clouds, realize that what you are dealing with is a surface packed with abstract shapes. The best advice is to keep your eye

on the overall pattern that the shapes create and to follow it as you paint. Even this advice can mean nothing, however, on a windy day, when the clouds move rapidly across the sky. In situations like this—or when you are dealing with other transient atmospheric effects—it's vital that you stick with your first impression. Work quickly, getting down the major details, then fill in the gaps from memory.

DEVELOPING YOUR OWN STYLE
As you work through the lessons in this book, don't feel bound to copy them. As often as possible, try to think of fresh solutions to the problems posed here.

Look at each photograph before you read the lesson. Analyze it, trying to figure out how you would approach it if you encountered it outdoors. Then, as you read the lesson, do so critically. If the solution we offer seems more effective than the one you've thought of, follow it, but if you prefer your own approach, give it a try.

There's no one way to paint a sky; in fact, there are hundreds, even thousands, of approaches that work. Use the solutions we offer as a point of departure for your own interpretations. As you gain confidence, you'll no doubt discover the endless challenge of rendering the sky in watercolor.

Capturing the Stormy Colors of Dawn

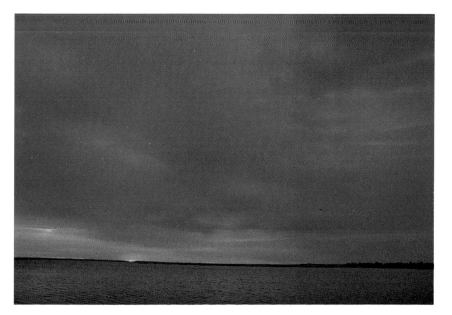

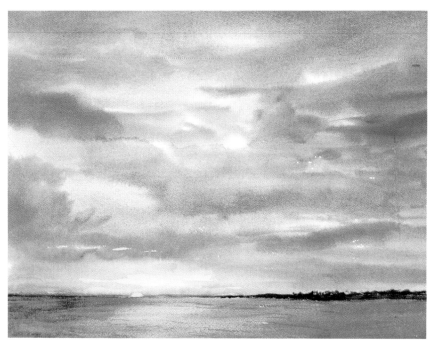

As brooding storm clouds sweep down upon a quiet plain, a sliver of brilliant sky signals the approaching dawn.

PROBLEM
Both the sky and the foreground are an almost unrelieved shade of cool, dark, purplish blue. Unless it's carefully controlled, the thin reddish band breaking through the dark will look forced and out of place.

SOLUTION
Lay in the brightest, lightest, warmest colors first. Don't limit them to just the obvious area above the horizon. Instead, analyze how the red in the sky is reflected on the plain below. After you apply the warm reddish underpainting, gradually add the darker, cooler tones.

☐ Begin by sketching the horizon and the low-lying hills that run along it; then using cadmium orange, new gamboge, and alizarin crimson, begin to paint the sky. To keep the horizon line crisp, work on dry paper. Concentrate most of the color around the spot where the sun is rising, but remember to extend your wash down into the foreground. Now let the paper dry.

Next tackle the clouds. Using a large brush, wet the top of the paper with clear water. When you begin to drop in pigment, work quickly, keeping your color light. You can always go back and make the color more intense, but it's hard to lighten once it's been laid down. Apply the paint loosely, following the patterns formed by the clouds. Keep the sky wet as you drop in darker tones. When you're satisfied with the effect you've achieved, let the paper dry. Here a mixture of ultramarine blue and alizarin crimson capture the color of the storm clouds.

Before you begin the foreground, decide how to capture the shimmering quality created by the reflected light. Here the red-

dish underpainting is allowed to show through the dark bluish paint, which is laid in more intensely toward the sides of the paper.

To deepen the blue, add a little Payne's gray and sepia. As a final step, paint the trees that lie along the horizon. Then, add texture to the foreground by running a brush moistened just slightly with dark blue paint across the paper.

DETAIL
Little irregularities like those here enliven the finished painting, so don't try to control your strokes too rigidly. Note, too, how tiny areas of the paper are totally free of paint; the speckles of white lighten the dark sky.

DETAIL
The colors that flicker along the horizon are warm and bright, yet not so strong that they appear garish. When you are working with brilliant oranges, reds, or yellows, use some restraint. Those hues are incredibly vibrant—a little goes a long way.

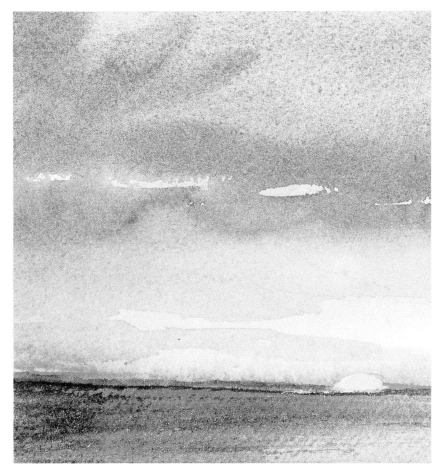

Learning to Work with Reflected Light

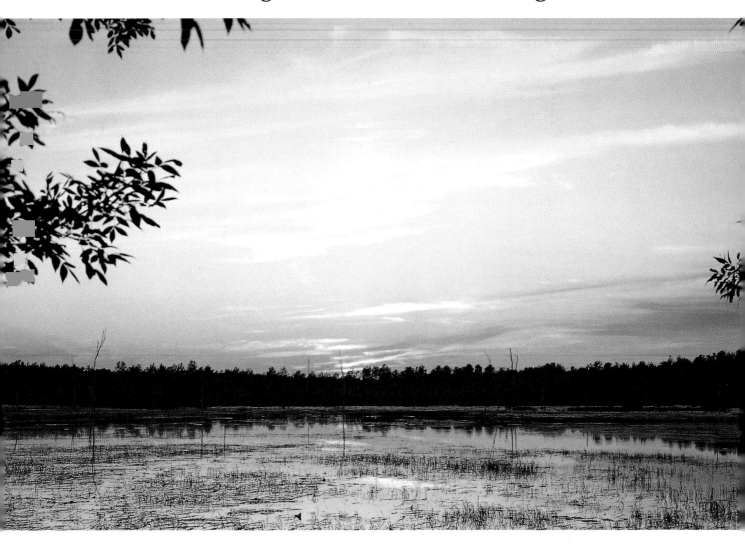

PROBLEM

The warm golden light that patterns the sky and the water is broken up by slashes of cool blues and purples. The entire scene should be drenched with light, but you'll want to emphasize the cool colors, too.

SOLUTION

Cover the paper with a light, warm underpainting; then gradually build up both the bright and the cool colors. Every part of the finished painting will have hints of golden orange.

At dawn, a sun-streaked sky is reflected in the still waters of a grassy pond.

STEP ONE

Sketch in the horizon line and the tree on the left. Then lay in a graded wash of alizarin crimson, cadmium orange, and cadmium red. Work over the entire paper, keeping the brightest tones right at the horizon line where the sun is breaking through. To capture the shimmering colors that float above the horizon, drop in a touch of mauve. Now let the paper dry.

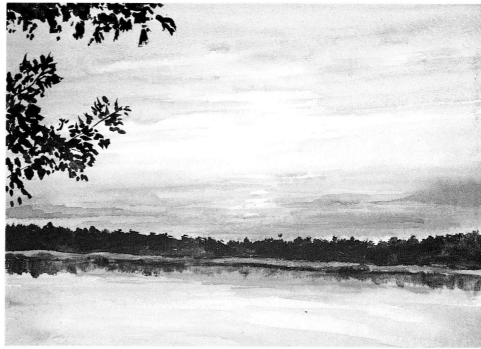

STEP TWO

Using pale washes of cerulean blue and ultramarine, begin streaking the sky with cool tones. Be sure not to cover all of the orange underpainting. Once the pale washes have been applied, add slightly darker values of mauve at the horizon and a strong brilliant orange mixed from alizarin crimson and new gamboge along the horizon and in the water. When the paper has dried, paint the trees in the background and the branches and leaves in the foreground on the left. Now, work the reflections of the trees into the top of the pond.

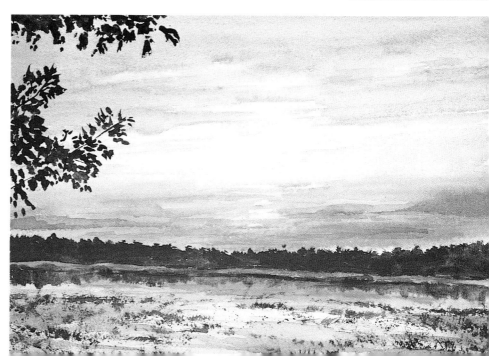

STEP THREE

All that remains to be done are the details in the foreground. Here the blue washes are a little weak; by strengthening them, you can make the foreground move out toward the viewer while everything else falls back into space. Next add the grasses that break through the water. Use a drybrush technique to capture their scraggly appearance and apply the paint with a light hand. If any detail gets too strong, it will pull attention away from the sky.

FINISHED PAINTING

The finished painting captures the glorious colors of sunrise; every inch of it is suffused with a golden orange glow. The cool blues and purples flicker across the scene naturally, and the sun's reflections are gracefully captured in the water.

A warm underpainting dominates the painting. The streaks of blue and purple float above the reddish orange wash but never steal attention from the sun-filled sky. Part of the reason the cool colors work is due to the care with which they are applied. Also, they are pale enough and transparent enough to reveal the underpainting.

The same warm color pervades the water, but the dark tones are stronger here. While the underpainting unites the sky and water, the dark patches of grass and the deep bluish purple passages pull the foreground forward.

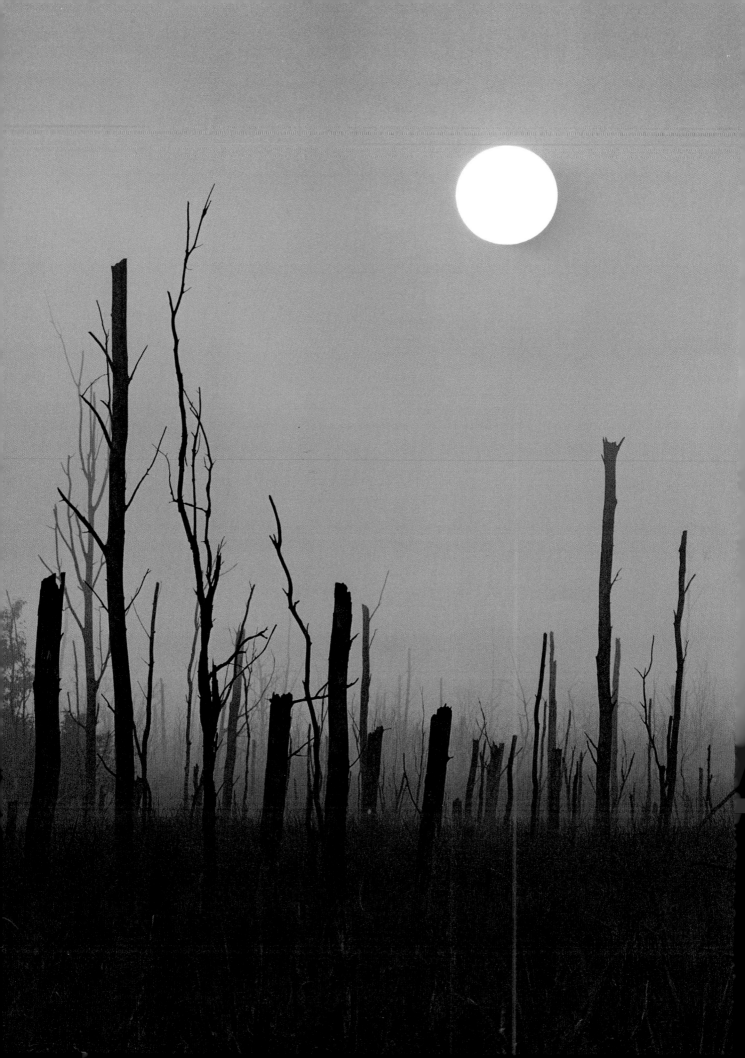

Discovering How to Paint Hazy Atmospheric Effects

PROBLEM
Although the hazy air mutes the background and foreground, and even the strong orange sky, the sun is so bright that the haze doesn't dim its power. The sun's color has to be adjusted to fit naturally into the scene.

SOLUTION
Save the sun for last. Mask it out right away and develop the rest of the painting. To capture the hazy feel that pervades the picture, use some gray to mute the strong oranges and reds in the sky.

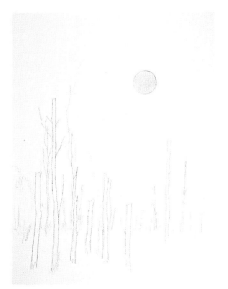

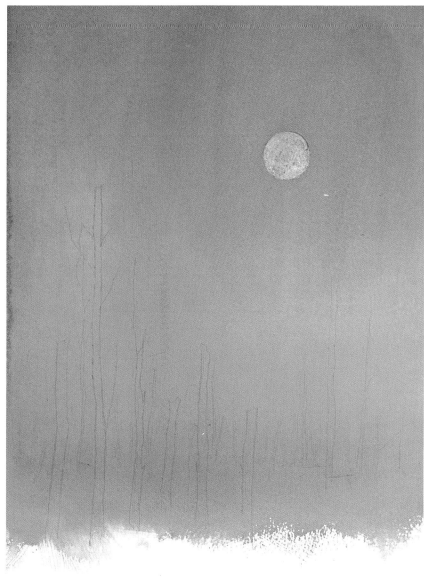

STEP ONE
Because the vegetation in the foreground does so much to set the mood here, a good, strong drawing is vital. Since you'll be laying in fairly dark pigment, make your pencil strokes dark so you'll be able to see them through the paint. Now cover the sun with a liquid masking solution.

STEP TWO
Begin laying in a middle-tone wash over the entire sky. First wet the paper with a sponge, and then work outward from the sun using loose, circular strokes. Right around the sun, use a mixture of cadmium orange, new gamboge, and alizarin crimson. As you move away from the sun, gradually add a touch of Davy's gray and then a little mauve. What you want is a soft halo effect, with the warmest colors encircling the sun.

Sunrise sets off the ghostly silhouettes of decaying trees as a hazy light steals over the scene.

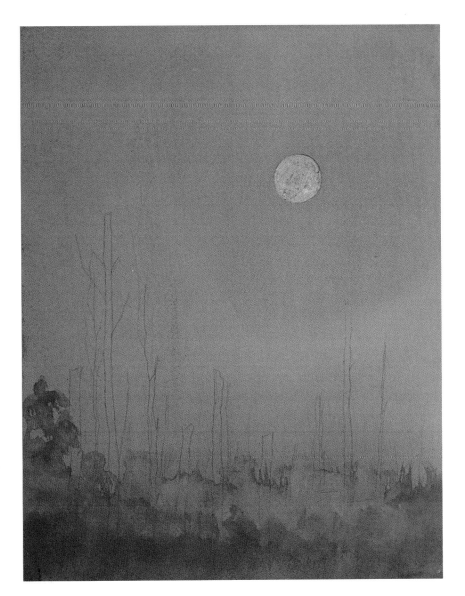

STEP THREE

Before you add the strongly sil-houetted vegetation in the fore-ground, develop the soft, murky grays that run thoughout the background and foreground. Here they are mixed from ultramarine, Payne's gray, and mauve. Near the horizon, where the color be-comes muted by the haze, it is kept light. Closer up, it's slightly darker. Throughout, color is ap-plied with fluid brushstrokes.

FINISHED PAINTING

The dark vegetation in the fore-ground is carefully painted with a dense blend of ultramarine, Payne's gray, and sepia. Now re-move the masking solution from the sun and begin painting it with new gamboge. Don't make it a solid yellow, though—use your paing to suggest its shape, with a deeper yellow along the sides and a highlight in the center. Evaluate how well the sun works with the rest of the painting. If it seems too pale, step up the intensity of the yellow.

The color of the sky shifts gradu-ally from a pure reddish orange near the sun to a muted grayish red near the horizon. The tones are laid in with circular strokes, working outward from the sun.

The vegetation is painted with three values of bluish gray. Along the horizon, the color is so pale that the warm underpainting shows through. The ground and the tall trees at the far left are rendered with a slightly darker tone. The silhouettes are very dark. Note how the haze dims objects in the distance while hardly affecting those in the im-mediate foreground.

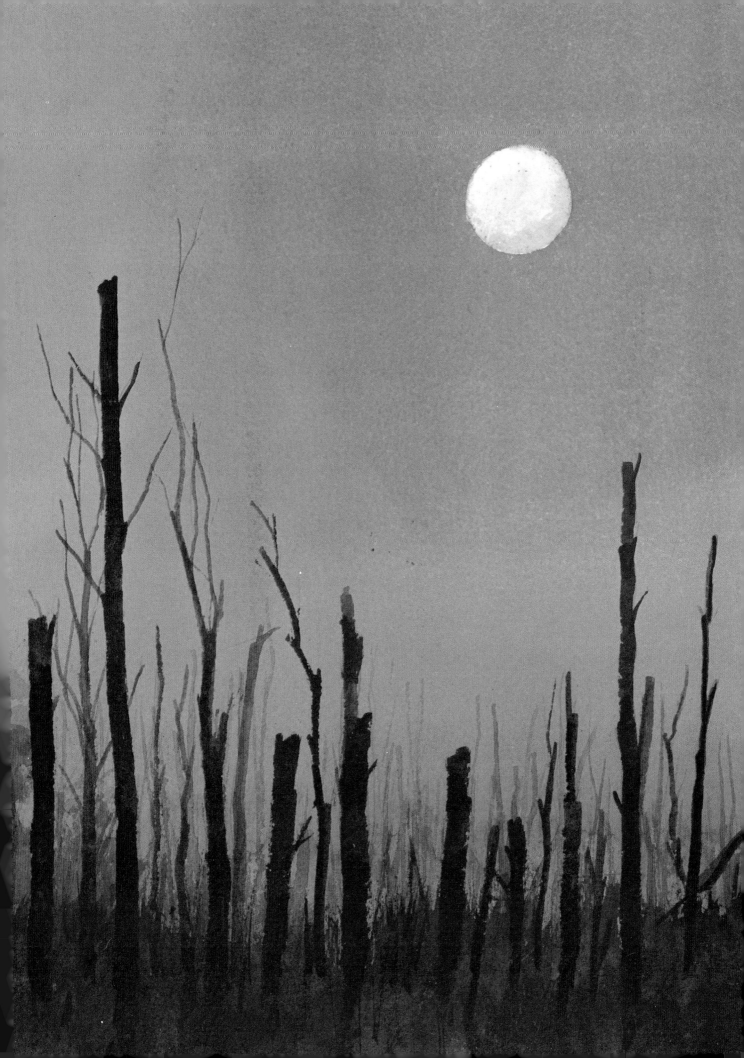

Working with Sharp Contrasts of Light and Dark

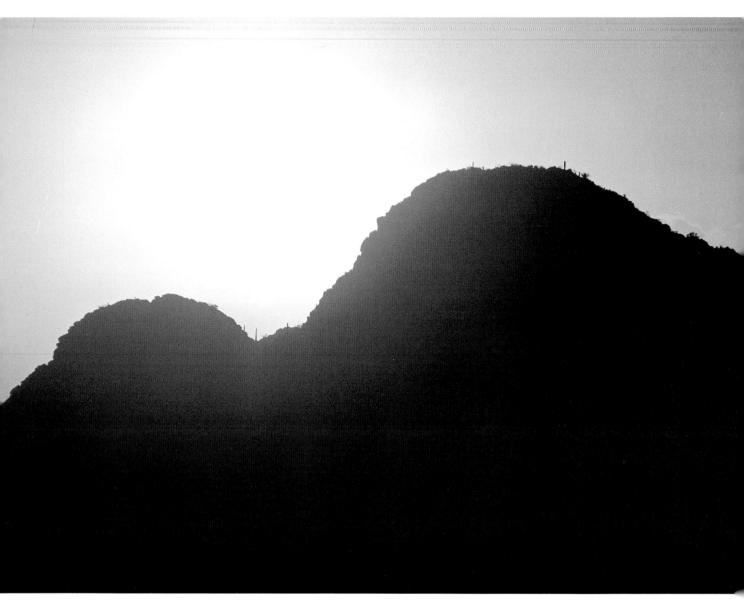

PROBLEM

The golden sky and the dark hills form a dramatic contrast. If you render the scene just as it appears in nature, your painting may look harsh and stilted.

SOLUTION

Lessen the contrast between the sky and the hills by laying-in a yellow wash over the entire paper; the wash will unify the two areas of the painting. When you begin working on the hills, make them slightly lighter than they actually appear and add touches of texture to them.

☐ Sketch the scene, then mask out the lightest area—the sun. The strong golds that you'll lay down around it will visually blend with the white, making it appear pale yellow.

Next, using circular strokes, begin to paint the sky. Apply lemon yellow around the sun; then, radiating outward, drop in new gamboge, cadmium orange, and alizarin crimson. Keep your brushstrokes loose and fluid, and gently blend each new color you

In Arizona at sunrise, the rugged hills of the
Sonoran desert lie silhouetted by a brilliant gold sky.

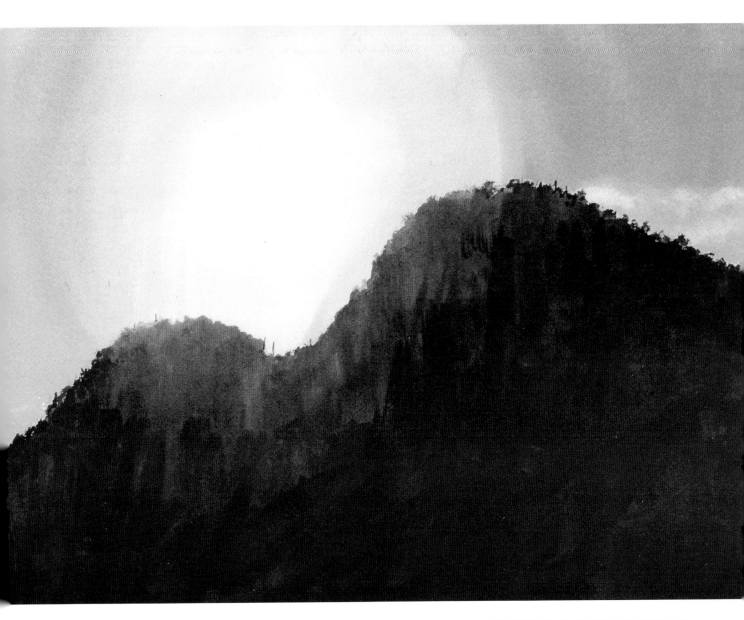

introduce into the previous one to avoid sharp edges. Work all over the surface of the paper, not just in the area of the sky.

Let your paper dry; then turn to the hills. Mix sepia, burnt sienna, and mauve together and apply the paint using rough vertical strokes. Try to create a feeling of texture. If you use a flat, evenly applied wash, the hills will look dull and lifeless. As you move farther away from the sun, add a little ultramarine to cool

down the warm browns.

Now move in for the finishing touches. To suggest pale cloud masses in the upper right corner, wet the area and then lift up the paint using a dry brush or a paper towel. Then, to ease the transition between the sky and the hills, take a small brush and apply bits of lemon yellow paint along the crest of the mountains. Finally, peel off the masking solution.

ASSIGNMENT
See how far you can push the limits of light and dark without losing a natural feel. First, render your scene as realistically as possible: if the foreground seems to be an unrelieved black, paint it that way; make the sky as light and bright as it appears. Often you'll find that the jump in value between two major areas is so great that the whole scene seems artificial. If that happens, try softening the contrast. Warm up the dark areas or use texture to break up dark masses.

Depicting a Monochromatic Sky

PROBLEM

So little is happening here that it's hard to know where to begin. The sky is a flat, even tone of blue and the foreground doesn't have much detail.

SOLUTION

Concentrate on the unusual. It's rare that the sky is the darkest area of a painting, so keep the blue strong, diluting it as little as possible.

□ Draw in the horizon line, then begin to paint the sky. When you are laying in a large area with one color, as you are here, mix much more pigment than you think you'll need. Otherwise, if you run out, you'll have trouble matching the exact color and value. Test your wash before you begin to paint to make sure you've got the color you want.

It's important to keep the foreground and sky clearly separated, so work on dry paper that you've turned upside down and propped up at a slight angle. That way, the paint won't run down into the foreground, leaving you free to work without worry. Here cerulean blue and ultramarine are mixed together to create a strong, dense blue. Apply the paint with a large brush to keep your strokes from getting too labored.

After the paint has dried, turn the paper around and start on the foreground. Keep it sparse, simple, and light enough to stand out clearly against the deep blue. Begin by applying a light yellow ocher wash over the entire foreground. When the wash dries, use quick, sure brushstrokes to put down the crisscrossing bands of olive green and mauve. Don't cover up all of the yellow underpainting—that's what makes the foreground warm and lively. Finally, paint in the stand of trees along the horizon.

As a storm approaches, rolling fields lie beneath a still, deep blue sky.

Learning How to Distinguish Warm and Cool Blues

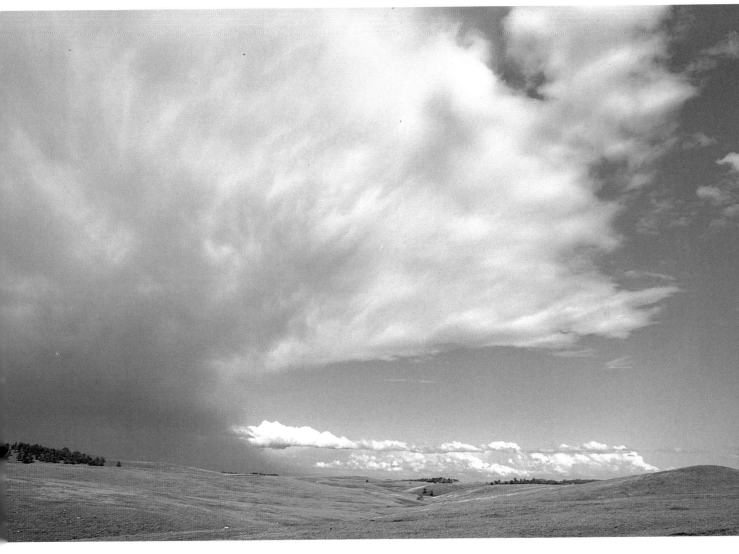

PROBLEM

The rain cloud that sweeps across the left side of this scene has very little definite shape or structure. It will be hard to keep it separate from the blue sky that lies beyond.

SOLUTION

Use color and value to pull the sky and the cloud apart. Paint the cloud first, in a cool shade of blue; then add the sky. To make the sky distinct, you can adjust its value and its warmth.

Far in the distance, an early summer rainstorm beats down upon a fresh green prairie.

STEP ONE

Gently sketch in the rain cloud and the horizon; then, using a natural sponge, wet the entire sky. For the cloud, you'll want cold, steely bluish gray tones. Both ultramarine and cerulean blue are too strong and warm. Instead, start with Payne's gray, tempered with a bit of yellow ocher. Drop the two colors onto the wet paper to indicate the lightest areas of the cloud. Working quickly now, add the darker portions of the cloud before the paper dries. Here Antwerp blue and alizarin crimson form an interesting cool shade. Because the paper is still damp, the light and dark areas run together naturally.

STEP TWO

The sky is blue too, but it's much warmer and more vibrant than the cloud mass, especially toward the top of the paper. Begin there, laying in a mixture of ultramarine and cerulean blue; work around the storm cloud and the clouds near the horizon. As you approach the center of the paper, mix a little yellow ocher with your cerulean blue. Near the horizon line, use just cerulean blue and alizarin crimson. If the edge around the cloud seems too sharp, soften it using a clean, wet brush.

STEP THREE

Add shadows to the long clouds that hover above the horizon. Work with a small brush for control, and make sure that the value you apply isn't darker than the dark part of the storm cloud. Leave the top of the clouds white—the white paper showing through adds a crisp dash to the painting. Now lay in the dark clumps of trees in the background.

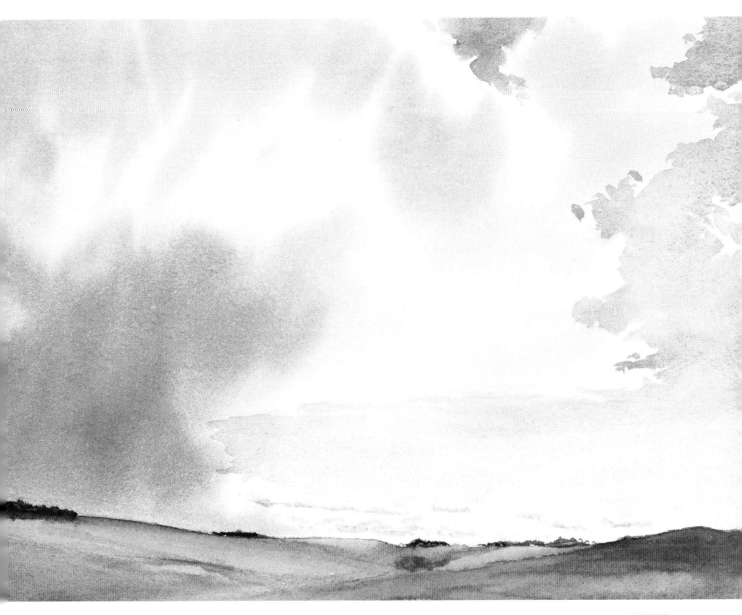

FINISHED PAINTING

With new gamboge, Hooker's green, burnt sienna, and sepia, lay in the foreground. Use broad, sweeping strokes applied in a rhythmic fashion to capture the gradations of the hills. Don't let the greens get too flat; you want some variety in your brushwork.

ASSIGNMENT

One of the many challenges a painter faces is to interpret the color of a sky. Understandably, mostly beginners think in terms of blue. But even the bluest sky can be built up of different tones.

Throughout this book, you'll find many references to yellow ocher and alizarin crimson—colors that seem unlikely choices for mixing blues. Get acquainted with how they work.

Begin with a damp piece of paper. You'll need Payne's gray, ultramarine, cerulean blue, yellow ocher, and alizarin crimson. At the top of the paper, lay in a wash composed of Payne's gray and ultramarine. While the paint is still wet, lay in a band of ultramarine and cerulean blue directly below the first band. Make sure the two areas blend together thoroughly. Now eliminate the ultramarine from your palette. Take cerulean blue, add just a touch of yellow ocher, and lay in a third band. For the final band, near the bottom of the paper, mix cerulean blue with alizarin crimson. Again, you'll need just a drop of the second color (red).

Do several of these graded washes, varying the amounts of gray, ocher, and crimson you use. Soon you'll discover how much color you need to just slightly change the blues that form the basis of your palette.

Exploring Lively, Distinct Cloud Patterns

PRORI FM

Three different situations come into play here: the clouds in the background are soft and indistinct, the smaller ones in the middle ground have sharp edges, and the large mass in the foreground is soft, billowy and tinged with yellow.

SOLUTION

Work out the soft foreground clouds first. To capture their texture, you'll need to work on wet paper. Later go back and rub out the clouds in the background; then define the sharp-edged cloud formations in the center with opaque gouache.

☐ Start by sketching the shapes of the major clouds, then wet the entire paper using a natural sponge. It won't abrade the surface of the paper the way a synthetic one will. Once the paper is wet, begin working on the light clouds in the foreground. (First analyze their color; only when the sun shines directly on clouds are they really white. In this painting, a mixture of yellow ocher and Payne's gray gets across the feel of the large cloud mass.) ith a large brush, work in the color loosely; what you're trying to capture is the soft, hazy way the shapes float against the sky.

Next take ultramarine and cerulean blue and mix a deep, rich tone. Lay in the sky quickly, while the paper is still wet. The blue will run into the cloud mass in the foreground, softening its contours. Before the paint dries, quickly take a piece of paper toweling or a small natural sponge and wipe out the small clouds in the upper left quarter of the painting. Next drop in opaque white to define the crisp clouds in the center. Work the paint rapidly into the still damp blue.

DETAIL

The techniques used in rendering these clouds create very different effects. The cloud on the left was wiped out with a piece of toweling; it looks hazy and indistinct. Those on the right were created by dropping opaque paint into the damp blue sky; they look sharp and clearly defined. The clouds on the right are much more dynamic and forceful than those on the left, which seem to float back into space.

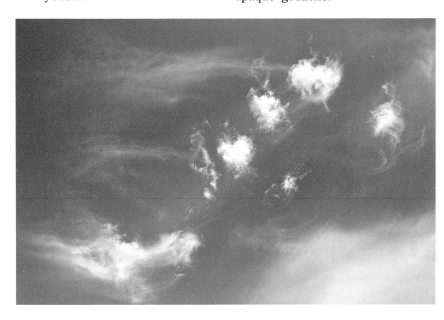

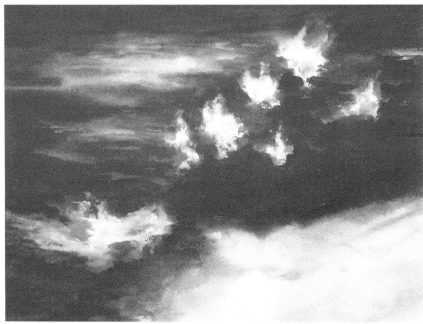

In autumn, thick cirrus clouds whirl across a dark blue sky.

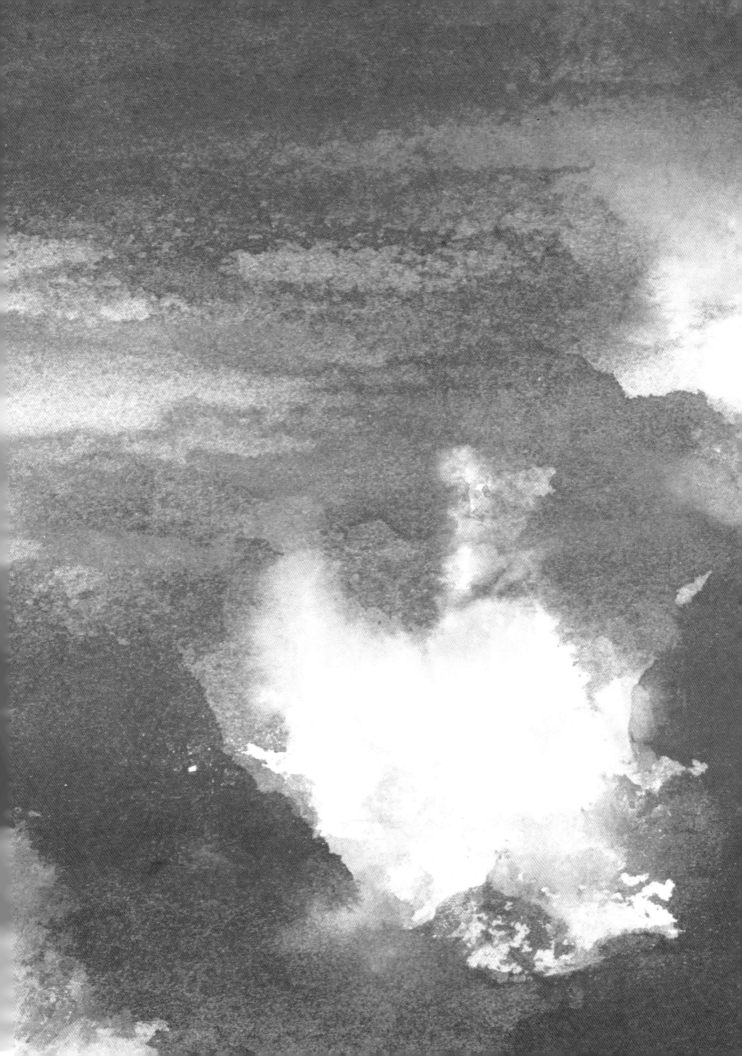

Depicting a Complex Overall Cloud Pattern

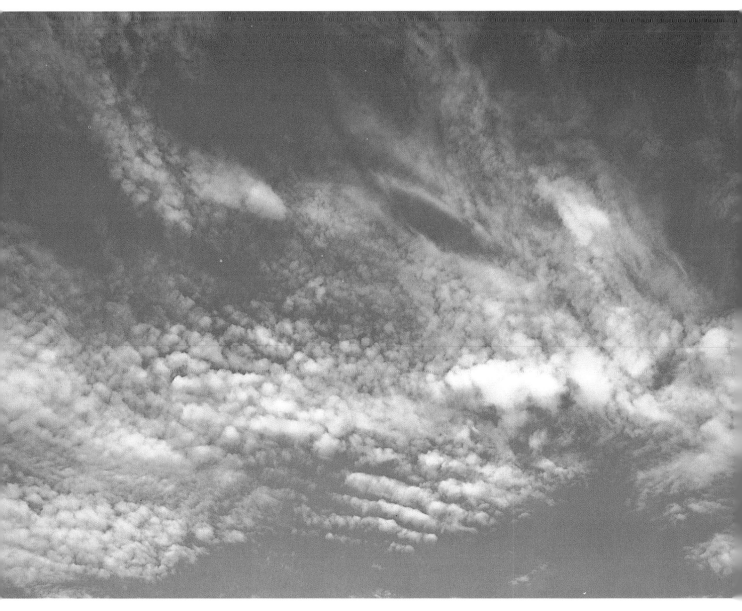

PROBLEM

When a pattern is as strong as the one you see here, to make sense out of it is difficult. The challenge is even greater when you're dealing with soft-edged masses.

SOLUTION

First simplify the pattern as much as possible; then lay down a deep-blue graded wash. To achieve a soft effect, drop in opaque white while the paper is still damp. Don't try to paint around the clouds; their edges will look hard and brittle.

☐ When the clouds are as complex as the ones you see here, don't bother sketching them. Instead, begin by analyzing the blue of the sky. Although it looks uniform at first, it is actually darker toward the top. Mix a wash of cerulean and ultramarine blue and apply it quickly to the paper. When you are laying in broad areas like this, use a large, soft brush. Toward the top of the paper, add a little Payne's gray to darken the blue.

*Masses of altocumulus clouds float across the sky,
forming a rich, dense pattern of white on blue.*

While the paint is still damp, begin dropping in the white paint. Blend it gently with the blue underpainting. Keep your eye on the overall pattern the clouds form and don't get stuck in any one spot. When you are happy with the pattern, stop.

You can see an almost pure white passage near the center of the painting. Almost everywhere else, the white paint has blended with the blue. This variation adds sparkle to a painting.

ASSIGNMENT

Don't wait until you're working on a painting to learn how to tackle cloud patterns. Begin at home with several wet-in-wet techniques.

First, prepare a big puddle of blue wash and apply it to three sheets of paper. While one is very wet, drop in opaque white. Explore how it mixes with the blue and how to control it with your brush.

Next, turn to the second sheet; it should be slightly damp. Again, put down opaque white. Note how the paint handles differently when the paper is just damp.

Finally, turn to the third sheet. It should be almost dry. Moisten the cloud areas with clear water. Run your brush over lightly to loosen some of the blue pigment. Now add the white paint.

Don't stop here—endless variations are possible.

Learning to Simplify Dramatic Cloud Formations

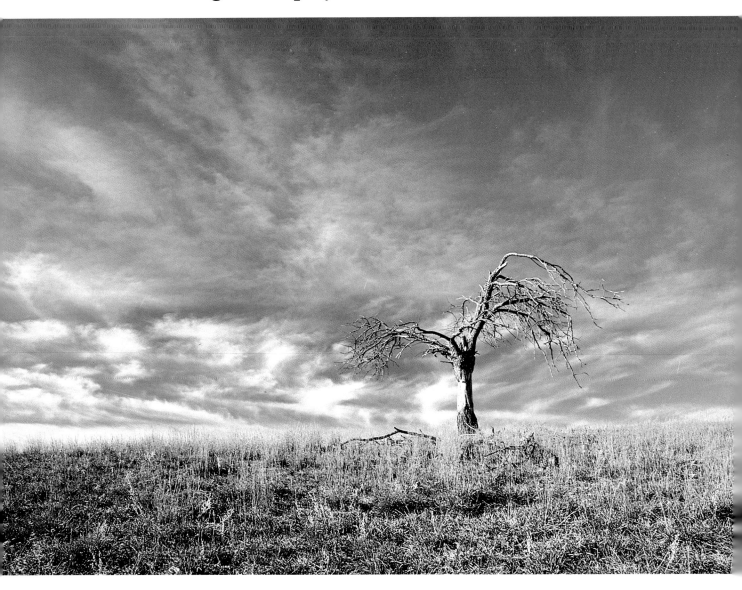

PROBLEM

This composition is deceptively simple. Even though there is only one tree and the prairie seems straightforward, strong, bright colors and complex patterns fill both the sky and prairie.

SOLUTION

Decrease the strong blue in the sky and downplay the clouds behind the tree. You don't always have to paint exactly what you see. Instead, think through the overall composition before you begin to work, and decide what needs to be changed to make an effective painting.

☐ Do a preliminary sketch and then mask out the tree. It's going to be hard to get the tree to stand out against the dramatic sky, so save it for last.

Next tackle one of the hardest parts of the painting—the sky. Begin by laying in a graded wash; the sky is darkest at the top and gradually shifts to a middle tone at the horizon. Don't try to match the brilliant blue you see. There is enough strong color in the foreground, so make the blue a little

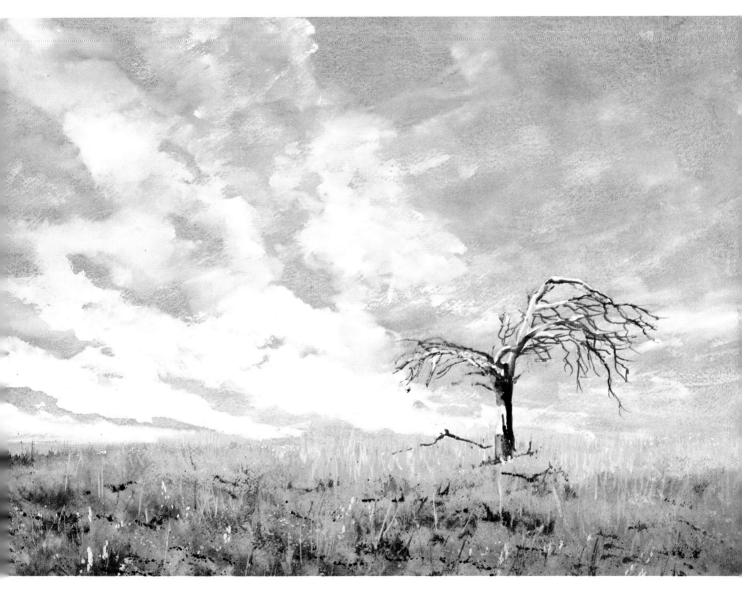

duller and grayer.

While the paint is still wet, start to indicate the large white clouds. Drop opaque gouache onto the paper, letting it mix slightly with the blue underpainting. Once you're satisfied with the pattern you've formed and with the contrast between the clouds and the sky, let the paper dry.

Now develop the foreground. First put down a wash of warm yellow ocher near the horizon line. As you move toward the bottom of the paper, add sepia and burnt sienna using vertical strokes to get across the feeling of tall grass. Next add texture and detail to the foreground. Using opaque paint and a fine brush, highlight a few clumps of grass. Then, to animate the field, spatter paint over it. Finally, remove the masking solution and paint the tree.

Discovering How to Depict Rays of Light

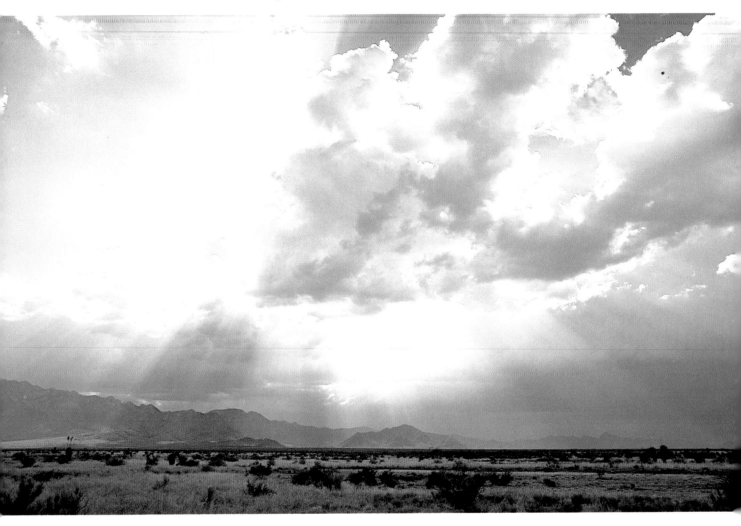

PROBLEM

When the sun lies almost hidden by a mass of clouds, you have to pay attention to three elements: the pattern of the clouds, the sky, and the rays of light. So much is going on that to capture a coherent image is difficult.

SOLUTION

When you approach a complicated subject like this one, it's especially important to plan a method of attack. Visualize the finished painting before you begin; then analyze how to achieve the effect you want. Here the rays of light are dealt with last—they are rubbed out with an eraser.

Storm clouds crowd together over an Arizona desert, masking the sun and allowing only a handful of its rays to break through.

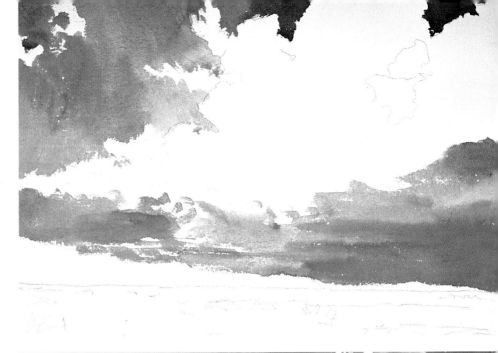

STEP ONE

Draw in the horizon line and the hills and roughly indicate the shape of the storm clouds. Then decide where to start. Since the sky is a much larger part of the scene than the cloud mass, render it first. Work with a variety of blues—ultramarine, cerulean, and Antwerp—warmed with a little yellow ocher. Don't try to make your sky wash too even; a little variety in the surface helps to capture a stormy feel. Right near the horizon, add a touch of alizarin crimson to convey a sense of distance.

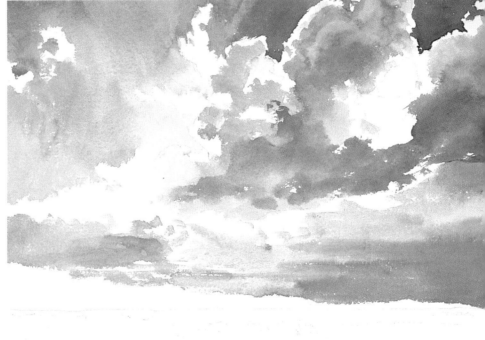

STEP TWO

Now move in on the clouds. You'll want to leave a white border around them to indicate the sun; keep that white shape irregular and full of movement. Use the same blues for the clouds as you used for the sky, but darken the tones with a little Payne's gray and alizarin crimson. Don't work with one flat tone because it's even more important here than in the sky to create a rich surface. Lay in some blue wash, and then add touches of gray and crimson right onto the wet paper, mixing the colors as you work.

STEP THREE

The white border around the storm clouds looks stark, so ease in touches of pale blue to break it up. Don't fill the white area or overpower it; simply pattern what could be a dead, empty space. Now paint in the hills along the horizon. Render them with the cool blues you've already used, to make them harmonize with the sky. Now add the foreground. Here the ground is a wash of yellow ocher and burnt sienna. While it's still wet, drop in dashes of mauve and Antwerp blue toward the immediate foreground.

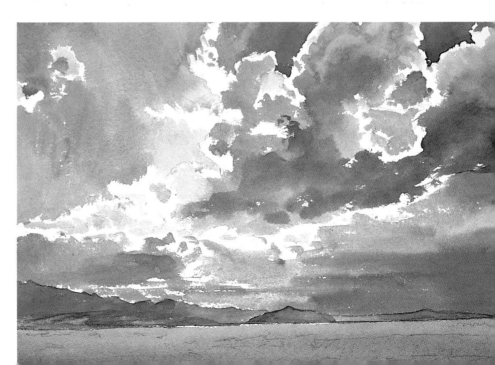

FINISHED PAINTING

Using restraint, enrich the foreground of the painting with new gamboge, Hooker's green, and burnt sienna. Don't add too much detail or it will pull attention away from the sky. Finish the foreground by spattering a dash of sepia over it.

Finally, when the paper is absolutely dry, take a soft eraser and pull out the rays of light that break through the clouds. Work gently; don't force the eraser across the surface or you may rip the paper. Keep the erased lines straight and even, and be sure to have them all radiate from one point. To achieve a dramatic effect, work with assurance.

ASSIGNMENT

It takes practice to use an eraser effectively on a watercolor painting. This exercise will help you understand how it's done.

Begin by preparing several small sheets of paper with a graded wash. Let the papers dry thoroughly; if they're even slightly moist, you'll end up with smeared (and ruined) works.

Take three erasers—an ink eraser, a kneaded one, and a regular soft pencil eraser—and experiment with all three. You'll soon discover that the ink eraser is the most abrasive. It'll pull at the surface of the paper, destroying the texture. The pencil eraser is your best bet; it may pull up the color more slowly, but the result will be much less harsh. Finally, the kneaded eraser is a handy tool for softening lines you've picked up with the pencil eraser. It's great, too, for cleaning up bits of paper and paint that remain after you've used the pencil eraser.

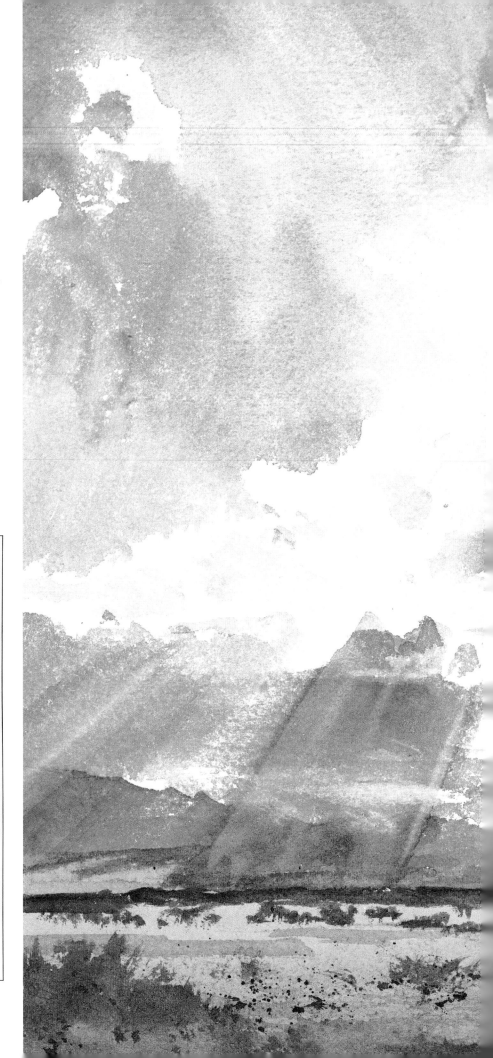

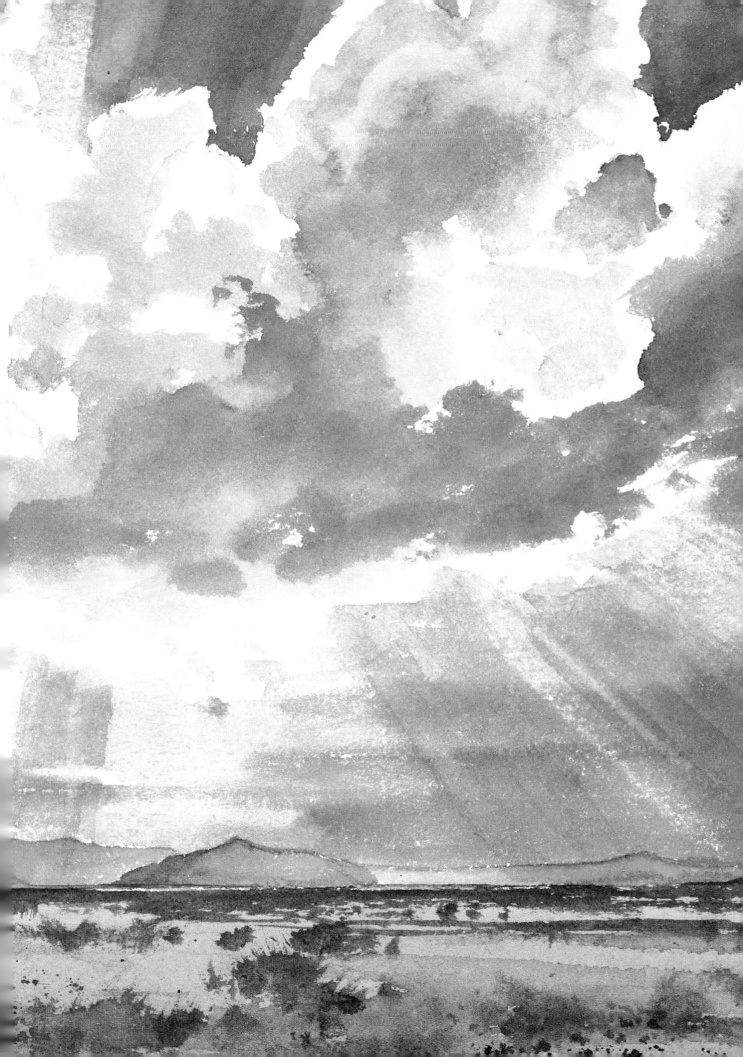

Capturing a Strong Silhouette Against an Early Morning Sky

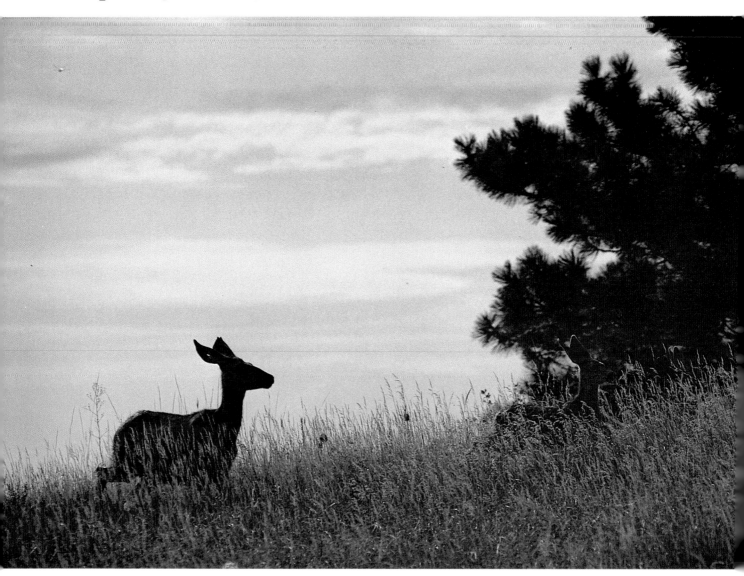

PROBLEM
The strong silhouettes of the deer and the tree make the sky almost incidental to the scene. Yet the sky sets the time of day and makes what could be a stiff and unnatural composition come alive. You've got to make the sky interesting and full of color, but not so lively that it pulls attention away from the foreground.

SOLUTION
Paint the sky first, working over the entire paper. The dark foreground will cover up whatever color you lay in, and you'll be able to work more freely if you're not trying to stay in just one area.

Early on a summer morning, as the sun streaks the sky with color, a mule deer pauses briefly before it disappears into the woods.

STEP ONE

Execute a careful sketch; then plan the sky. Keep your washes light; after you mix each color, paint a test swatch to make sure the color isn't too intense. It's easier to lay in blue over pink than vice versa, so start with a pale wash of alizarin crimson. When it's dry, begin laying in the blues. Toward the top, work in Antwerp blue and toward the horizon, cerulean blue. Don't make the sky too regular—the bands of color should have interesting, slightly irregular contours.

STEP TWO

Now intensify the blue bands in the sky. Follow the pattern you observe in nature as you begin, and don't cover up all of the pink underpainting. Here, cerulean blue bands are applied in the middle of the sky. At the bottom, cerulean is mixed with ultramarine, and at the top, cool bands of Antwerp blue and alizarin float across the paper.

STEP THREE

Let the paper dry before you move in to paint the deer and the tree. While you're waiting, decide what colors to use. In a silhouette situation like this, any dark color—even straight black—could probably be used. But the effect is much more interesting if you include one or two of the colors used elsewhere in the composition. For the tree, use ultramarine darkened with Payne's gray and sepia. Render the deer with the same mixture, but add a drop of burnt sienna to bring out the color of the animal's coat.

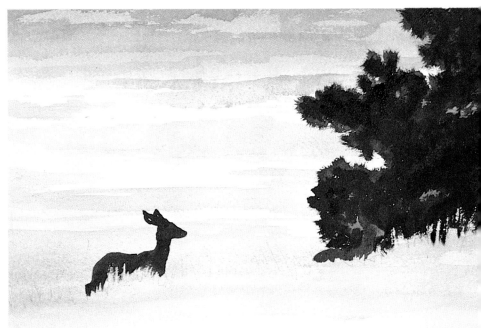

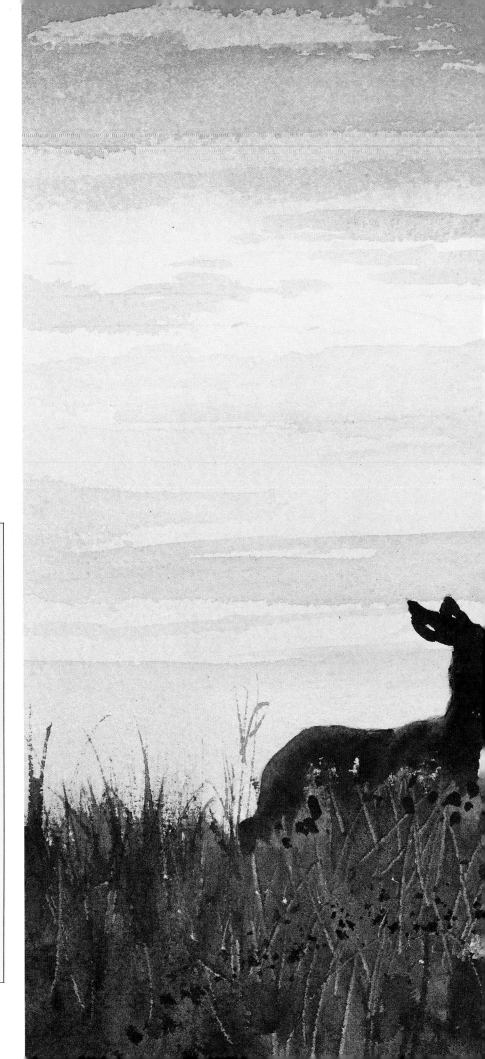

FINISHED PAINTING

Now add the foreground. First apply a wash mixed from yellow ocher, burnt sienna, sepia, and Payne's gray; then, while the paint is still wet, scratch out some of the tall grasses. To do this, simply use the tip of a brush handle. Finally, add a little punch to the foreground by spattering sepia over the grass.

ASSIGNMENT

Momentary scenes like this one, with an animal paused for just a second, have to be captured quickly. One of the most practical ways to do that is to work with a camera. Most artists rely on photography in one way or another, and for artists interested in skies, it can be invaluable. Many of the shifting patterns that clouds form are ephemeral—before you can begin to get down the image you want, the entire pattern may change. Try carrying a camera with you when you go scouting for new painting situations, and record any sky formation that interests you.

Once your film has been developed, organize a file of your pictures. Separate them according to time of day and season. Later on, when you are working on a painting and need to have a specific image—say, a late afternoon sky in autumn—you'll be able to turn to your file and find a suitable sky.

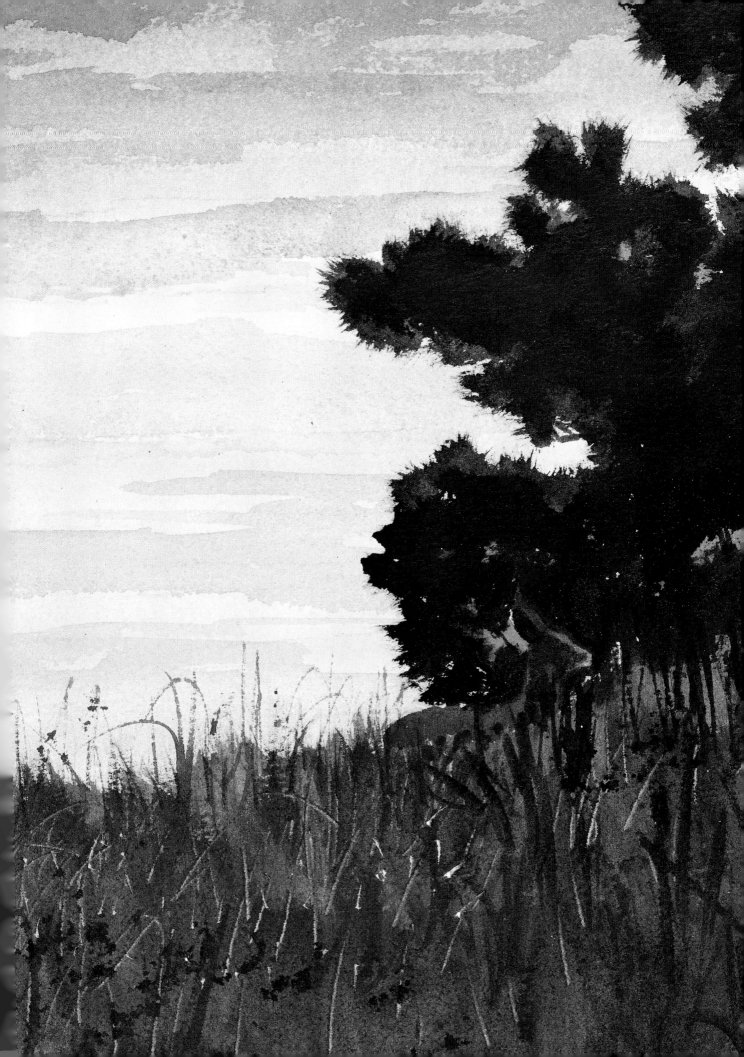

Using a Wet-in-Wet Technique to Depict Cloud Masses

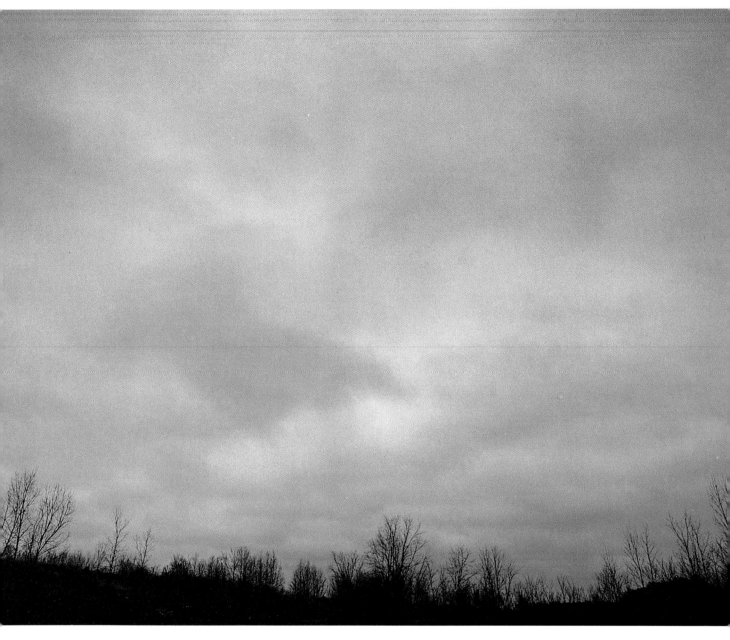

PROBLEM

When you're dealing with nebulous clouds like these, there isn't much to hang on to. Their edges aren't well defined and they run into one another. Finally, in some places, subtle patches of light break through.

SOLUTION

Don't be too literal in your approach. To get the soft feel of this kind of sky, work with a wet-in-wet technique; follow the overall cloud patterns and let the light shine through.

☐ Wet the entire paper with clear water. Then quickly drop ultramarine onto the right and left sides of the paper. Keep the blue light and as you work, follow the patterns created by the clouds. Temper the blue with touches of alizarin crimson and burnt sienna. Next move to the center of the paper. Using the same colors, begin to depict the central clouds.

To convey the feeling of rays of light, lift the paper up and let

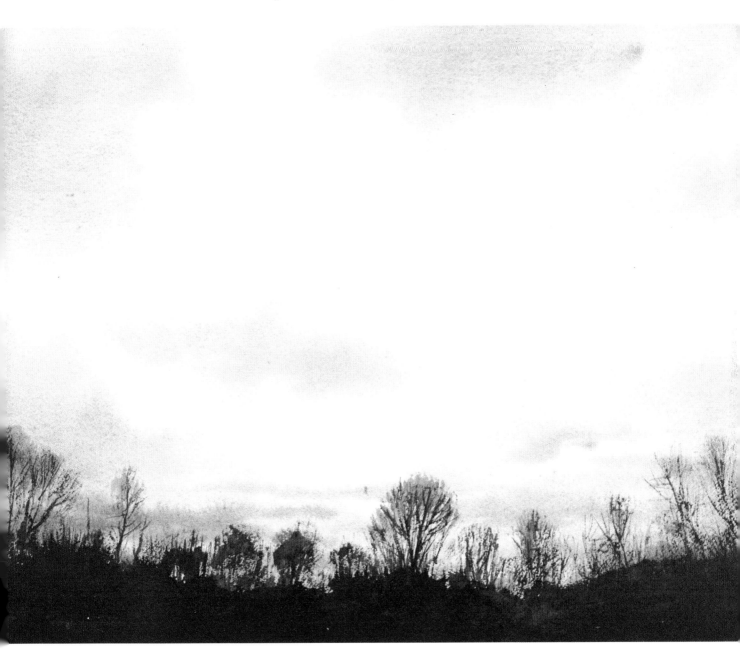

the paint run down. Move the paper up and down and back and forth. As you work, try to control the flow of the paint—you don't want to completely cover up the light, white areas. If you lose control, wash the paint off with a wet sponge and start all over again. As soon as you've captured a strong pattern, set the paper down and let the paint dry.

For the foreground, mix sepia with a touch of ultramarine, and then lay in the rolling hills and the tree trunks. Let the paint dry. Finally, use a pale sepia wash to suggest the masses of branches that radiate from the trunks.

The soft, wet, lush clouds result from careful control of the paint flow. The color runs effortlessly into the white areas, breaking up the white with gentle, raylike streaks.

Balancing a Dramatic Cloud Formation and a Plain Gray Sky

PROBLEM

Most of the scene is taken up by the plain bluish gray sky. The focal point—the cloud formation—must blend in with the gray sky yet have enough drama to lend interest to the painting.

SOLUTION

Develop the light, cloud-filled area near the horizon first, then carefully shift to a graded wash for the bluish gray sky above. Make the transition between the two areas as soft as possible.

☐ Sketch in the horizon; then, using new gamboge and yellow ocher, lay in the pale area behind the cloud mass. While the wash is still wet, work upward, gradually adding cerulean blue, then ultramarine, and then ultramarine warmed with a hint of alizarin crimson. As you move from color to color, make sure to blend each new tone into the preceding one.

While the paint is still wet, tackle the clouds. First depict the dark, shadowy areas with a mixture of yellow ocher, alizarin crimson, and Payne's gray. Next mix opaque white with a dash of yellow ocher and drop in the soft white portions of the clouds. Don't let their edges get too sharp. If necessary, drop in a bit of clear water to soften any harsh lines.

Most beginning painters make their clouds almost pure white, but clouds are rarely white. They reflect the color of the light that fills the sky and may be grayish, reddish, or—as they are here—tinged with yellow. Don't be afraid to experiment with unlikely colors when you approach cloud-filled skies. You'll find your paintings will become much more vital and realistic if you move beyond the expected.

To finish the painting, indicate the hillside that runs across the bottom of the picture. Try a pale mauve wash—the cool purplish tone is great for conveying a feeling of distance. When it's dry, lay in the trees in the foreground with Hooker's green. Add detail and texture to the trees with sepia using a drybrush technique.

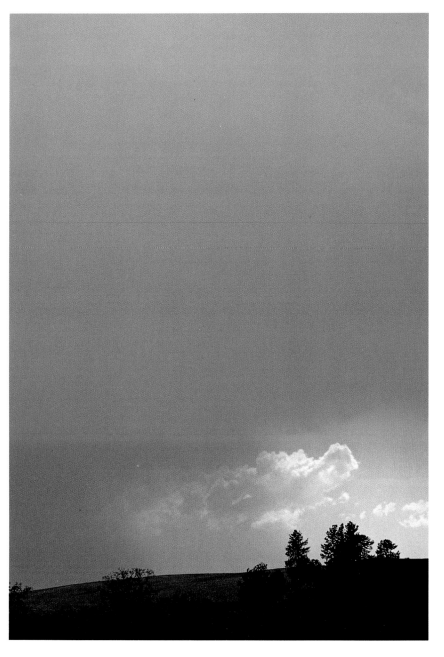

During a rainstorm, low-lying clouds press close to the ground.

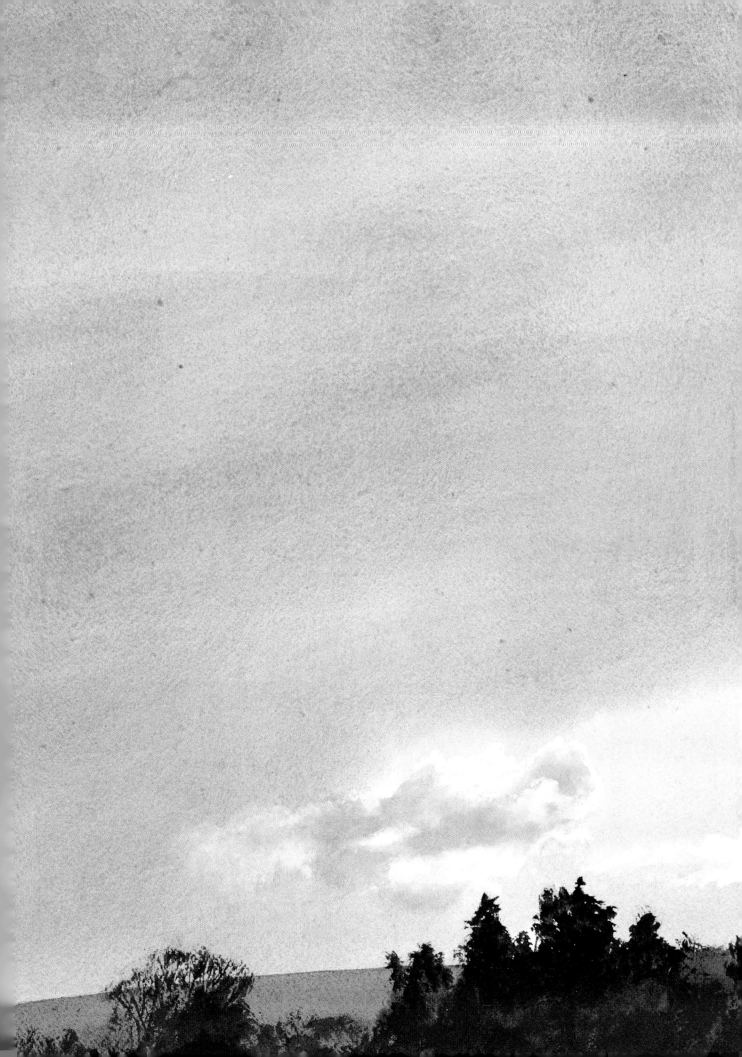

Using a Clean, Sharp Edge to Hold the Shape of a Cloud

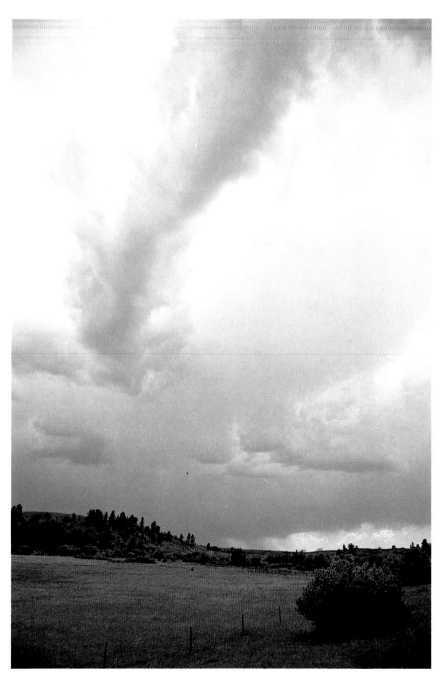

Dark storm clouds spiral down toward a soft green summer landscape.

PROBLEM

Even though the dark vertical cloud is what you notice first, soft diffuse cloud formations actually fill the whole sky. You'll need to capture two atmospheric effects.

SOLUTION

Work wet-in-wet first, rendering the soft clouds that occupy most of the sky. Let the paper dry thoroughly, and then lay in the darker cloud. Because you'll be working on dry paper, you'll be able to keep the cloud's contours clean and sharp.

STEP ONE

After you sketch in the foreground, wet the sky with a sponge. Now lay in a cool gray wash over the whole sky; here the gray is mixed from Payne's gray and yellow ocher. While the wash is still wet, drop in darker colors with a large round brush to indicate the brooding clouds that eddy out near the horizon and at the top of the paper. Use cerulean blue and ultramarine for the basic shapes, and add a small touch of alizarin crimson and burnt sienna near the horizon. Let the paper dry—if it's even a little damp, you'll have trouble with the next step.

STEP TWO

Begin to execute the dark cloud that shoots down through the sky. Try a mixture of Payne's gray, yellow ocher, and cerulean blue. By keeping your brush fairly dry, you'll be able to take advantage of the paper's texture. The paint will cling to the raised portions but won't fill up the depressions. Also, because the paper is dry you'll achieve a crisp, clear line.

Now, while the freshly applied paint is damp, drop in the darkest area of the cloud and the smoky clouds that run along the horizon. For this, mix cerulean blue with ultramarine and alizarin crimson. Finally, with a light wash of cerulean blue and yellow ocher, add the splash of bright sky that breaks through the clouds along the horizon.

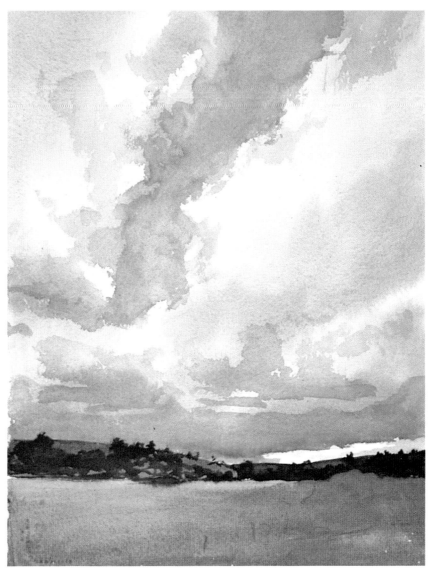

STEP THREE

When you approach the foreground, think in terms of value. The grassy field will be the lightest value, and the trees and hills will be rendered in two darker values of green. Beginning with the distant hills and trees, put down a middle-tone mixture of Hooker's green and burnt sienna. Now accentuate the dark portions of the trees with Hooker's green, sepia, and Payne's gray. When everything is dry, lay in the foreground with a blend of Hooker's green, yellow ocher, burnt sienna, and just a touch of cool mauve.

FINISHED PAINTING (OVERLEAF)

Let the field dry. Then, using the same colors you used in step three, paint the shrub in the lower right corner. You'll want to bring a little life to the foreground now: first lay in washes of green over the grass, and then add some brownish strokes at the very bottom of the paper. The brown strokes move out from the shrub at a sharp angle, adding a definite sense of perspective to the scene and leading the viewer's eye into the painting.

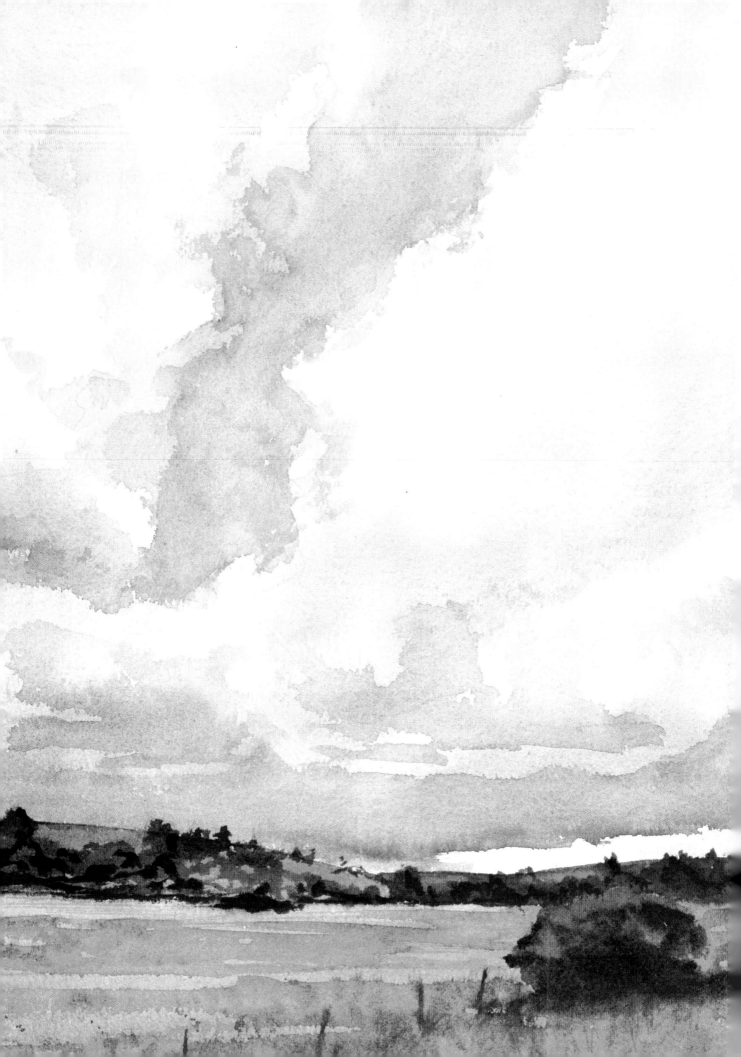

Capturing the Beauty of a Rainbow

PROBLEM

A rainbow is extremely difficult to capture in paint. It is light and ephemeral yet made up of definite colors. If it doesn't blend in naturally with the sky, it will look garish and seem pasted onto the paper.

SOLUTION

Lay in the blue sky first; then carefully wipe out the area where the rainbow will go. Don't mask the area out—the transition between the sky and the rainbow will be too harsh if you do.

☐ Although at first the sky seems to be a single shade of blue, it's actually darker toward the horizon. To capture the subtle shift of color, apply a graded wash to wet paper. Here cerulean blue and yellow ocher are mixed with a touch of ultramarine. Since it's easier to control a wash if you don't have to worry about the paint running into the foreground, turn your paper upside down. As soon as you've laid in the wash, and while the paper is still wet, use a paper towel or dry sponge to wipe up the paint where the clouds and the rainbow will be. Move quickly now. The paper should be slightly damp when you put down the rainbow.

The colors in the rainbow are mauve, ultramarine, alizarin crimson, cadmium orange, new gamboge, lemon yellow, Hooker's green, and cerulean blue. Keep your values very light and let each color blend into the ones surrounding it. Getting the right colors and values as well as a soft, natural feel is difficult — you may need several attempts.

To show the clouds that break through the bottom of the rainbow, again take a piece of toweling or a sponge and pick up the paint. Now put down the foreground. Begin with a wash of new gamboge; then add mauve and sepia for the shadowy areas and the details. When everything is dry, evaluate your painting. (Here the rainbow was too bright toward the top. To soften it, a kneaded eraser was used to gently pick up touches of paint.)

DETAIL (OVERLEAF)

Here you can see what happens when you wipe up wet paint. First, note the soft edges of the rainbow. Then look at the clouds that cut through the arcs. They don't seem harsh but float gently in front of the rainbow.

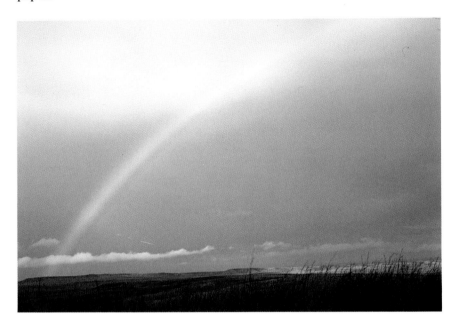

A rainbow springs across a pale blue sky, animating the prairie below.

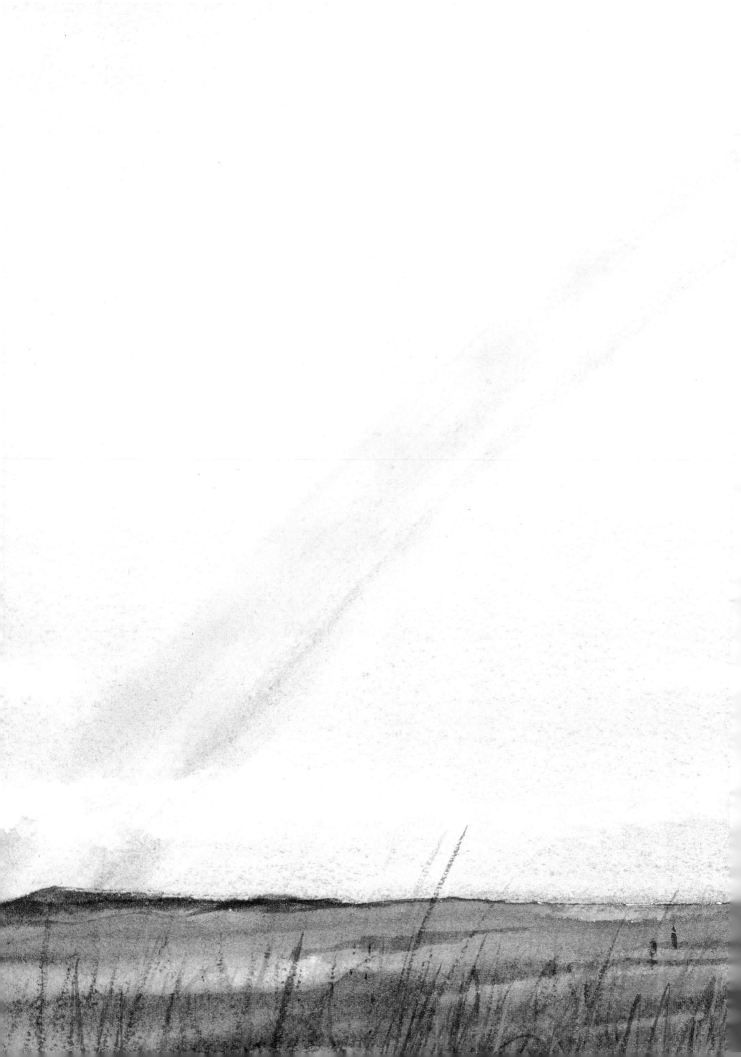

Discovering How to Work with Late Afternoon Light

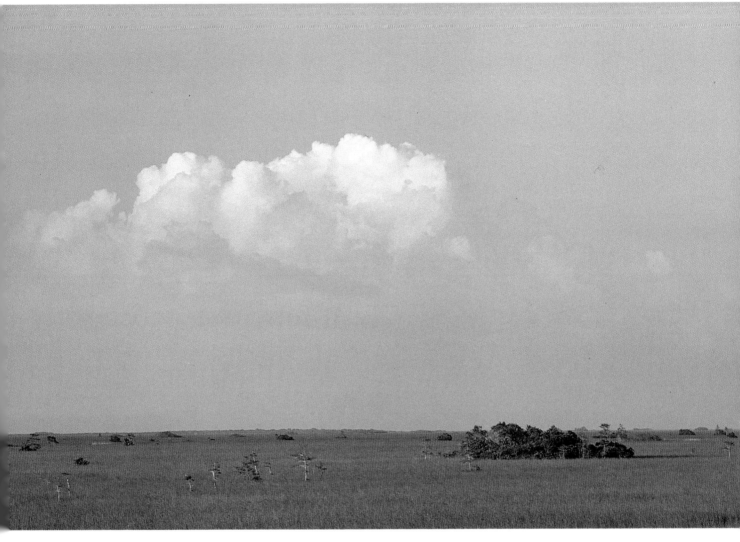

PROBLEM

These clouds are suffused with a warm pink tone—in fact, the whole scene has a pinkish yellow cast. You have to inject your painting with a pinkish tone without overstating it.

SOLUTION

Instead of adding red and gold to all of your colors, first do a flat underpainting with alizarin crimson and new gamboge. The underpainting will shine through all of the colors you put on top, and so unify the entire scene.

☐ Cover the paper with a pale wash of alizarin crimson and new gamboge; let the paint dry. Now lay in the sky, starting with cerulean blue. Work around the large cloud formation, chiseling out its shape. Toward the top of the paper, deepen the cerulean blue with ultramarine, and near the horizon, drop in a little alizarin crimson.

Using pale washes mixed from your blues and alizarin, paint in the shadowy areas along the undersides of the clouds. Keep your values light or the clouds will blend in with the medium-value sky. Now lay in the foreground. Start with a wash of new gamboge, and then use burnt sienna and olive green to depict the grasses, shadows, and trees. As a final accent, paint the hills that sprawl along the horizon using mauve.

Soft, billowy clouds float lazily above the Everglades, in a late afternoon sky.

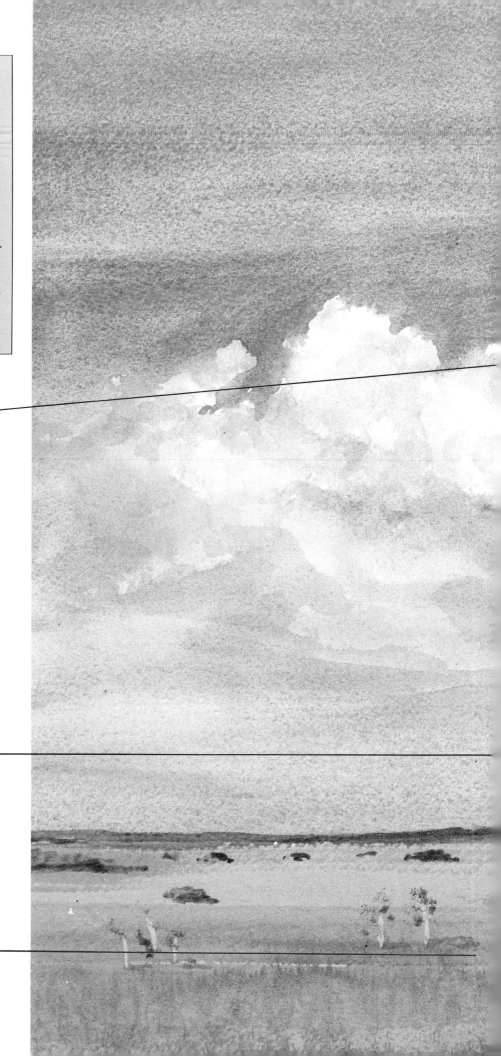

ASSIGNMENT

In the late afternoon, the sky is often cast with a pinkish tone. During other times of the day, the atmosphere is also characterized by a particular hint of color. Try to figure out what colors you see in the early morning, at noon, in the late afternoon, or at twilight. For example, in the summer the sky at dawn may seem suffused with pale yellow; in the dead of winter the sky is often a cold, steely gray. Once you've isolated those basic colors, prepare your watercolor paper ahead of time: lay in a wash over several sheets before you go outdoors to paint.

The underpainting of alizarin crimson and new gamboge warms the white paper and acts as a base for the colors you add later. The shadows are pale and melt into one another; they're mixed from various densities of ultramarine and cerulean blue, plus a touch of alizarin crimson.

The blue of the sky near the foreground is tempered with uneven touches of alizarin crimson. The purplish blue that results creates a powerful sense of distance.

Horizontal brushstrokes add an expansive feel to the foreground, making it seem to rush outward, beyond the limits of the paper. The warm, rich colors fit in perfectly with the warmth of the brilliant sky.

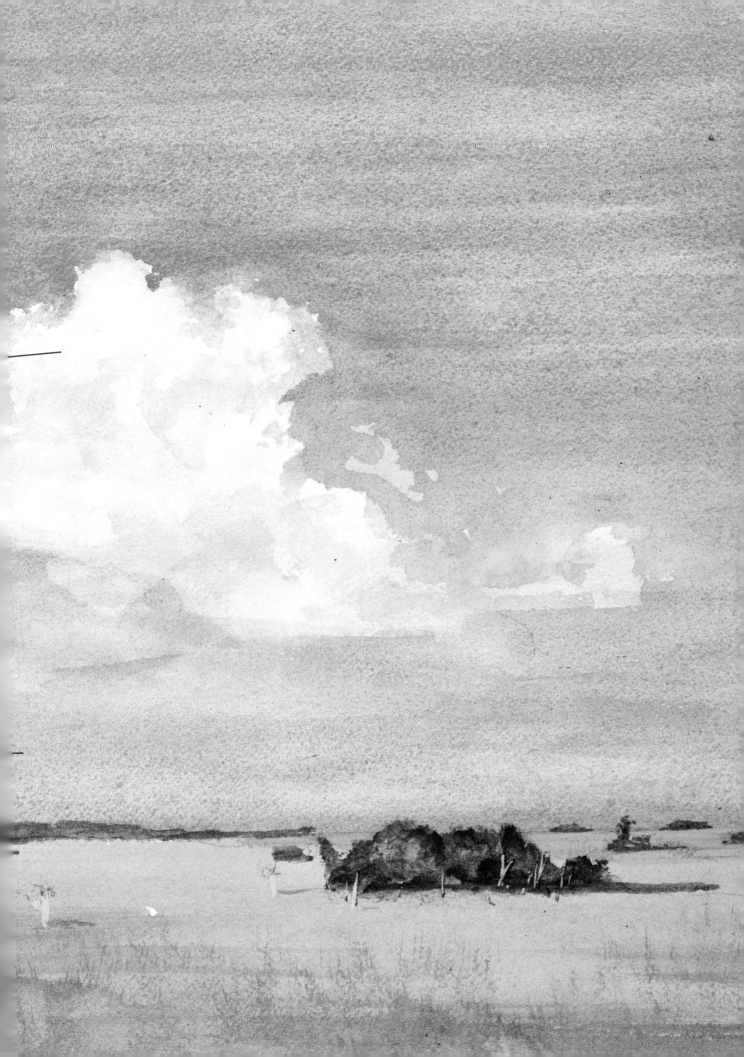

Working with Dense Cloud Masses

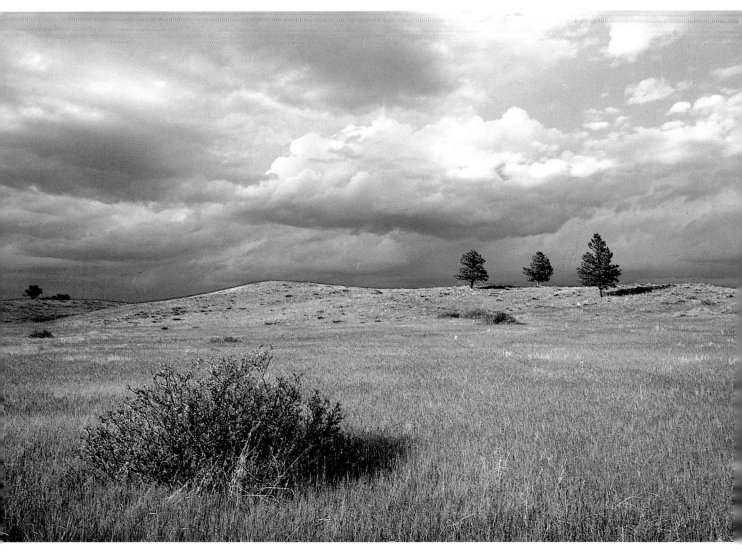

PROBLEM

This scene is packed with richly textured clouds—so many that none of the sky shows through. Furthermore, there's no strong contrast between darks and lights. The clouds aren't your only problem; you'll also want to capture the radiant light that bathes the entire scene.

SOLUTION

Forget about showing all of the surface details that fill the clouds. Instead, simplify them, following whatever pattern you see. Then accentuate the bright green hills that roll across the foreground to suggest the radiance of the sky.

Thick storm clouds press down on a brightly lit prairie.

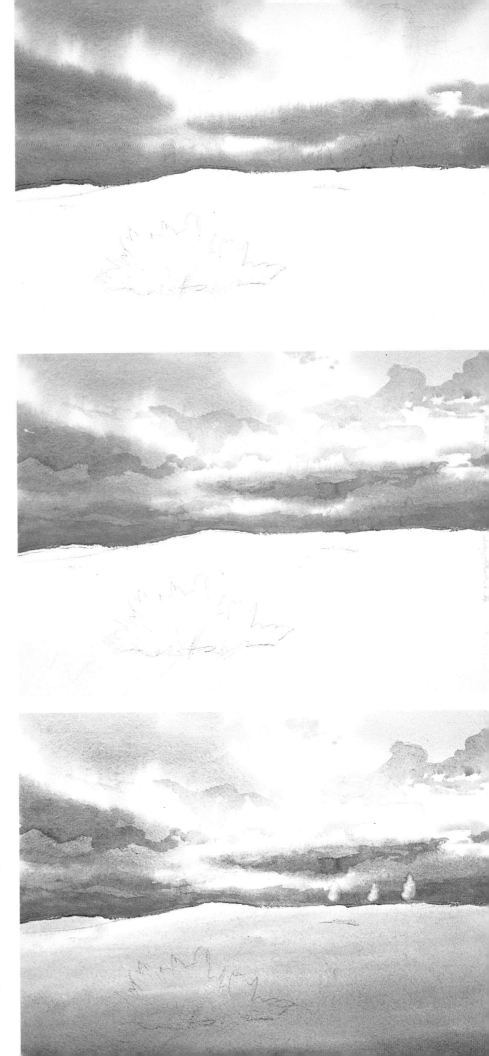

STEP ONE

Do a preliminary drawing; then wet the sky with a sponge or a flat brush, 1½″ to 2″ wide. Mix a cool wash of Payne's gray, cerulean blue, and yellow ocher, and drop it onto the top right and left corners of the paper. Let the water on the paper carry the pigment loosely, down and outward. You'll want a darker, warmer tone for the clouds that float above the horizon—try mixing ultramarine, Payne's gray, yellow ocher, and a touch of alizarin crimson. Drop the paint in and again let the water carry it. If you start to lose the pattern you see, use a small round brush to direct the flow of the paint.

STEP TWO

Up until now, you've worked wet-in-wet, establishing the basic underlying areas of bluish gray. Now, to add structure to the sky, you'll have to add sharper, clearer passages of paint. Before you begin, analyze the scene: look for the most definite patterns of darks. Mix ultramarine and cerulean blue with Payne's gray, and then start to paint. Leave some edges crisp; soften others with a brush dipped in clear water.

STEP THREE

If the foreground gets too dark and heavy, you'll lose the radiant light that washes across the whole scene. What you want is a rich, verdant green that pulsates with warmth. Start laying in the foreground with a graded wash: at the horizon use pure yellow ocher—the gold will make the sun seem to break through the clouds, hitting the distant mountains; as you move forward, introduce Hooker's green and then burnt sienna and sepia. While the paint dries, use a small brush moistened with clear water to wash out the three trees in the distance.

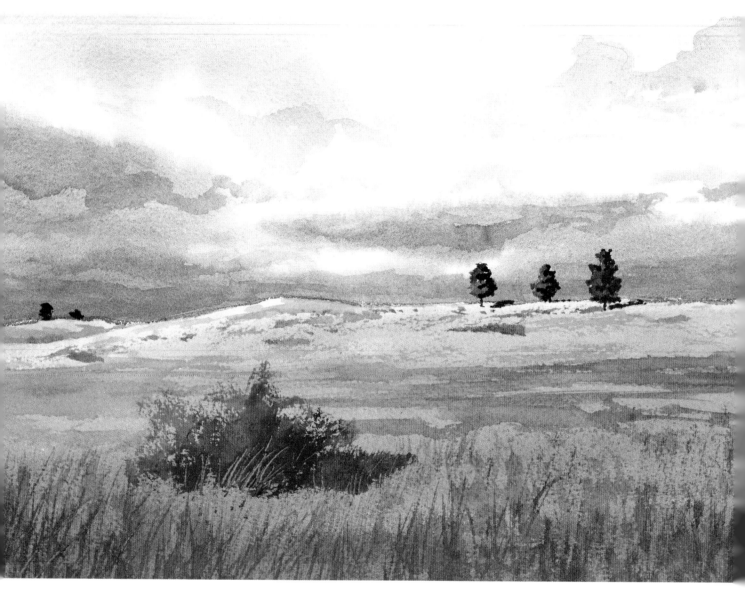

FINISHED PAINTING
Add light, sweeping washes over the graded wash in the foreground; here, Hooker's green, yellow ocher, burnt sienna, and sepia are used. Next add the dark trees along the horizon and the shrub in the foreground. Finally, use a drybrush technique to render the tall grasses visible in the immediate foreground.

DETAIL

Here you can see the two techniques used to render the sky. In the background, a soft, hazy bluish gray runs into the white paper—the paint is applied while the paper is wet. After the paper has dried, the darker, sharper passages that hover over the indistinct background are added.

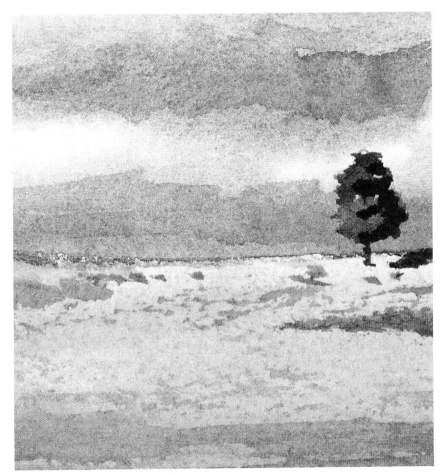

DETAIL

The deep blue sky along the horizon contrasts neatly with the golden green hills. Gradually, toward the bottom of the paper, the ground becomes deeper and richer.

Using Opaque Gouache to Render Thick, Heavy Clouds

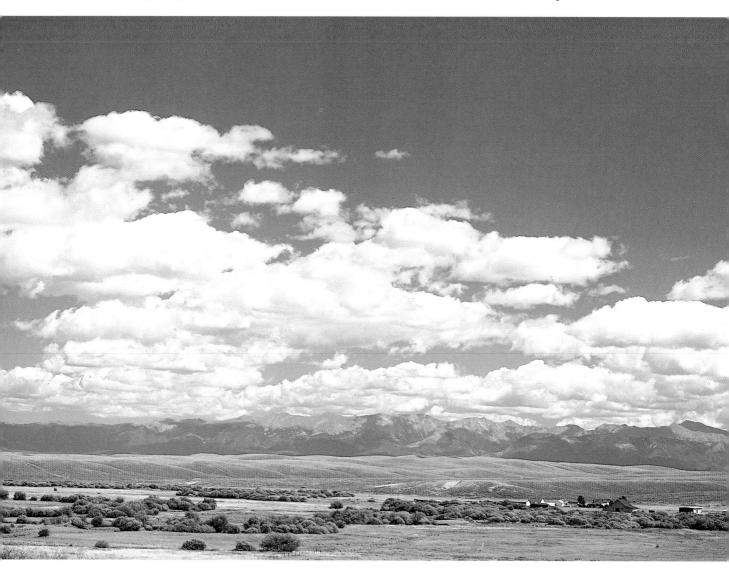

PROBLEM

These cumulus clouds contrast sharply with the rich blue sky and the shift from deep blue to bright white gives the scene much of its power. But the clouds aren't just white—their shadows are grayish gold, and if you make the shadows too dark, you'll lose a lot of the contrast on which your painting depends.

SOLUTION

Begin with the sky, laying in a rich blue graded wash. Then paint the clouds with gouache. First establish their shapes with white, and then gently work in their shadows, constantly balancing the value of the shadowy areas with the value of the sky behind them.

On an autumn afternoon, thick cumulus clouds fill the sky, sweeping back over the rolling Wyoming ranch land.

STEP ONE

Sketch the scene; then begin to paint the sky. In your graded wash, you'll want to work light to dark, beginning along the horizon. (Turn your paper upside down so you won't have to worry about paint running into the fore-ground.) Along the horizon, put down cerulean blue and yellow ocher, then gradually shift to a mixture of cerulean blue and ul-tramarine. Next work in pure ultramarine, and then deepen it with a touch of Payne's gray. Let the paint dry.

STEP TWO

Keeping your eye on the patterns formed by the clouds, start paint-ing the clouds closest to you. Lay in their basic shapes using white gouache. For the little clouds that float high in the sky, apply the paint with a drybrush technique. The broken strokes will let the blue of the sky show through, making the clouds seem far away.

Now turn to the shadows. Mix white gouache with Payne's gray and yellow ocher, but keep the color lighter than you think it should be. Carefully work the paint into the clouds, using soft, gentle strokes—you don't want any harsh edges.

STEP THREE

Now it's time to finish the clouds. Add the masses that drift above the horizon, first with pure white and then with the same shadow colors you used before. To achieve a sense of perspective, make the shadows slightly darker on these low-lying clouds; that will push them back into the dis-tance. Once the clouds are done, you may have to increase the value of the sky that lies just above the mountains. (Here, for example, the darkish shadows made the sky seem too light.) Next paint the mountains using yellow ocher, burnt sienna, and ultramarine.

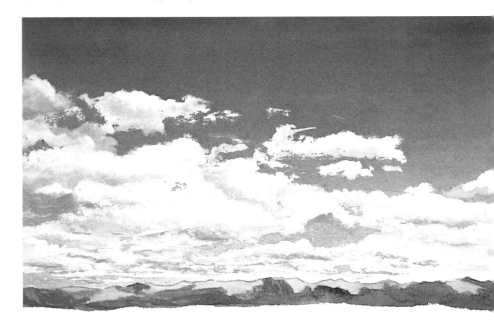

FINISHED PAINTING

To balance the activity in the sky, you'll want a rich variety of greens to spill out across the plain. All the greens you see here are mixed from new gamboge, ultramarine, Hooker's green, yellow ocher, and burnt sienna. Keep the play of lights and darks lively, and finish your painting by adding a little texture to the lower left corner.

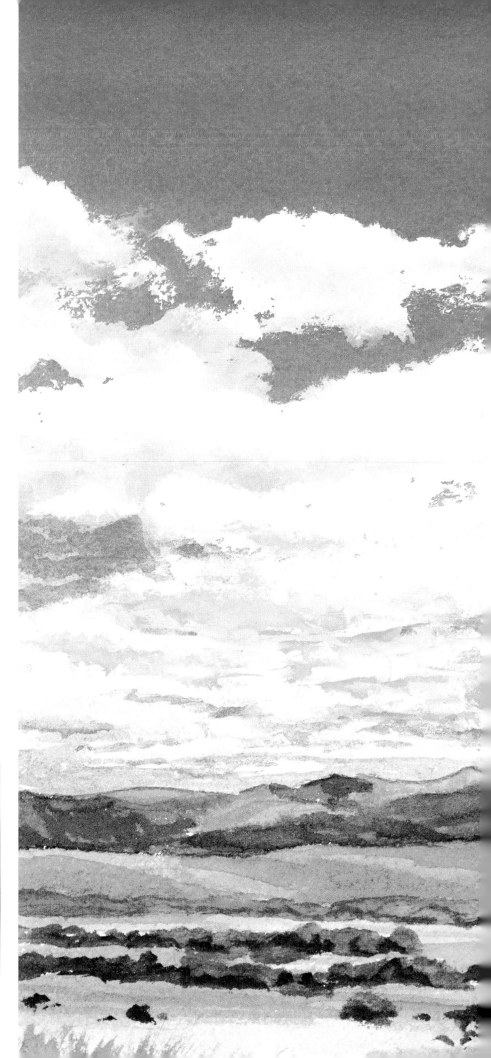

ASSIGNMENT

Learn how to control the value of shadows before you attempt to paint a rich cloud formation that's full of lights and darks. You'll be working with gouache, applying it to a prepared surface.

Start by laying in a medium-blue graded wash over an entire sheet of watercolor paper. Let the paint dry. Next use pure white gouache to depict some basic cloud shapes, working either from nature or from a photograph. Keep the contours lively and interesting—you don't want the clouds to look like cotton balls pasted onto a backdrop.

Now mix white with a small amount of gray and yellow. What you need is a very pale shade, just one value darker than pure white. Paint in some of the shadows, using loose strokes. Now make your mixture of white, gray, and yellow one value darker. Lay in more of the shadows. You should immediately see the difference in value between the white and the two light gray tones.

If you make shadows any darker, they may look like holes punched through the clouds. Keep them lighter than the blue sky behind them.

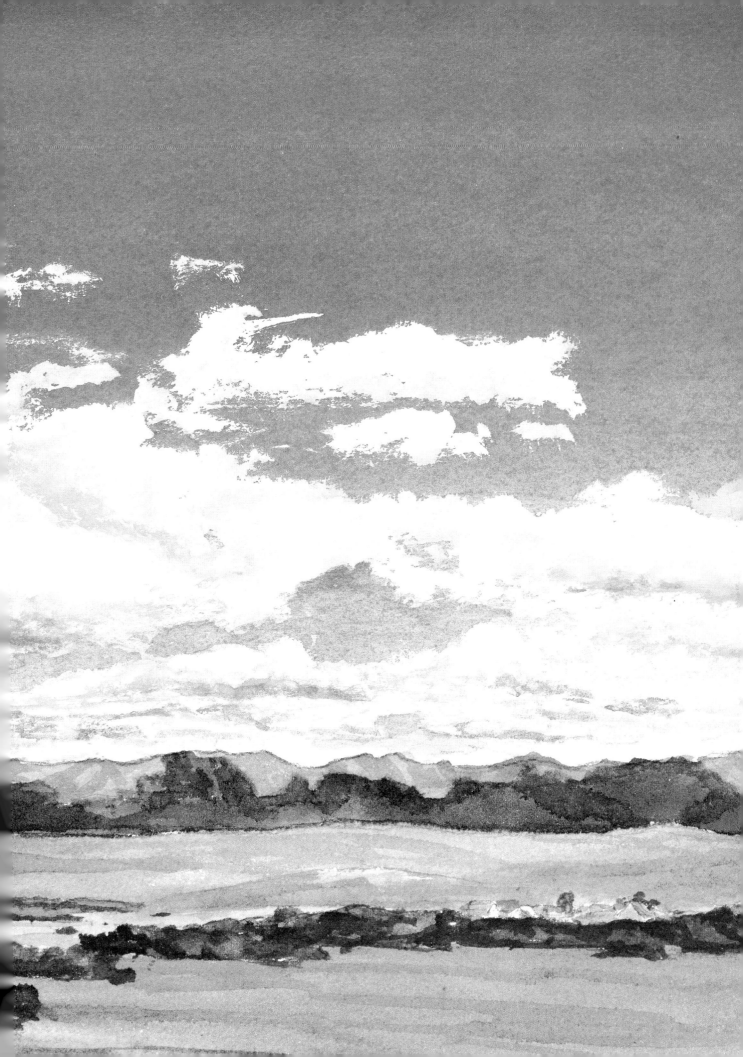

Learning How to Handle Complex Patterns

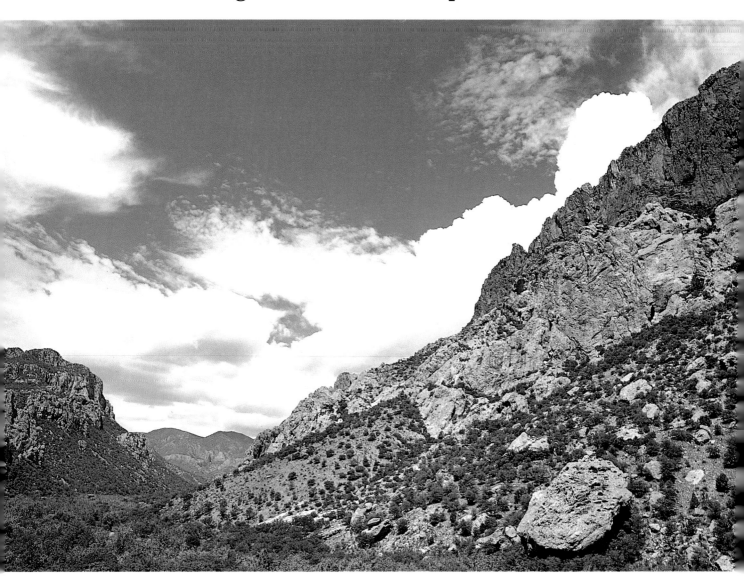

PROBLEM

So much drama is crowded into this scene that you could easily lose your way when painting it. The clouds and the rich blue sky compete for attention with the rocky mountains.

SOLUTION

Use the cloud masses to separate the deep blue sky from the mountains. Crisply define the edges of the clouds and use a strong blue to depict the sky.

☐ Sketch rocky foreground; then begin the sky. Whenever a painting relies strongly—as this one does—on the effect you create with the sky, paint that first. Then, if you don't capture the feeling you want at first, you can always start over again.

Working on dry paper, take a big brush and a wash of deep ultramarine and lay in the clear patch of sky. In the center, keep the edge fairly well defined. Let

64

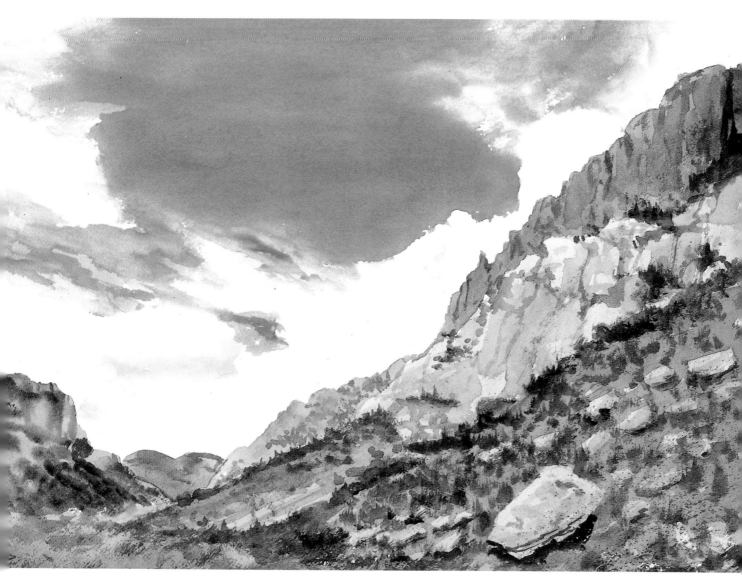

the paper dry. Then work in the lighter areas toward the sides of the paper, adding a little water to dilute your blue. Finally, use a pale wash of blue and mauve to depict the clouds that lie just above the mountains. Let the paper dry again.

The dark sky and the clouds seem to sweep across the paper. Note how the ultramarine wash has been applied unevenly: in some places the color is strong, in others, light; in some areas the edges are sharp, in others, soft. This variety makes the sky charged with excitement.

The foreground is fairly complex, so before you start to paint it analyze the values of the different rock masses. Lay in the most distant mountain with mauve and sepia, and then begin the rocky slopes. Start by applying a flat wash of yellow ocher over the entire foreground. Next define each mass with darker washes mixed from yellow ocher and sepia. When you are satisfied with the values in each area, add texture and detail using yellow ocher, sepia, and Hooker's green. Don't get carried away—simplify the patterns formed by the rocks and the grass, and balance them against the strongly patterned sky.

Rendering the Shape and Structure of Clouds

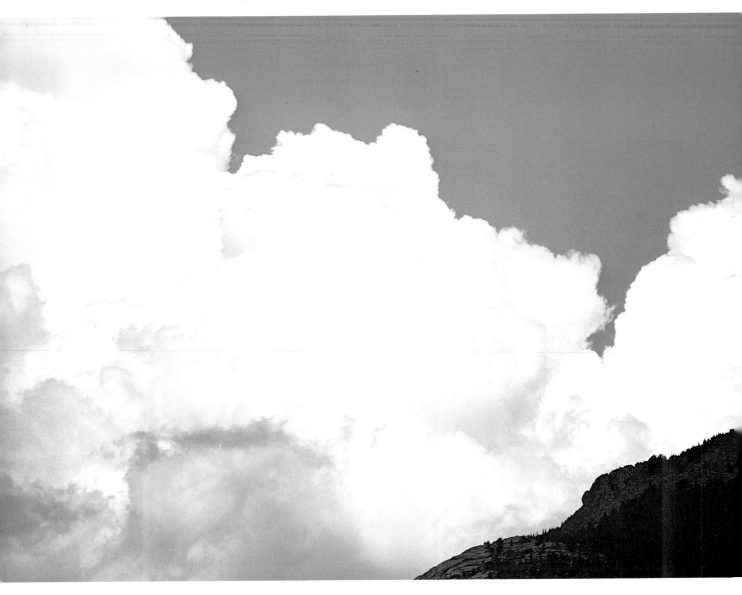

PROBLEM

Soft clouds like these are a challenge to paint. All too often, they end up looking like pasted-on cotton balls. Only the shadows define their structure, and even the shadows are light and unfocused.

SOLUTION

Concentrate on the shadowy portions of the clouds and keep them light. If the shadows get too dark, they will look like holes punctured in the clouds.

☐ Sketch the cliff in the foreground and the outline of the cloud formation. Then lay in the sky with ultramarine and cerulean blue, carefully picking out the shape of the cloud. While the paint dries, study the shadows on the clouds.

For the shadows, you'll want to use washes mixed from cerulean blue, alizarin crimson, and Payne's gray. Keep the washes light and do a few test swatches before you begin to paint. Follow the patterns formed by the shadows, at first using a very light

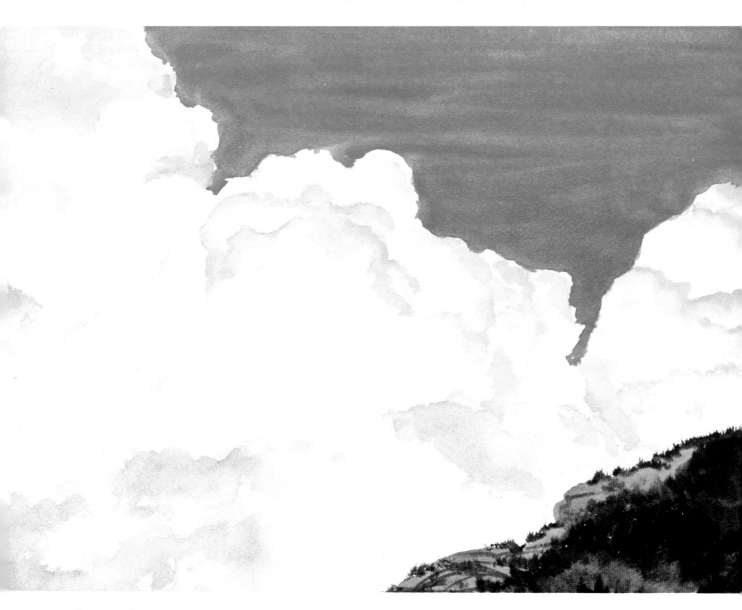

tone. Once you've established the shape of the clouds, darken the upper edges of some of the shadows; right away, soften the bottom edges of your strokes with a brush dipped into clear water. Keep the pattern lively and don't concentrate the dark shadows in any one area.

Now turn to the foreground. Keep it simple—add just enough detail to make it clear that there is a cliff in the picture. Here a flat wash of mauve is applied first, and then Hooker's green and sepia are used to pick out details.

ASSIGNMENT

Practice painting soft white clouds at home before you tackle them outdoors. Find a picture of a sky that's filled with clouds and work from it. To render the shadows, try using only the three colors used in this lesson: cerulean blue, alizarin crimson, and Payne's gray.

Start by laying in the sky. Then turn to the clouds, looking for the shadows. This isn't always easy, since most people tend to concentrate on the white areas in clouds. You'll be doing just the opposite, painting the darks around the whites.

Keep your washes light. You'll be surprised to see how dark they'll look once they're down on pure white paper. Let your washes overlap, and don't put too many darks in any one area.

Achieving a Sense of Perspective

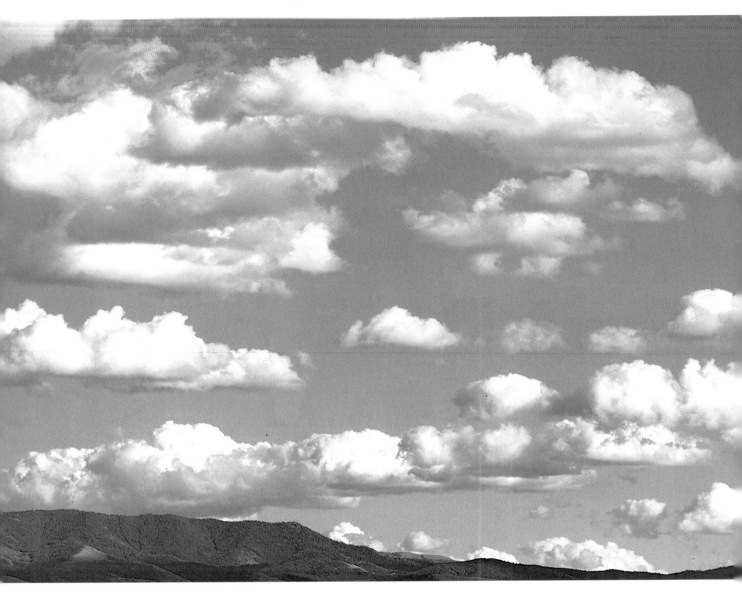

PROBLEM
This is an extremely difficult painting situation. Some of the clouds are far away, and others, close at hand. If you don't convey a sense of receding space, your painting won't make sense. All the clouds will look as if they are stacked on top of one another.

SOLUTION
Develop the shadows in the clouds very carefully. Use them to indicate both the shape and distance of the clouds.

☐ Draw the clouds and the hills that run across the bottom of the picture. Then lay in a graded wash, working carefully around each cloud. You may be tempted to put a wash over the entire sheet of paper and then wipe out the clouds with toweling, but that technique won't work here. If you try it, the clouds will look too soft and undefined. By painting around the clouds, you will be able to

As far as the eye can see, long, flat cumulus clouds drift in a brilliant blue sky.

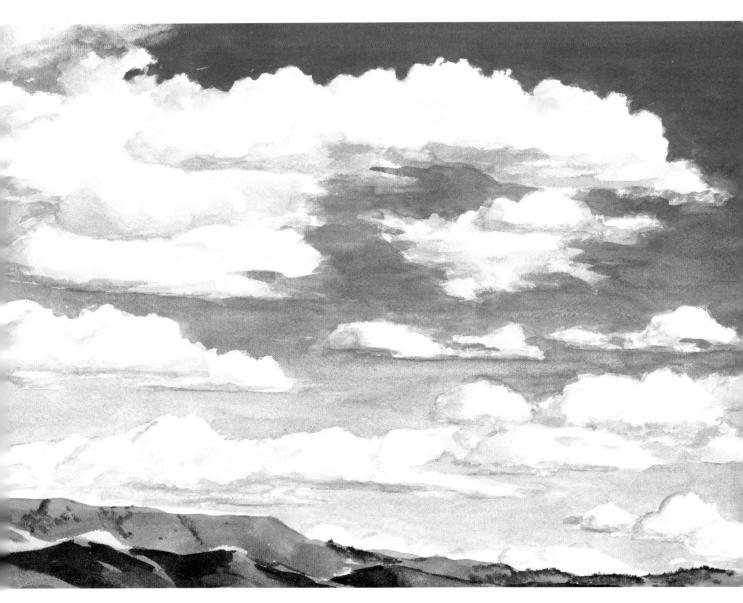

show the distinct shape of each cloud.

Begin the sky at the top with deep ultramarine, and then gradually shift to cerulean blue. Toward the horizon, add a touch of yellow ocher to the cerulean. When the paint is dry, start on the cloud shadows. Here they are rendered mostly with pale tints of ultramarine and alizarin crimson. In a few places, there is a warm touch

of yellow ocher.

The darker tints show the undersides of the clouds; the lighter ones sculpt out the surface detail. As you work, soften the edges of your strokes using another brush that's been dipped into clear water. You don't want any harsh edges—just an easy, flowing rhythm.

Now develop the foreground. In this painting, it's done with

Hooker's green, mauve, sepia, and yellow ocher. Note how the green is a little bolder and brighter in the painting than it is in the photograph. Accentuating the green pulls the hills down and out toward the viewer, and it enhances the sense of perspective already achieved.

Experimenting with Bold Color

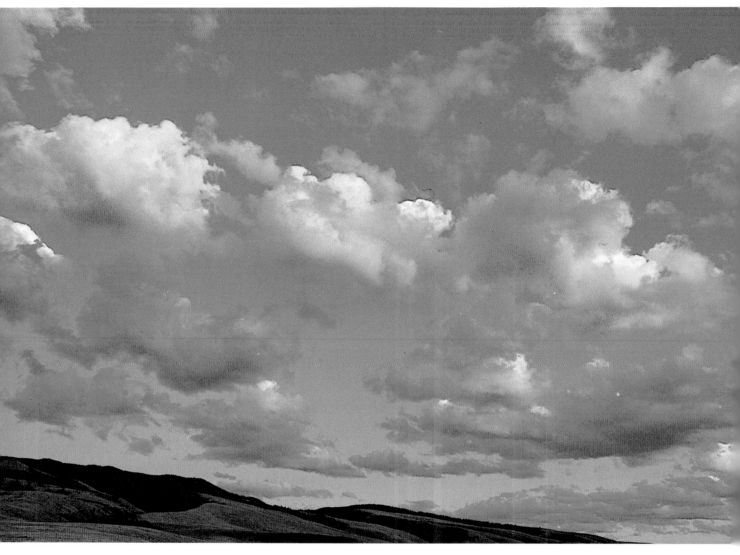

PROBLEM

The warm pink and gold clouds are lighter than the sky. Their shapes are fairly soft and indistinct, so it will be hard to paint around them. If you put them down first, their edges will look too harsh.

SOLUTION

Mask out the brightly colored clouds and you'll be free to develop the rest of the sky as boldly as you like. Lay in a graded wash for the sky; then use gouache for the clouds.

☐ Draw the horizon line and the shapes of the major clouds; then mask out the clouds. Using a big brush, lay in a graded wash. Here strong ultramarine and cerulean blue are applied at the top of the paper. Gradually the wash becomes lighter, and then, near the horizon, touches of alizarin crimson and yellow ocher are added.

Now paint the dark clouds that float right above the horizon. To capture their deep color, mix opaque ultramarine and burnt sienna. Work loosely, with fluid

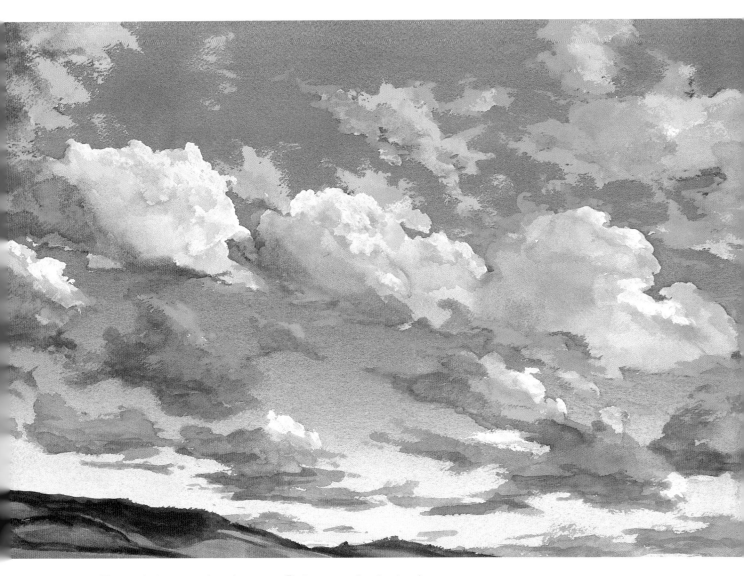

strokes. Toward the top of each cloud, dab on some light, bright tones. Here opaque white, alizarin crimson, and cadmium orange capture the reflection of the sun's rays.

Now peel off the masking solution. Using opaque white, alizarin crimson, and cadmium orange, gently paint the large clouds. Work with soft strokes, gradually blending one color into the next. To establish a sense of perspective, place the lightest colors at the very top of the clouds.

Before you begin the foreground, stop and evaluate the pattern you have created. If any of the clouds seem too weak, continue to sculpt them, using dark hues for their undersides and light hues along the tops.

Make the foreground as plain as possible; you don't want it to pull attention away from the glorious sky. Here two tones of olive green and sepia are applied to create a simple but believable effect.

Capturing the Play of Light and Dark at Twilight

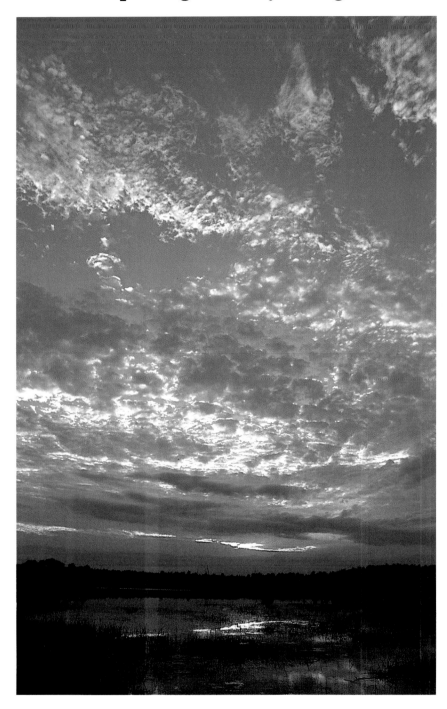

As the sun sets over a pond, dark and light clouds weave back and forth across a rich blue sky.

PROBLEM

The light clouds scattered throughout the sky are the problem here. You can't paint around them because there are too many and their shapes are irregular, and dropping white paint onto a wet blue surface would make them too soft.

SOLUTION

Use opaque gouache for the whites, and paint the light clouds last, after the rest of the painting has been completed. Render them using a drybrush technique to give the white paint an interesting, uneven quality.

STEP ONE

All you need here is a simple sketch showing the horizon and the major shapes in the foreground. Now start to paint. Since you'll be adding the lights with opaque white, you can cover the entire sky with a graded wash. For the rosy, shimmering light that breaks through the clouds near the horizon, you'll want a warm hue. Here alizarin crimson and yellow ocher are laid in above the horizon. Next the color shifts to cerulean blue, and high up in the sky ultramarine comes into play.

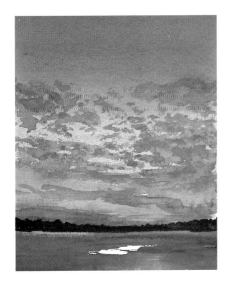

STEP TWO

Once the wash has dried, start building up the dark clouds. Here they are mixed from ultramarine, alizarin crimson, and mauve. Start adding the other darks, too. For the trees that run along the shore, try ultramarine and alizarin crimson deepened with Payne's gray. Now fill in the foreground, laying in the pond with a rich blend of ultramarine, alizarin crimson, and Payne's gray. The deep color will make the pond shoot forward and push the distant trees and clouds back into space. To capture the warm highlights on the water, drop in some alizarin crimson and yellow ocher.

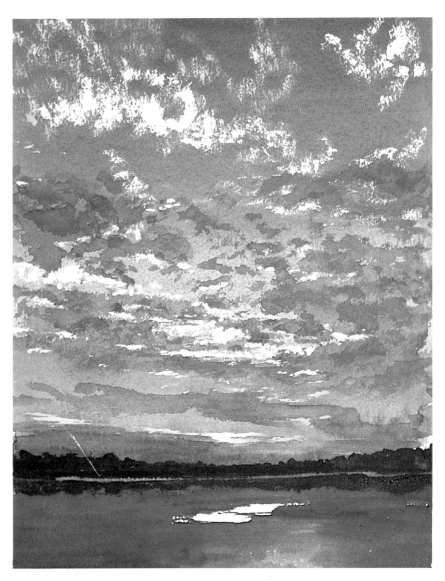

STEP THREE

When you begin adding the light, bright clouds, keep one thought in mind—pattern. It's the way these clouds fill the sky that makes this scene so exciting. Working with opaque paint and a drybrush technique, pull the brush rapidly over the paper. The broken strokes will allow the blue wash to show through, so the whites won't look too harsh. For the indistinct clouds at the very top of the scene, mix a bit of alizarin crimson with the white; similarly, warm up the whites toward the horizon with a dash of yellow ocher. Finally, using ultramarine and Payne's gray, add the reflections in the water near the horizon.

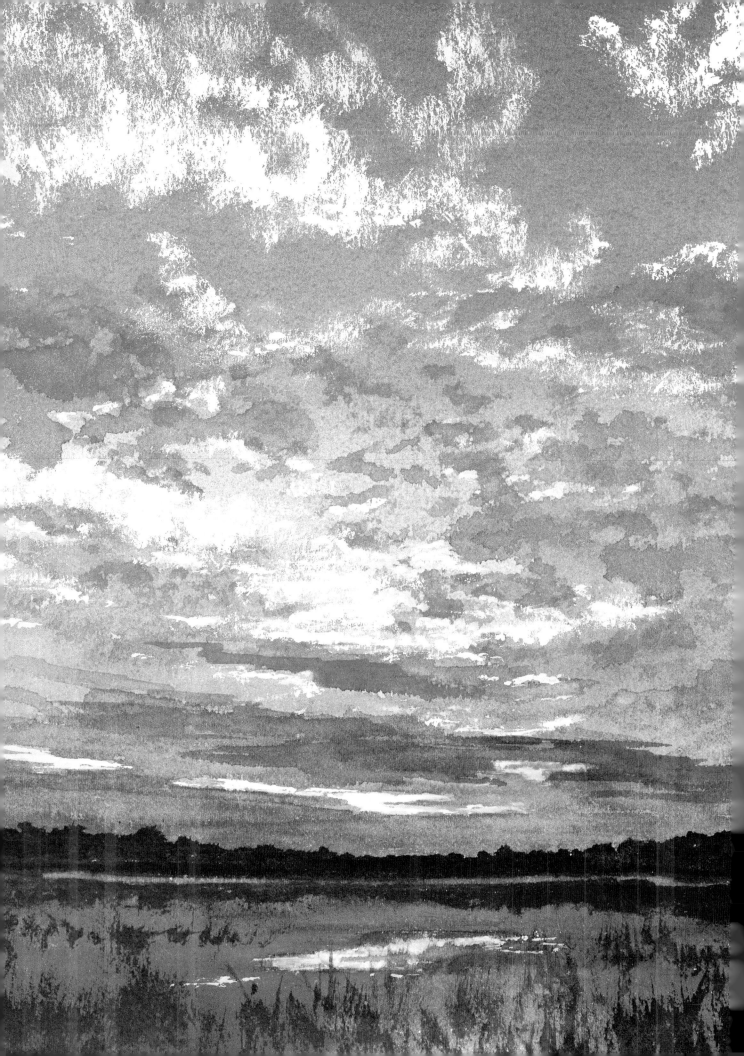

FINISHED PAINTING

The grasses that fill the water are rendered with ultramarine and Payne's gray. They are laid in with a dry brush and, once again, with careful attention to pattern.

DETAIL

All the colors that come into play in the process of painting stand out when you move in on a detail. The lights contain not just white but red and yellow, and the blues are tinged with purple and gray. The surface is rich with color, texture, and visual excitement.

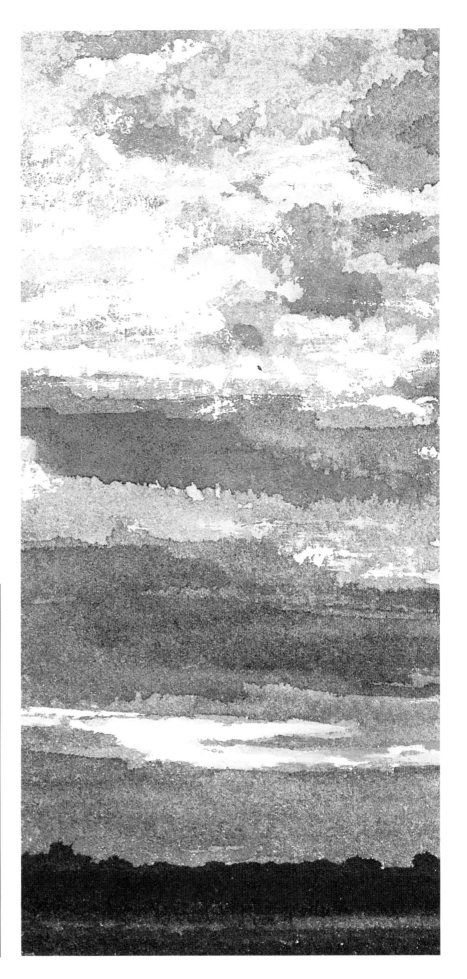

ASSIGNMENT

Spend some time working with pattern. Take several small sheets of paper—8″ by 10″ is a good size for the quick studies you'll be executing—and a medium-size brush. On the small paper, the medium-size brushstrokes will seem large.

Go outside at twilight on an evening when there's some drama in the sky. Look first for broad masses of color and lay them down; then narrow in on smaller areas. Forget about how your finished paintings will look—just go after the abstract patterns you see in front of you. Work loosely and quickly, spending no more than five or ten minutes on any painting. What you are striving for is the ability to see patterns and a way to render them in paint.

Using a Light-to-Dark Approach to Show Subtle Value Shifts

At sunset in the Smoky Mountains, soft, hazy light filters through a screen of dark clouds.

PROBLEM

Scenes like this one are straight-forward: the shapes are simple, there's not too much action in the sky, and only a few colors come into play. To capture the scene's simplicity, you'll have to keep an eye on the values you use.

SOLUTION

Use a traditional light-to-dark approach; it's the easiest way to control values. Simplify the clouds in the sky slightly, and when the painting is finished, use an eraser to pull out the rays of light that shoot through the clouds.

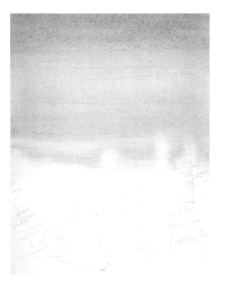

STEP ONE

Get the main lines of the composition down in a quick sketch; then focus on the sky. The light that falls over the entire scene unifies the composition, making the sky harmonize with the mountains. To capture that harmony, start your graded sky wash at the distant mountain range. Begin with alizarin crimson; then, working upward, shift to cadmium orange and cadmium yellow; then, to mauve and cerulean blue. Now take a brush that's been moistened with clear water and pull some of the alizarin crimson down over the mountain ranges in the middle distance.

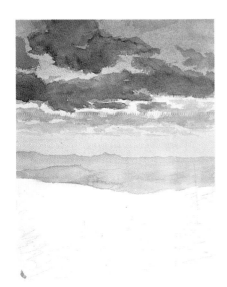

STEP TWO

Once the wash has dried, develop the cloud formations. Start with the darkest ones near the top of the painting, rendering them with ultramarine, alizarin crimson, and burnt sienna. As you move down toward the mountains, the clouds become lighter. Here they are painted with ultramarine and alizarin crimson. The distant mountains are laid in with cerulean blue and alizarin crimson; the crimson unites them with the sky.

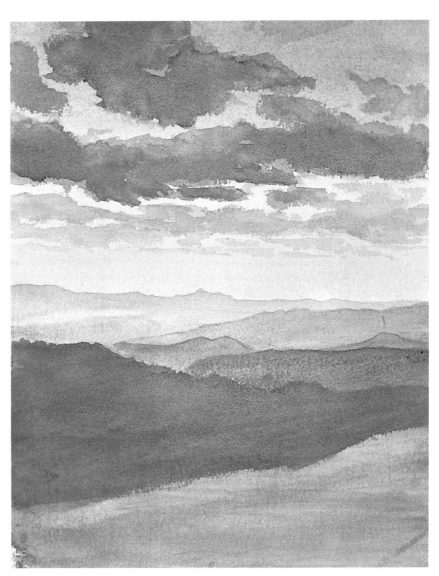

STEP THREE

Working toward the bottom of the painting, finish the mountains in the background. Make each range slightly darker than the one behind it. Be careful to keep the shifts in value subtle; if you make the mountains too dark, you'll lose the softly lit quality that fills the scene. Here the mountains are painted with ultramarine and alizarin crimson.

FINISHED PAINTING (OVERLEAF)

To push the rest of the painting back into space, make the immediate foreground very dark. Use a rich mixture of ultramarine, Payne's gray, and just a touch of yellow ocher. Let the paint dry. Then add the dark trees; here they are mixed from ultramarine, Payne's gray, yellow ocher, Hooker's green, and sepia. Wait until everything is bone dry, and then use an eraser to pull up the rays of light that break through the clouds.

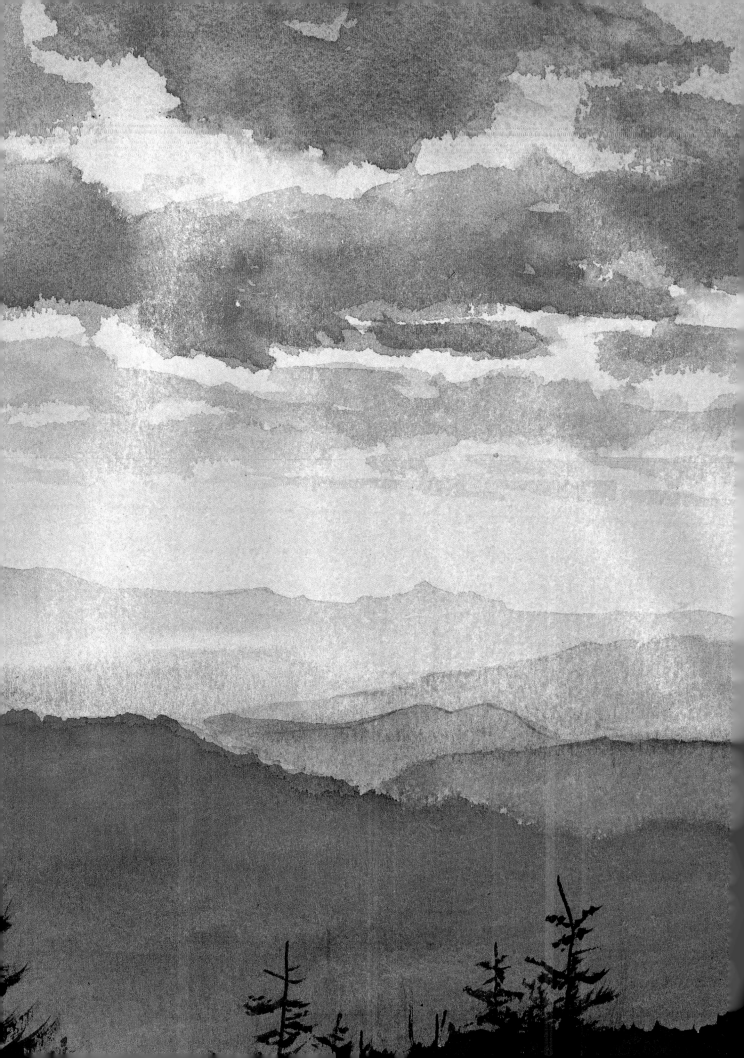

Mastering Complex Atmospheric Effects

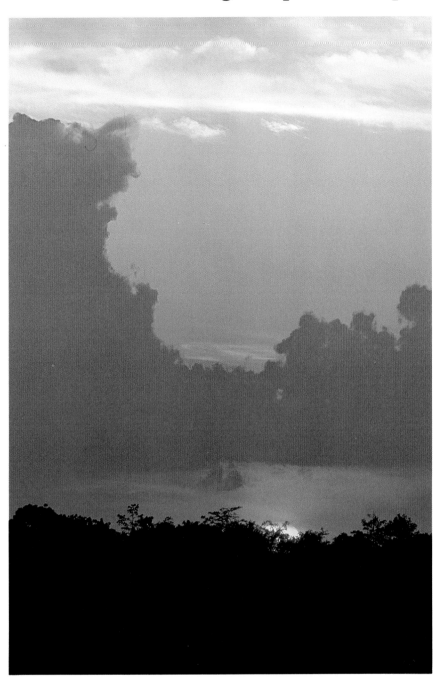

As the sun sets in the Everglades, large clouds sweep upward, some cast in shadow, others catching the last light of day.

PROBLEM

It's hard to figure out where to start. The large cloud formation has a lively, irregular shape; it would be difficult to paint around. And to capture the sensation of the evening sky behind it, you'll want to use bold, loose strokes.

SOLUTION

Begin by tinting the entire paper with a rosy tone to give the scene luminosity. Then go ahead and lay in the brilliant colors above the horizon. While the paint is still wet, wipe out the large cloud formation. You'll paint it last.

☐ Cover the entire sheet of paper with a light tone mixed from new gamboge, yellow ocher, and alizarin crimson. Let the wash dry. Next paint the sun with a strong new gamboge; then put down the warm, bright colors that stretch up from the horizon. Here the sky colors begin with cadmium red and move on to alizarin crimson, cadmium yellow, Davy's gray, and cerulean blue. At the very top, the dark patches are done with cerulean blue and burnt sienna. Now take a paper towel and wipe out the large mass of clouds.

When the sky is dry, turn to the cloud formation. Here it's rendered with ultramarine and burnt sienna. The paint is applied with loose, fluid strokes, with the edges undulating gently.

After you've painted the foreground, look at the overall color pattern you've created. Here the area right above the horizon is too garish, so a wash of pale mauve is applied at both sides. The result: a natural yet dramatic sweep of color that captures the interaction of light and atmosphere.

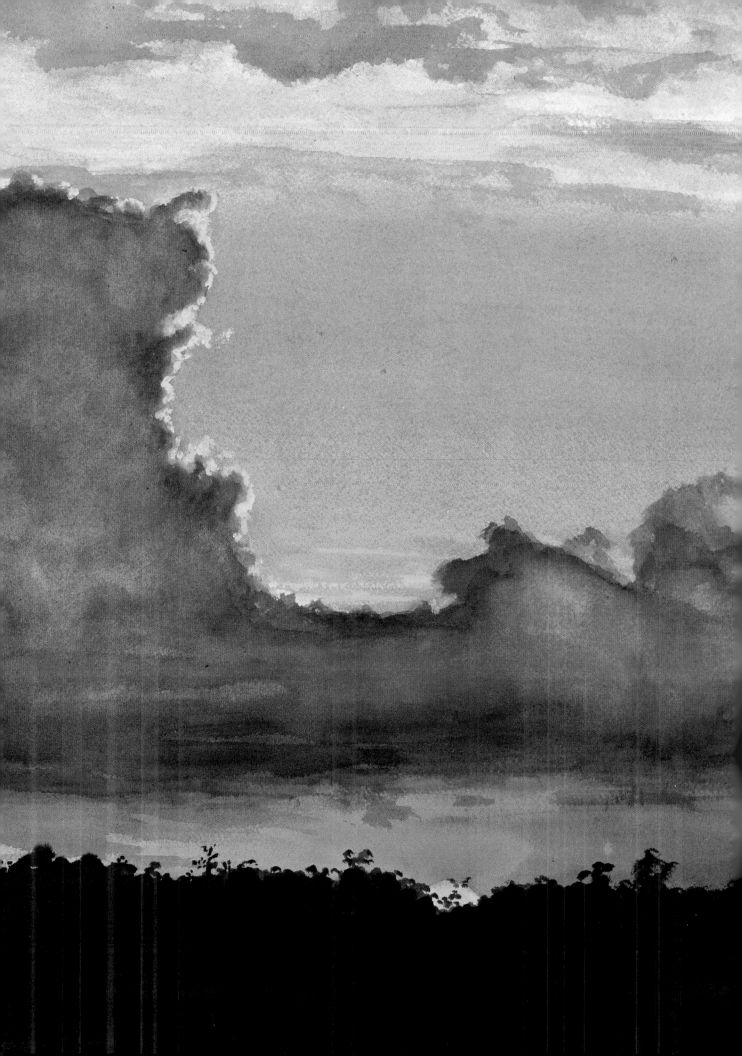

Working with Reflected Light

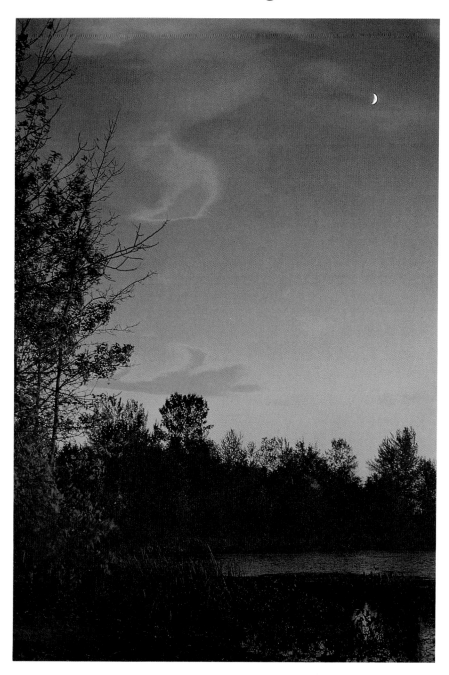

PROBLEM

The setting sun casts a strong reddish orange light on the clouds above, and the same color permeates the scene. You'll have to suffuse the painting with a warm rosy tone to capture the feeling of the sunset.

SOLUTION

Execute a reddish orange underpainting; then lay in a graded wash. To capture the strong, exciting color of the clouds, try using opaque gouache.

☐ Sketch the scene, and then cover the paper with a pale wash mixed from alizarin crimson and cadmium orange. When the paper is dry, begin the sky. Apply a graded wash starting at the top of the paper. Here the wash is made up of ultramarine, followed by cerulean blue, cadmium orange, and, near the horizon, alizarin crimson.

As soon as the sky is dry, turn to the clouds. Mix opaque white with cadmium red, yellow ocher, cadmium yellow, and alizarin crimson. When you start to paint, keep your brushstrokes loose to suggest the hazy quality of the sky. Don't apply the gouache too thickly—if you do, it will likely crack and flake when it dries. Now paint the crescent moon with opaque white.

The foreground is an important part of this painting. Like the sky, it is permeated with a reddish orange hue. The underpainting has to shine through, or the trees and water will contrast with the sky. Here the trees are rendered with sepia, ultramarine, and Hooker's green, and the water is depicted with cerulean blue. In the lightest passages, and especially in the water, the reddish orange underpainting lends warmth and vibrancy to the scene.

At sunset, a crescent moon stands out against a warm, hazy sky.

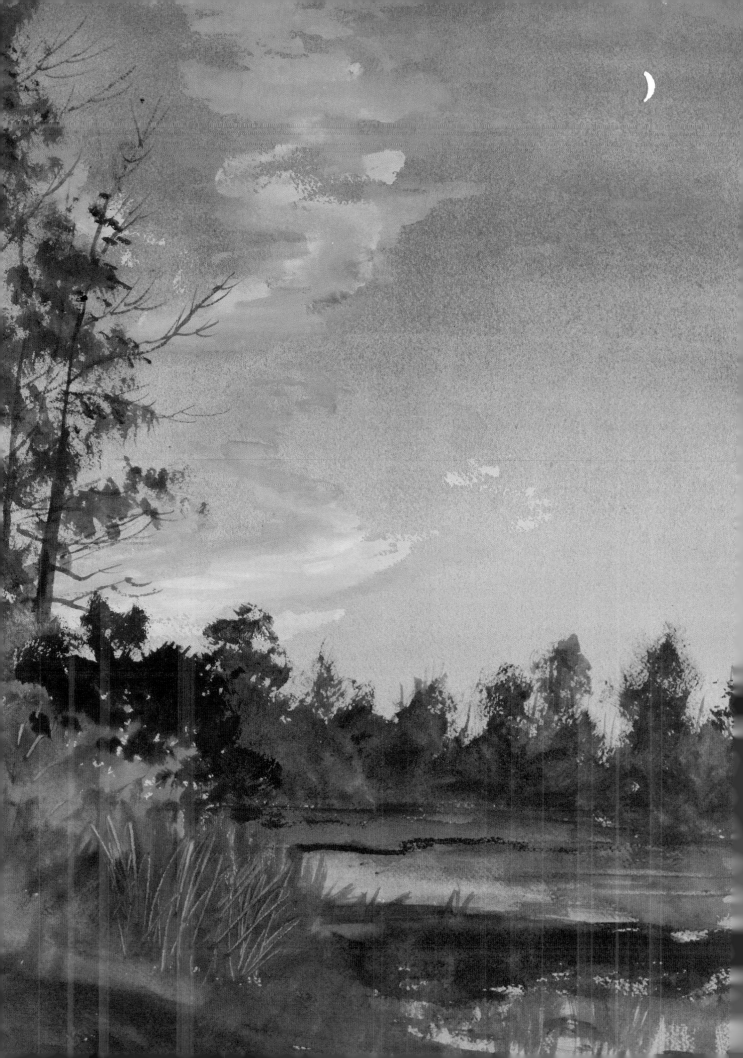

DETAIL (RIGHT)

High in the sky, subtle touches of rose-colored gouache drift across the blue. Applied thinly and with a drybrush technique, the gouache seems almost transparent, not thick and heavy as you might expect. The moon is painted with opaque white.

DETAIL (BELOW)

Even in the darkish foreground the warm underpainting unifies the scene. Here the underpainting is visible in the water and in the sky behind the clouds. Since the clouds are made up of golds and reds, too, they fit into the painting naturally.

Little touches can add interest to a heavy foreground. Note here, for example, how the grasses that have been pulled out of wet paint with the back of a brush handle enliven the scene.

ASSIGNMENT

Gouache handles much like transparent watercolor and the two media work together smoothly. Get acquainted with the opaque paint and discover what it can do for your paintings.

Take a sheet of watercolor paper and cover it with a wash of transparent watercolor. Let the paint dry. Then experiment with gouache. Don't worry about composition; your goal is simply to learn about the properties of gouache.

First apply the paint thickly with a fully loaded brush. Next try a drybrush technique. Now try both diluting the paint and applying it very thickly. You'll find that if you put down too much paint in one spot, it may crack when it dries.

After you've gained some confidence with gouache, try using it in a painting. This medium is ideal for laying in light areas over dark backdrops or even for adding small touches of light, bright paint over a medium-tone ground.

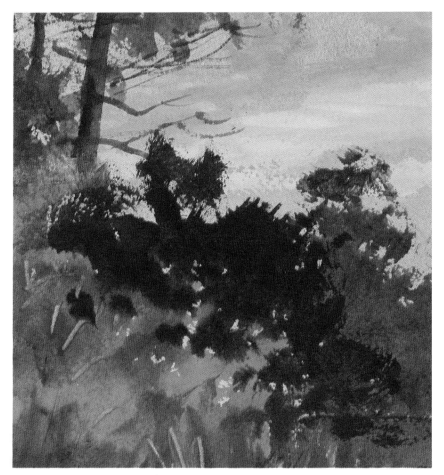

Painting Around Clouds

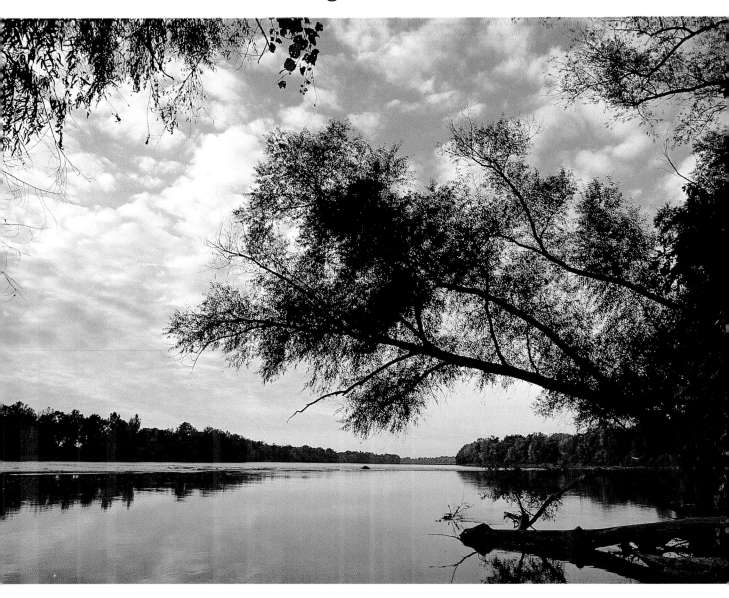

PROBLEM

Except for the dark trees in the foreground, this scene is a study in pale blue tinged with pink and yellow. Everything has to stay light and fresh if the painting is to capture the feel of dawn.

SOLUTION

Look past the obvious blues in the sky to the underlying colors. Then put down an underpainting of yellow and pink, before you turn to the blues. To keep the sky light, try painting around the clouds; the pale underpainting will subtly color the clouds.

At dawn in autumn, clouds float high above the Wabash River.

STEP ONE

Sketch in the sweep of the river and the trees in the foreground, and then start to paint. Beginning near the horizon, lay in a wash of alizarin crimson. While the paint is still wet, cover the rest of the paper with a pale wash of new gamboge and yellow ocher. You want just a hint of color—almost an ivory tone. Over the wet paint, drop cerulean blue into the water in the foreground.

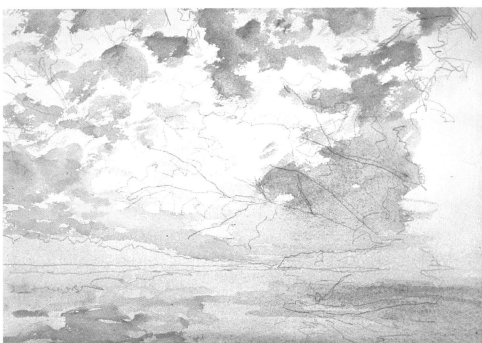

STEP TWO

After the paint has dried, use cerulean blue for the sky. Near the top of the paper, apply a wash of pure color; near the horizon add a little yellow ocher and Payne's gray to dull the color and make the sky seem a little farther away. Paint around the clouds, looking for the pattern of blue that lies behind them. Keep your brush fairly dry so you'll be able to control the flow of the paint.

STEP THREE

Now it's time to work in the darks. Here they are all mixed from a base of sepia and burnt sienna; Hooker's green and Antwerp blue are added to the earth tones to give the color a little punch. Begin by painting the trees that rush backward along the river; then add their reflections in the water. Now start to paint the trees in the immediate foreground. Do the major branches first and then the trunk that's lying in the water.

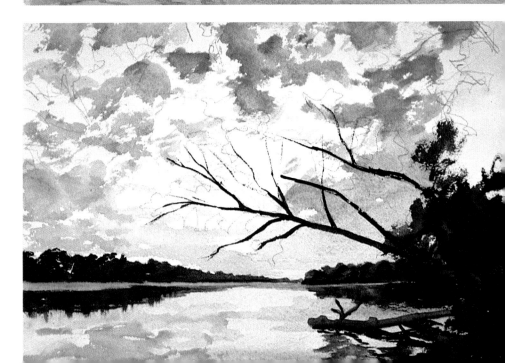

FINISHED PAINTING

Complete the dark trees with a drybrush technique—broken, scraggly strokes are perfect for depicting foliage. The rich, lively brown you see here is created from a little yellow ocher added to sepia and ultramarine. When all of the dark trees are completed, you may find that the water seems too pale. That happens here, so ultramarine is added to the water in the immediate foreground. The dark blue makes all the other colors fall into place and strengthens the sense of perspective.

The warmth of pure cerulean blue captures the fresh quality of the sky at dawn. Behind it, the pale yellow underpainting subtly enhances the scene's mood.

Toward the horizon, the cerulean blue is a little duller where yellow ocher and Payne's gray have been added to it. The dull tone makes the sky here seem far away.

The feathery strokes used to render the leaves let patches of sky show through and keep the foreground from appearing too leaden.

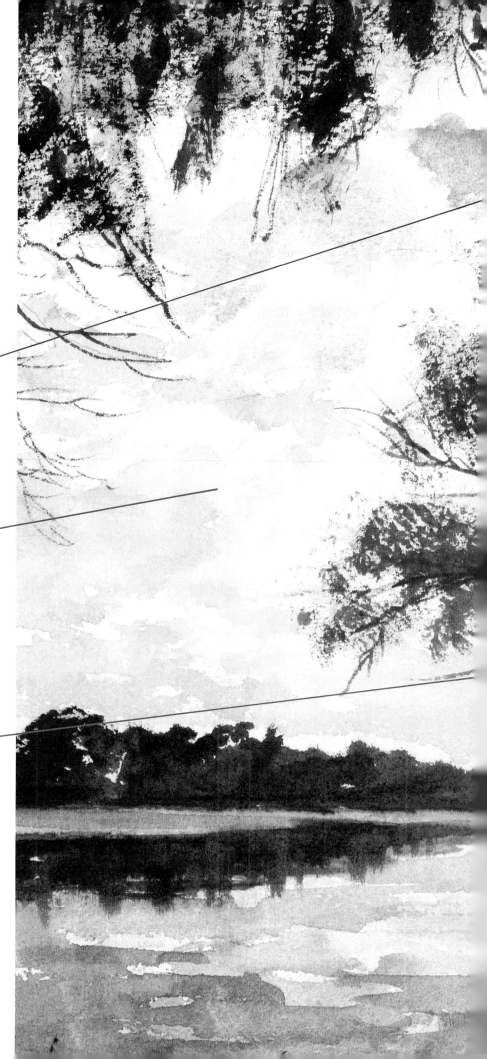

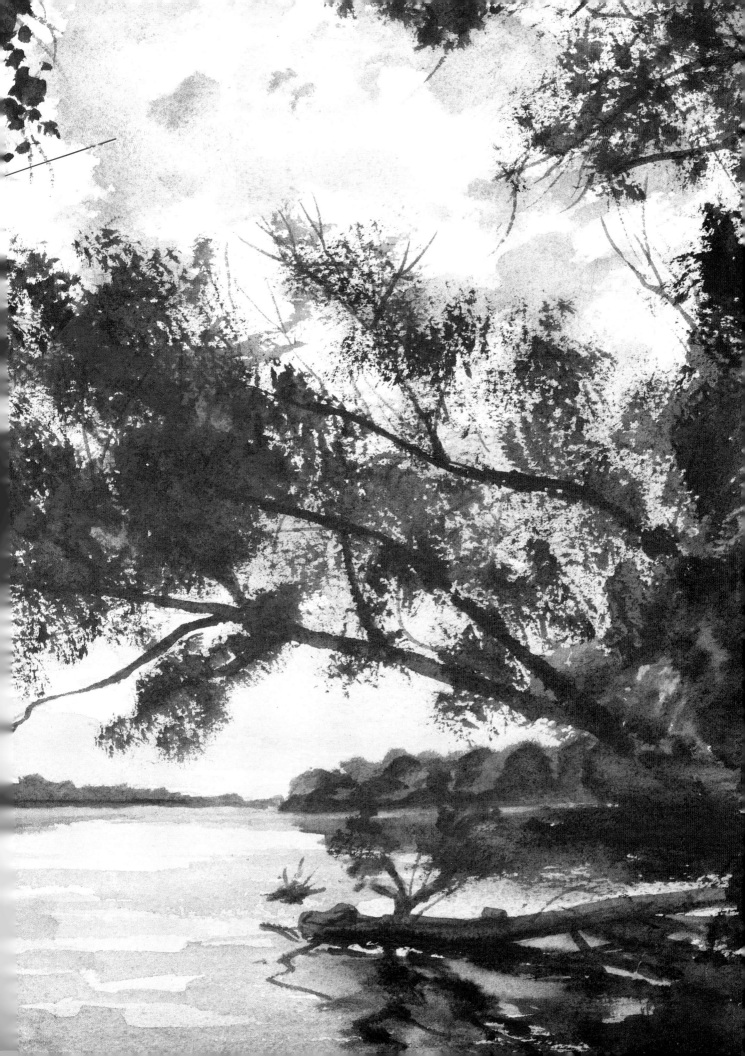

Making Sense out of a Complex Sky and Perspective

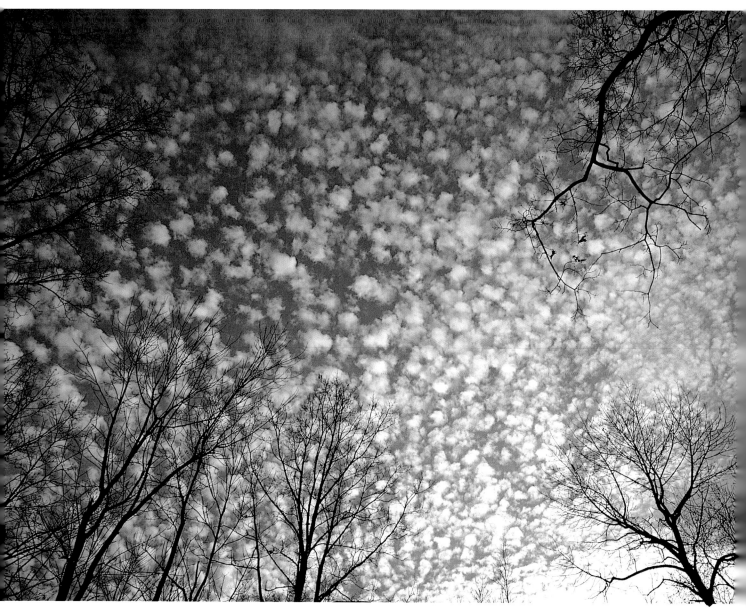

PROBLEM

The pattern created by the clouds is incredibly dense—so dense that it's hard to decipher. And the perspective is complicated, too—you are looking up through a grove of trees at the complex sky.

SOLUTION

Cover the entire paper with a rich blue wash; then while the paint is still wet, drop in opaque white. Simplify the clouds so their pattern isn't too overwhelming. To pull everything together, paint the trees.

☐ Before you begin, study the clouds. Try to figure out which ones are closest to you and which ones are farthest away. Start by laying in the sky, covering the paper with a strong cerulean wash. Move quickly now. Before the blue paint dries, drop down small dots of opaque white. As the paint dries, add more white to the clouds that seem closest to you. To indicate clouds in the dis-

*Thick, dense altocumulus clouds
hover over a grove of trees.*

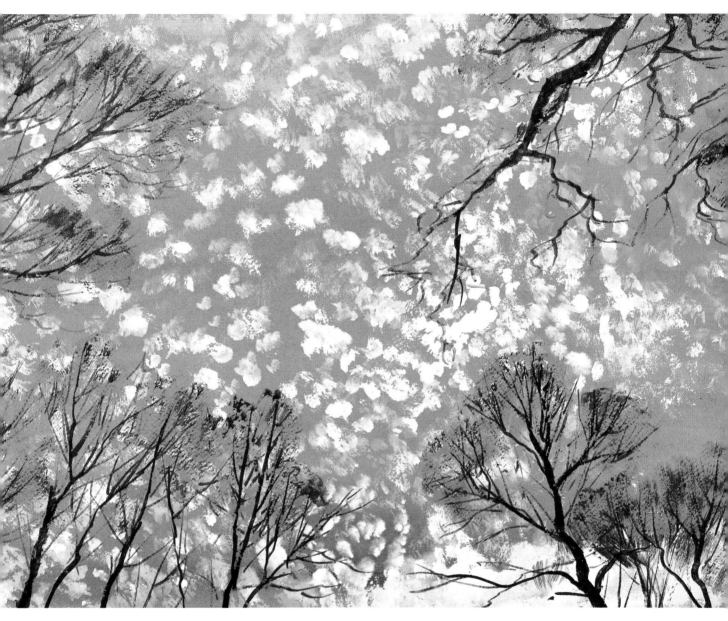

tance, blend the white into the blue. The dabs of pure strong white seem closest; those that have been mixed with the blue, much farther away. When you are working with this technique, it's important that you work rapidly and don't let the blue paint get too dry.

While you are manipulating the white paint, stop frequently to study the overall pattern you are creating. If you get carried away, the painting may end up looking like a piece of wallpaper. You don't want too regular a pattern or one that has no internal logic. The clouds have to make sense.

Let the paint dry and then turn to the trees. Here they are painted with a mixture of sepia and ultramarine. The ultramarine darkens the brown, but in a more lively way than a gray or black would. The blue also helps the trees harmonize with the sky. As you lay in the trunks and branches, pay attention to perspective and follow what you see as carefully as possible. For the little twigs at the ends of the branches, use a drybrush approach. Keep your strokes light—if you put down too much brown the trees will look heavy.

Capturing the Feeling of an Icy Winter Sky

PROBLEM

The effect created by the freezing-cold, ice-filled air is incredibly subtle. Bands of whitish blue radiate from the sun. You'll have to control your colors and values very carefully to achieve the effect that you want.

SOLUTION

Keep everything soft by working wet-in-wet. To capture the halo effect, use circular strokes. You'll actually be doing a graded wash, but instead of applying it from top to bottom, you'll work outward from one central point.

□ Sketch in the foreground, and then moisten the paper with a natural sponge. Control of values will be critical now, so be sure to plan how you are going to attack the scene before you begin to paint. Use cerulean blue to render the sky—it's ideal for capturing the icy feel of midwinter. You'll want to keep it very pale, and in the center of the halo, try adding just a touch of yellow ocher to indicate where the sun lies hidden.

Start to paint at the halo's center; then gradually move outward using circular strokes. Break up the blue with bands of white, but don't let the light-to-dark progression get too monotonous. It's difficult to control a circular graded wash—don't get discouraged by your first attempts. Remember, if the result isn't what you want, you can always wash the paper with clean water and start all over again.

Once you're satisfied with the halo, work on the sky along the horizon. Strong horizontal strokes executed with cerulean blue, Payne's gray, and yellow ocher keep the circular pattern from becoming too studied.

Let the paper dry before you begin the foreground. You'll use the same colors—cerulean blue and yellow ocher—plus you'll add more Payne's gray for the deep shadows. As you start to lay in the foreground, concentrate your color toward the sides of the paper. Keep the center light to indicate the highlight caused by the sun.

Finally, add the scraggly clumps of grass that break through the snow. The clumps closest to you should be darker and more defined than those farther away. At the very end, spatter a little brownish gray paint over the snow-covered ground to animate it.

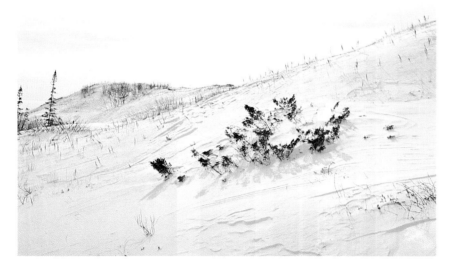

In sub-zero temperatures, the air is laden with icy particles which seem to form a halo around the sun.

Learning to Control the Contrast Between Snow and Sky

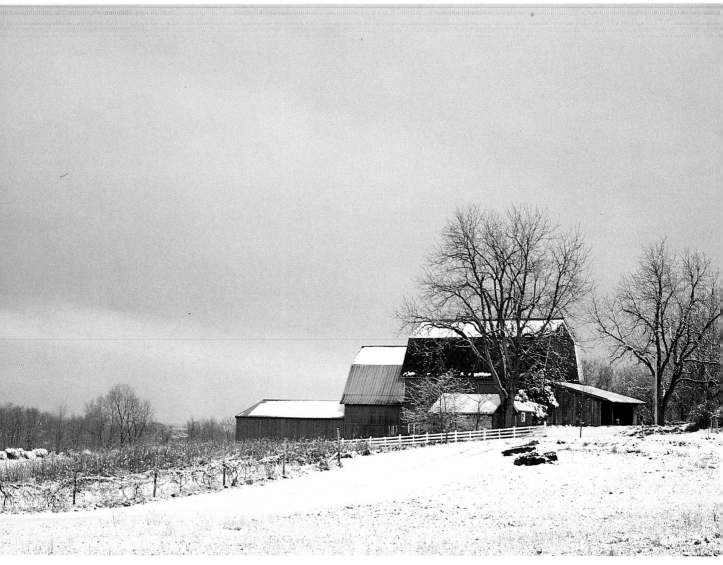

PROBLEM

Here you are confronted with a typical winter landscape. The sky is clear, without much variation, the foreground is blanketed with snow, and except for the barn all the values fall in a light- to middle-tone range.

SOLUTION

Don't go for the dramatics. Follow a traditional light-to-dark approach and keep control of all your values. Be especially careful of the value relationship between sky and snow: don't make the sky too dark or the snow too light. It's easy to disregard what you see and think in clichés. Remember, snow isn't always bright white and the sky isn't always sky blue.

☐ Execute a careful drawing—when a scene includes a building, you need to begin by establishing a clear framework. Next paint the sky, working around the barn. First wet the sky area with a sponge; then start to drop in your color—here cerulean blue, Payne's gray, yellow ocher, and, right at the horizon, a touch of alizarin crimson. Don't let the tones get too flat—let an occasional dash of blue stand out. Now let the paper dry.

*In the cold, frosty air of a December day,
a barn hugs the snow-covered ground.*

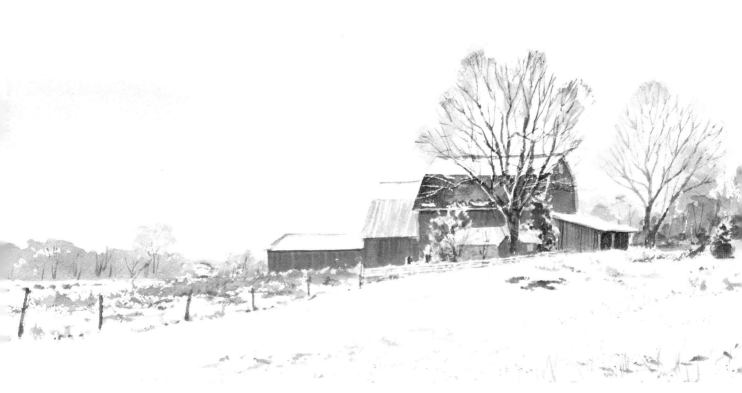

Shift to slightly darker values to lay in the trees and hills in the background. Use very light washes of ultramarine and mauve mixed with burnt sienna. Next, turn to the barn. It's the focus of the scene, so execute it carefully. Work with deliberate vertical strokes and keep the color flat. Add the trees that grow by the barn, and then tackle the foreground.

You may be tempted to leave the foreground pure white, but snow is usually much more complex. It captures the shadows of the clouds passing overhead, as well as those cast by the hills and valleys of the ground itself. Use a very pale wash of blue and gray, and be sure to let some patches of white paper shine through. As a final step, use white gouache to render the roof of the barn, the lightest and brightest area in the painting; then enliven the foreground with bits of grass, the fence posts, and a dash of spattering.

DETAIL (LEFT)

In the cool, hazy grayish sky, a patch of blue breaks through. It not only makes the sky more lively but also helps balance the composition. Without it, all the strong color would be concentrated on the red barn on the right side of the complete painting. Here the cool tones of the purplish trees have just a touch of warm burnt sienna in them. The brownish tone subtly relates the trees to the barn and grasses in the foreground.

DETAIL (BELOW)

A pale bluish gray wash is used to render the foreground. Through the wash, bits of crisp white paper sparkle through. The ocher spattering and bits of grass keep the snow-covered ground from becoming monotonous and flat.

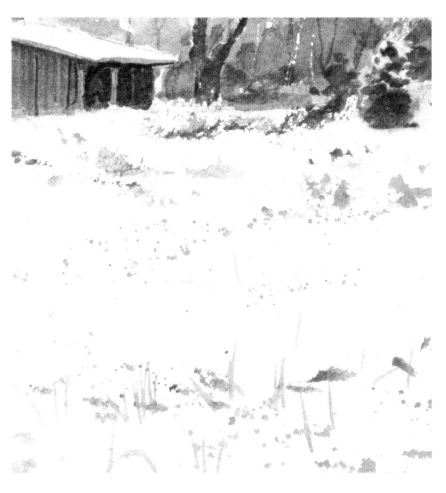

ASSIGNMENT

In winter, the color of the sky can be difficult to capture, especially if the ground is covered with snow. Snow itself presents a challenge because it is almost always tinged with color and is not pure white.

Become sensitive to the colors of winter by making quick watercolor studies on snowy days. Experiment with different grays and blues, and even with touches of alizarin crimson and yellow ocher. Keep the sky clearly separated from the snow; if the two areas are almost the same value, add touches of a stronger blue or gray to portions of the sky. Or try accentuating the shadows that fall onto the snow. You may be surprised to find that sometimes the snowy ground is actually slightly darker than the winter sky.

Rendering a Simple Winter Landscape

PROBLEM

The sparseness of a scene like this grips whoever encounters it. The same qualities that make it appealing—it's clean and crisp and light—make it difficult to paint. When a composition is this simple, every stroke has to be just right.

SOLUTION

Use a traditional light to dark approach. Understand when you begin that simple situations such as this can be very hard to execute. Pay attention to your technique and concentrate on capturing the colors and patterns you see.

☐ After you have finished your preliminary sketch, wet the sky with a brush. You want to keep a clean horizon line, so don't moisten the entire sheet of paper. Because you are trying to separate the sky from the snow-covered ground, turn the paper upside down—then you won't have to worry about the sky wash running into the foreground. Begin laying in a graded wash. Near the horizon, use a mixture of alizarin crimson and cerulean blue and then switch to a pure cerulean. Halfway down the paper, add a bit of yellow ocher, and at the very bottom, tone the cerulean with a little Payne's gray.

While you are waiting for the paper to dry, look at the foreground. Usually a snowy white plain has at least a touch of color. Here, though, because the contrast between the sky and the ground is so important and the ground occupies such a tiny portion of the scene, you are probably better off leaving it pure white.

When the sky is dry, paint the tree trunks and branches with burnt sienna and sepia. Let them dry, and then with a pale wash mixed from the same two earth tones, indicate the masses of tiny twigs which fill the crowns of the trees.

Finally, controlling the flow of pigment, spatter a tiny bit of brown across the snowy plain. You don't need much—just a touch will add enough color to keep the white paper from becoming dull.

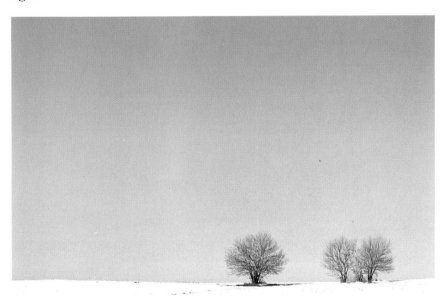

On a late afternoon in March, a cold pale blue sky acts as a backdrop for a cluster of trees.

Experimenting with Dark Clouds and Brilliant Light

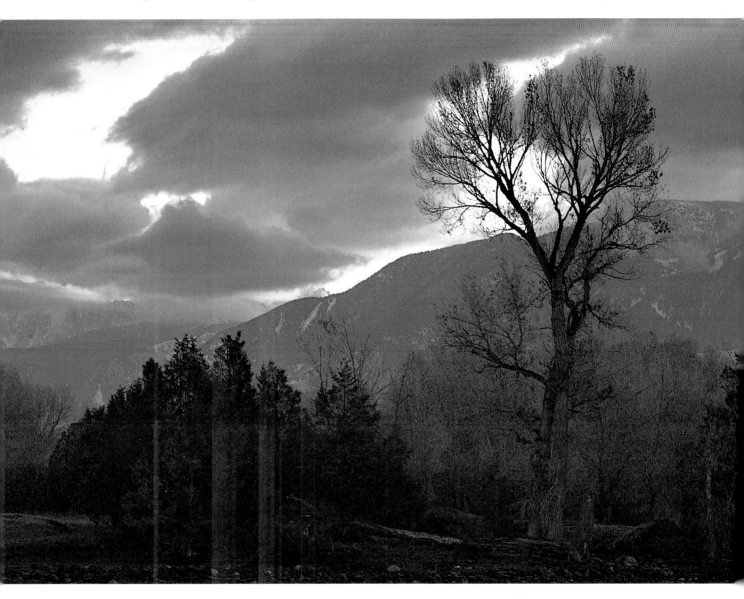

PROBLEM
Most of this scene is dark and brooding, but the light that shines behind the clouds is brilliant and clear. The light patches aren't a uniform color—they range from pale blue to pink and gold.

SOLUTION
A multicolored underpainting will capture the lively play of blues, pinks, and golds. When it's dry, you can paint the dark blue clouds over it.

At dawn in Montana, light breaks over the mountain while dark clouds shoot across the sky.

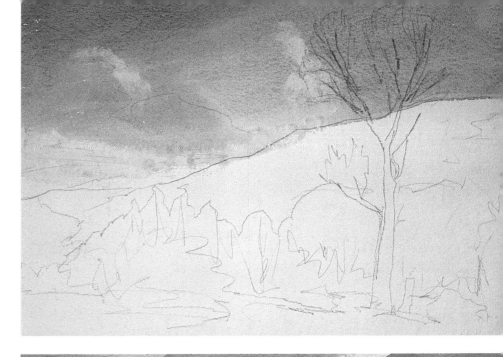

STEP ONE

Wet the sky with a large brush and then begin to drop in paint. Here cerulean blue, alizarin crimson, and new gamboge are worked into the wet paper. The colors are allowed to run together, creating pale purples and oranges. Before you continue, let the paper dry.

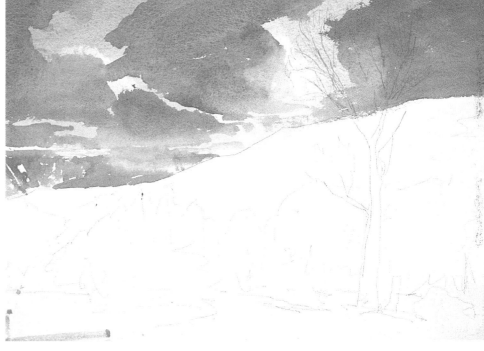

STEP TWO

Over the dry underpainting, lay in the dark clouds. Use a mixture of cerulean blue, alizarin crimson, and ultramarine. Don't apply the paint too evenly: soften some edges with water and render other areas with a drybrush technique. You want to indicate all the action that the clouds create. While the clouds are still wet, paint the distant mountain with the same mixture of blues and red. Drop a little water on the wet paint to soften the mountain and to suggest the cloud that's bearing down on it.

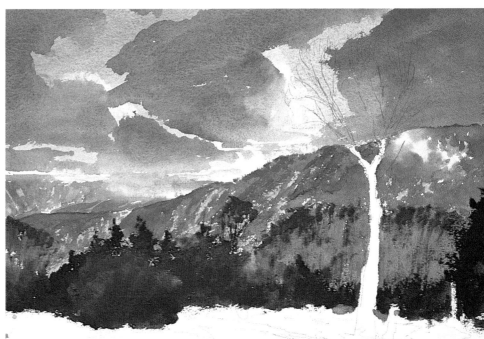

STEP THREE

Now turn to the other mountains. Mix together ultramarine, Payne's gray, and cerulean blue; then lay in the paint loosely, making some areas light and other dark. For the trees in the middleground, try a mixture of mauve and burnt sienna blended with a little new gamboge. Use strong vertical strokes to suggest the way they mass together. Finally, render the darker evergreens with Hooker's green, sepia, and ultramarine.

FINISHED PAINTING

Finally, paint the immediate foreground and the tall tree on the right using various combinations of yellow ocher, sepia, ultramarine, and Payne's gray. To suggest the twigs that radiate from the branches of the tree, use a pale brown wash applied with a drybrush technique. On the ground, furrow the earth with bands of deep, rich paint and spatter dark pigment over it to break up the flat grayish brown wash.

On some clouds, the edges are sharp and crisply defined. Deep ultramarine stands out clearly against the cerulean blue underpainting. Behind the dark blue clouds, pale blues and pinks float in the sky. The pale colors shift gradually from one hue to the next because they are allowed to bleed together when applied to the damp paper.

Over the distant mountains, a hazy effect is created by dropping water onto the wet blue paint. The water dilutes the blue and spreads upward, giving a soft and diffuse feeling to this section of the painting.

ASSIGNMENT

Prepare several sheets of paper with a multicolored underpainting. Then use the prepared paper the next time you paint a cloudy scene set at dawn or dusk.

The secret to success here is to keep all the colors you drop into the wet paper very pale. If your colors are too strong, they will be conspicuous in your finished paintings. Prepare one sheet of paper using yellows and reds. On another, try cool blues and purples. Do a third sheet with both warm and cool tones.

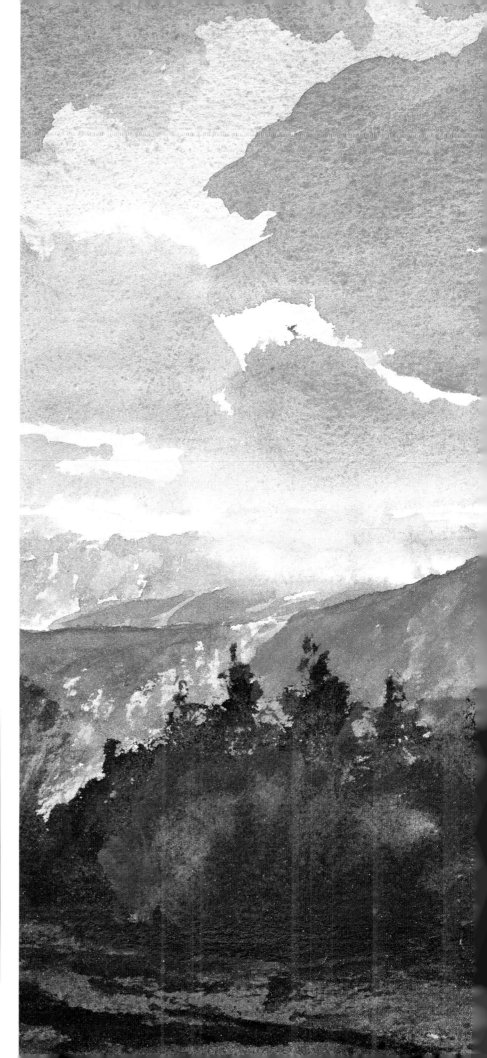

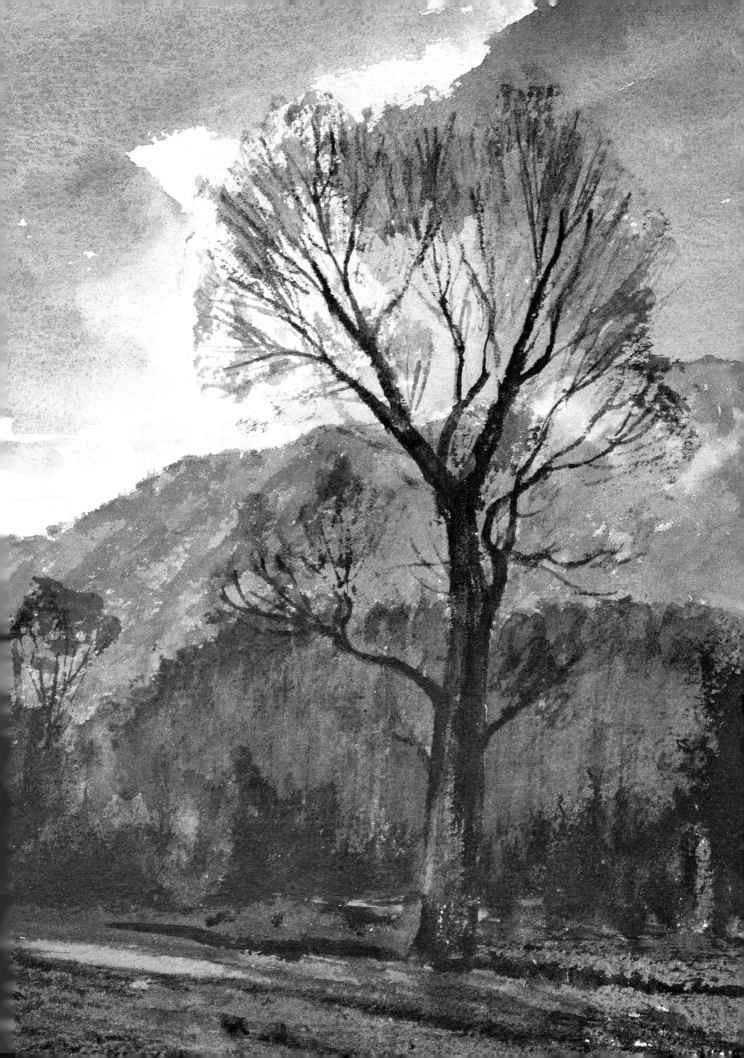

Laying in a Cloud-Shrouded Sky and a Vivid Foreground

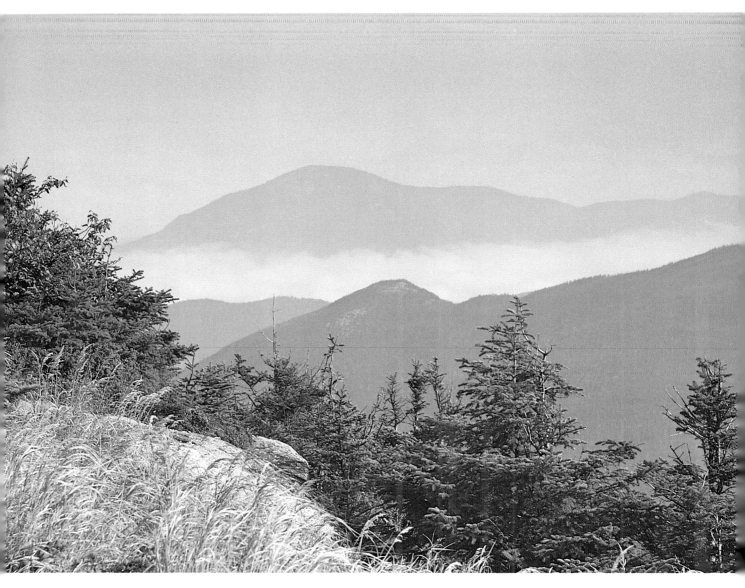

PROBLEM

Everything up close is sharp and clear and loaded with color. But the colors get softer and lighter as you move back toward the mountains. The farthest mountain is even partially obscured by a cloud.

SOLUTION

If you can capture the distant feel of the mountains and the foggy clouds that roll in, the sharp, crisp foreground will fall easily into place. So work light to dark—start with the sky and the mountains.

☐ In your sketch, capture all the major parts of the composition. Then start painting the sky. Use a cool flat wash mixed from cerulean blue and Payne's gray, and lay it in all the way to the dark mountain in the foreground. Then let the paper dry.

Now move in on the mountains. For the one farthest away, mix cerulean blue with a bit of yellow ocher. As you paint, keep in mind the cloud bank that nestles between the two distant peaks; don't cover up all of the

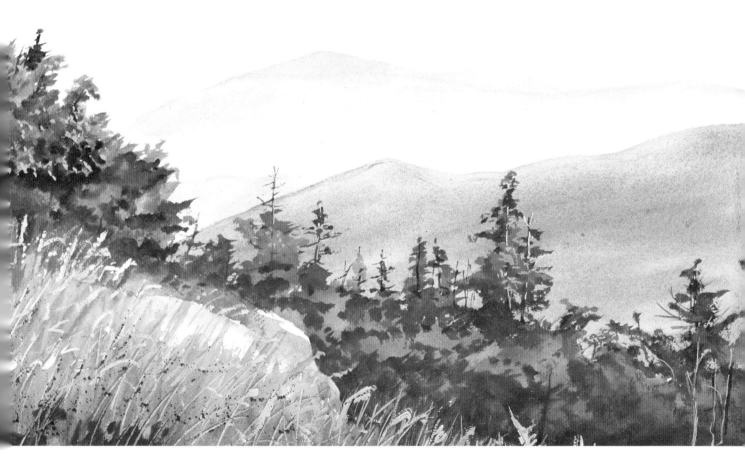

pale wash you applied at the beginning. For the intermediate mountain, add a bit of Payne's gray to your wash. To depict the mountain closest to you, you'll need an even stronger color, so drop some ultramarine into your wash to make it deeper and cooler.

Build your blues up gradually, letting the paper dry between each step. If you rush and change tones while the paper's still moist, the blues will bleed into one another. You'll lose the cool,

controlled look you are trying to achieve. These blues that you've laid in will help achieve a sense of space by receding while the warm colors in the foreground push forward.

Once the backdrop is dry, build up the foreground. A lot of rich earth tones come into play here. The leaves on the left are mixed from burnt sienna, sepia, and cadmium orange. The greens are built up from Hooker's green, burnt sienna, and new gamboge; for the dark accents, splash in a

little Payne's gray. The golden grasses that fill the immediate foreground are rendered with yellow ocher, sepia, and burnt sienna. Finally, add detail to the grasses and the trees on the left with opaque paint—yellow ocher mixed with white—and then spatter dark sepia against the lower left corner.

In the finished painting, the warm vibrant vegetation springs forward, clearly separated from the cool mountains that lie in the distance.

Working with Unusual Atmospheric Effects

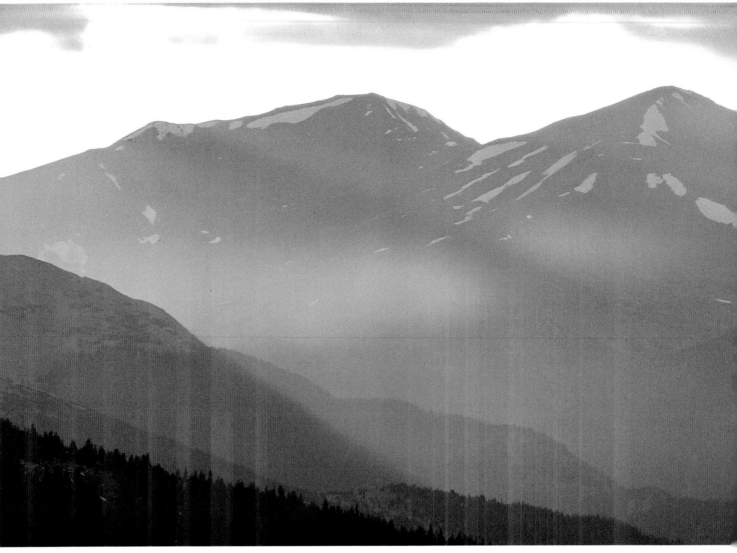

PROBLEM

Sometimes nature outdoes herself. Here, in the heat of summer, with light swimming down over the mountains, a rainstorm has begun. The light is hazy but bright. To capture a moment like this is never easy.

SOLUTION

Stop to analyze what you are looking at before you start to paint. Except for creating the hazy feeling, this whole scene can be handled wet-in-wet, from light to dark. You can use a sponge to wipe out the hazy passages.

☐ Start with a clear sketch. Then paint the light yellow sky by laying in a flat wash of new gamboge. Let the wash dry, and then add the clouds at the very top of the paper. Here they are rendered with a combination that at first may seem odd: mauve and cadmium orange. The purplish color cools down the orange and gives it a smoky, mysterious feel.

Now turn to the mountains. Establish their light base color

Late on an afternoon in August, with gold light drenching the skies, rain pours down on the Rocky Mountains.

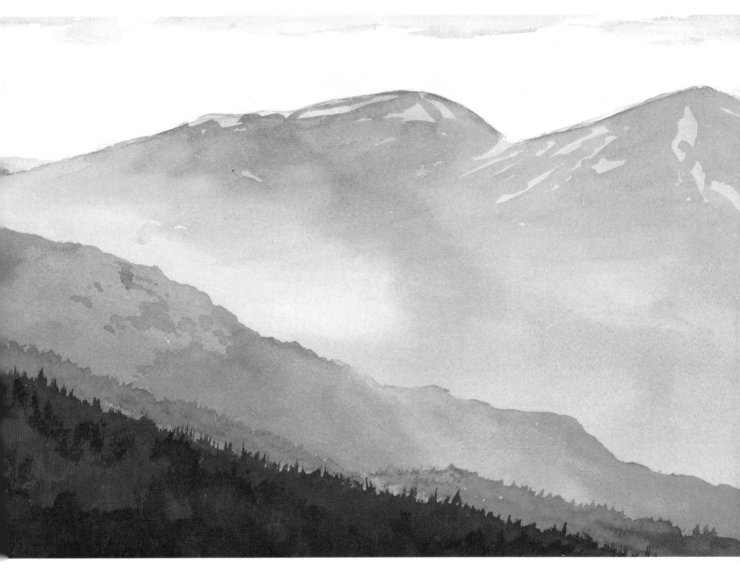

first, again using a mixture of mauve and cadmium orange. Increase the amount of orange pigment as you move toward the bottom of the paper. Then let the paper dry.

Now it's time to add a little drama. Run a big soft brush that's been soaked in clear water over the whole mountain formation. Work gently, never scrubbing the paper. Now drop in a stronger value of mauve and orange. The wet paper will create a soft, easy feel. While the paper is still moist, take a sponge and wipe away the hazy area that lies in front of the most distant mountain. All the edges should look soft and light.

Last, paint the dark slope that occupies the foreground. Add a lot of mauve to your orange, and if the paint still isn't dark enough, add a dab of gray.

The finished painting captures all of the odd colors and light effects that fill the composition, yet it doesn't appear unnatural. This occurs in part because of the extremely limited palette. By restricting yourself to just a few colors, you increase the chance of creating a harmonious work, one where each part moves naturally into the next.

Sorting out Abstract Patterns

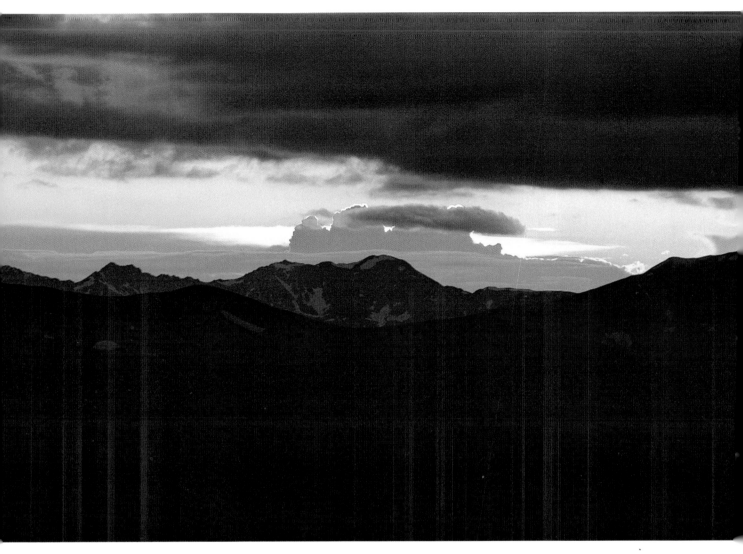

PROBLEM

When you are standing in the middle of a scene like this one, you can feel, hear, and see the drama. When you begin to paint it—probably later and from memory—you'll want to capture that strong mood.

SOLUTION

When a situation is this odd, interpret what you see freely. Sketch the scene on the spot, and make color notes to guide you later. In your painting, you'll start with light colors and gradually build up to the darks.

At sunset, snow, rain, and wind all hurl themselves against the Rockies.

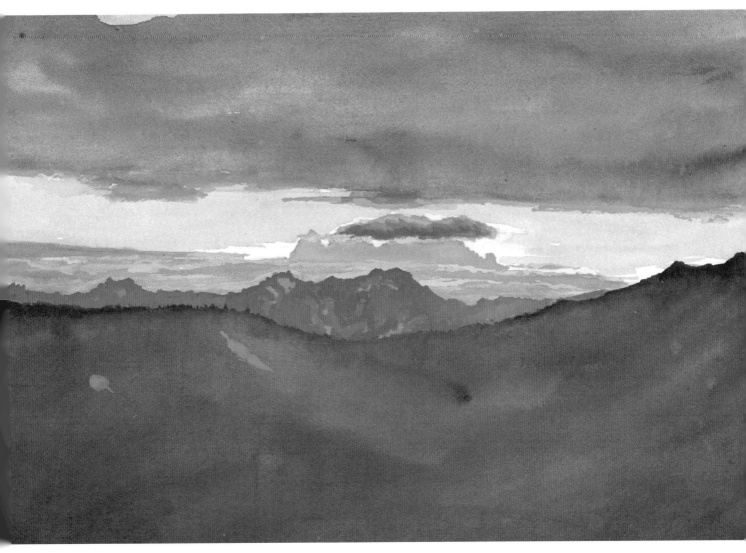

☐ There's not much to draw—
just the general shapes in front of
you. Sketch them lightly. Now lay
a bright yellow wash of new gam-
boge over the entire paper. Here
the color is applied right from the
tube, with just enough water
added to keep it moist. Beginning
with strong yellow matters—it
will be one of the brighter,
warmer colors in the painting.

In the center of the paper build
on the new gamboge foundation.
First, take opaque yellow and
work in the brightest passages;
then, when it's dry, use cadmium
orange and mauve to capture the

clouds that float beneath the
bright yellow sky. Finally, use a
deep mixture of mauve and
Davy's gray to paint the small
dark cloud in the center of the
scene.

When you've completed the
center of the painting, look for
abstract patterns throughout the
rest of the scene; the dark
shapes may be easier to follow if
you think of them that way. Begin
at the very top of the paper, use
mauve and Davy's gray to render
the large dark cloud. Along the
lower edge of the cloud, apply
cadmium orange.

Next paint the mountain in the
background with alizarin crimson,
burnt sienna, and cerulean blue.
Value is important here—the
color should be darker than the
cloud but not as dark as the
mountain in the foreground. To
paint the foreground, use alizarin
crimson, ultramarine, and sepia.

When everything is dry, look
for spots that need to be high-
lighted. Here a few touches of
opaque white and orange are
added in the center of the paper
to lighten the area around the
sun.

Using Underpainting to Capture Afternoon Light

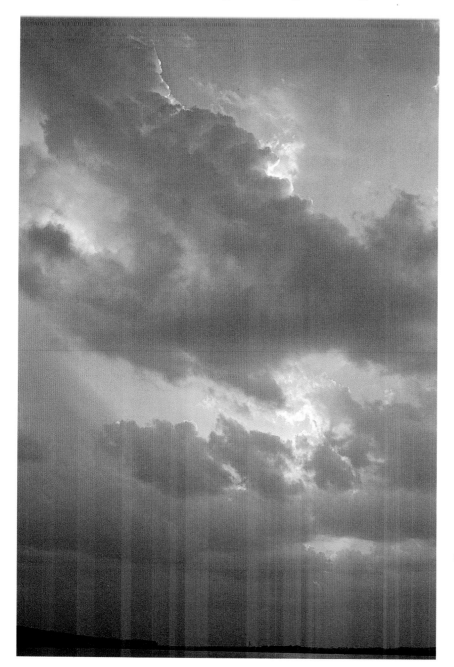

PROBLEM

The dark clouds dominate this scene, but the patches of bright light make it come alive. The light areas have to stand out clearly or your painting will look dull and leaden.

SOLUTION

Lay in a warm underpainting over a whole sheet of paper. When that wash dries, add the darks. This procedure will enable you to control the amount of light that breaks through the clouds.

STEP ONE

With a pencil, lightly indicate the basic shapes of the clouds and draw in the horizon. Now using a large flat brush, cover the entire paper with a pale wash of new gamboge. Add alizarin crimson near the horizon and in the areas where the lightest passages will be.

Late on a summer afternoon,
patches of brilliant luminescent sky
break through a bank of dark clouds.

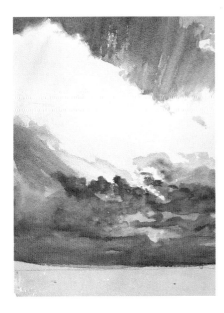

STEP TWO

Add the middle values. Working around the major dark cloud, paint the sky and the smaller clouds. Don't just apply a flat wash—let the colors go down unevenly, and let your brushstrokes suggest movement. All the blues and grays here are mixed from cerulean blue, Davy's gray, yellow ocher, and alizarin crimson.

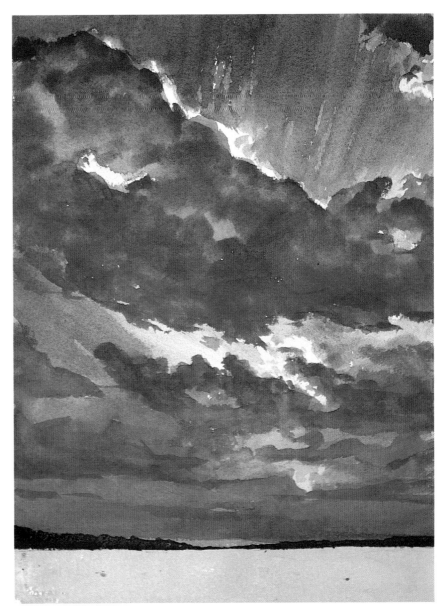

STEP THREE

To paint the large cloud formation, use the same colors as in the previous step. The Davy's gray will help capture the cold, steely atmosphere that runs through the entire scene. Don't cover up all of the underpainting but let bits of it show through. Before you move to the foreground, paint the trees along the horizon.

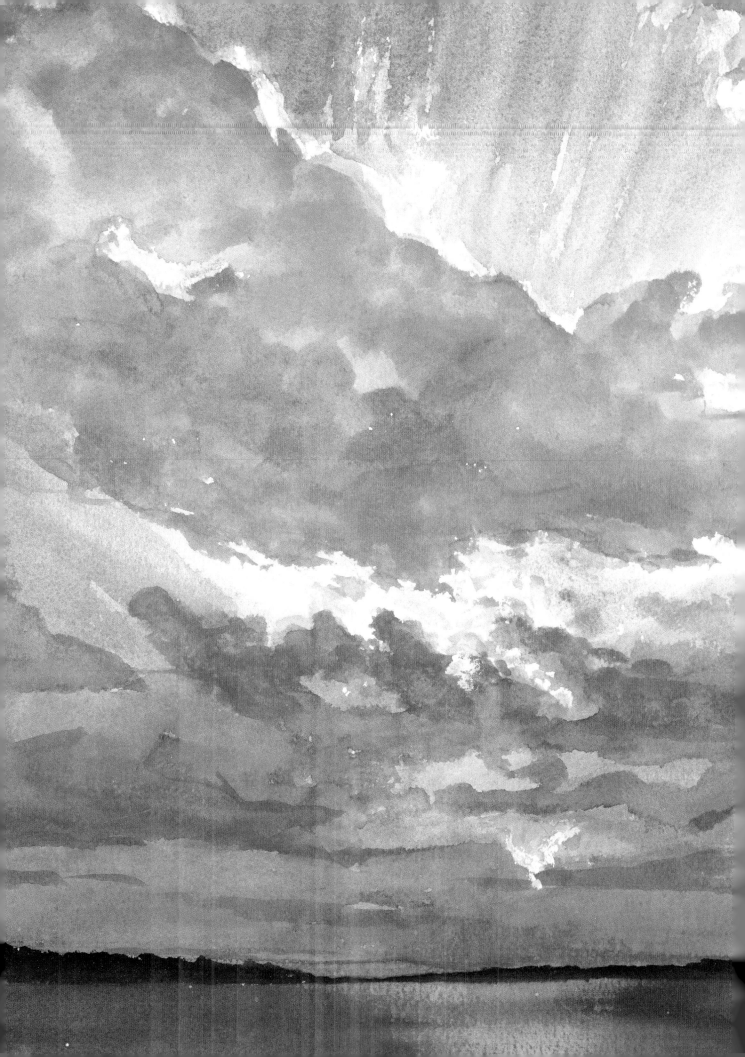

FINISHED PAINTING

About all that's left to paint now is the foreground. First lay in a wash of new gamboge and alizarin crimson. Let the paint dry, and then move on to the dark water. To capture the highlights that play across the water, use a dry-brush technique. Mix cerulean blue with Davy's gray; then gently stroke the paint onto the surface. Finally, reinforce the bright areas in the sky with splashes of gold paint.

DETAIL

Here bold brushstrokes clearly suggest a sense of movement. They rush up from the dark gray cloud and seem to continue beyond the edges of the paper. Bands of blue merge with touches of yellow ocher and Davy's gray, creating a rich, dramatic effect.

DETAIL

The underpainting of new gamboge and alizarin crimson tints all the light areas and gives them a warm glow. As a final step, these passages are highlighted with dabs of gold paint. The gold seems even brighter than it actually is because of the contrast provided by the deep gray cloud.

Painting a Sunset over a Lake

PROBLEM

This complex sky has both hard and soft edges. Some clouds have definite shapes while others are nebulous and undefined.

SOLUTION

Work quickly and try to capture the general feel of the clouds. Lay in the warm colors first; then build up the cooler, darker hues.

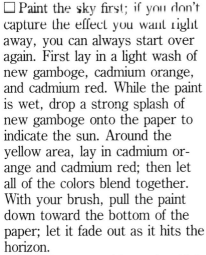

☐ Paint the sky first; if you don't capture the effect you want right away, you can always start over again. First lay in a light wash of new gamboge, cadmium orange, and cadmium red. While the paint is wet, drop a strong splash of new gamboge onto the paper to indicate the sun. Around the yellow area, lay in cadmium orange and cadmium red; then let all of the colors blend together. With your brush, pull the paint down toward the bottom of the paper; let it fade out as it hits the horizon.

For the warm shimmering highlights in the water, put down a wash of cadmium red and cadmium orange. Before you begin to add the blues, allow the paper to dry.

Mix wash of cerulean blue and ultramarine for the sky. Load a big round brush with the color and start painting. Follow the overall pattern you see, working with care around the sun. Be sure to let the underpainting show through the blue. Near the top of the paper, you'll want to suggest the hazy light that falls over the entire scene. Dilute your wash slightly and let the color bleed softly over the paper.

Capturing the ripples in the water calls for short, careful strokes made with a small brush. Here the dark ripples are painted with cerulean blue, alizarin crimson, and burnt sienna. Add only a few strokes to the center of the paper; the underpainting will suggest the light of the setting sun striking the water.

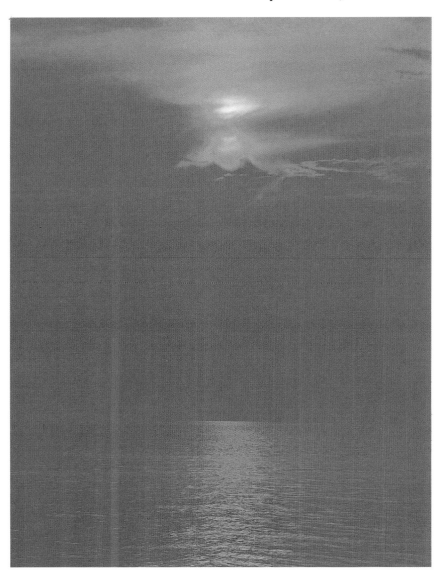

As the sun sets over Lake Michigan, hazy light breaks through the clouds and reflects on the water below.

110

Capturing the Feeling of Fog

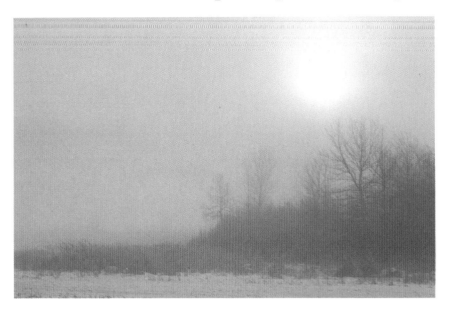

PROBLEM

Working with fog or hazy light can be extremely difficult. Everything here is so soft and diffuse that there's hardly anything definite to hang on to.

SOLUTION

Work wet-in-wet to capture the hazy atmosphere, and add a little punch to your painting by slightly increasing the strength of the gold. As you develop the scene, keep all the values very light.

☐ Before you start painting, lightly sketch the composition. Block out the sun with a liquid masking solution so can freely paint the sky. Now wet the entire paper with a natural sponge. Begin by laying in a wash around the sun, working with a large oval brush and circular strokes. Lay in the paint all the way down to the horizon. As you move outward from the sun, gradually increase the value of your paint. Farther out, decrease the value; you'll suggest how the sun warms the area right around it. Here the colors used are yellow ocher, cadmium orange, alizarin crimson, and Davy's gray.

While the paint is still wet, add the general shape of the trees using a very light wash mixed from ultramarine, burnt sienna, and Davy's gray. After the paint has dried, moisten your brush with a slightly darker value; then add a few trunks and branches to give structure to the trees.

Finally, turn to the foreground. For the icy ground, start by laying in a pale flat wash of yellow ocher and cadmium orange. When it's dry, add the grayish shadows that lie across the ground and then the bits of grass that break through the snow.

In the finished painting, the colors are slightly brighter than they appear in nature, which adds a touch of drama to the scene. Because of the wet-in-wet approach, however, the hazy, lyrical feeling of the foggy morning is still captured.

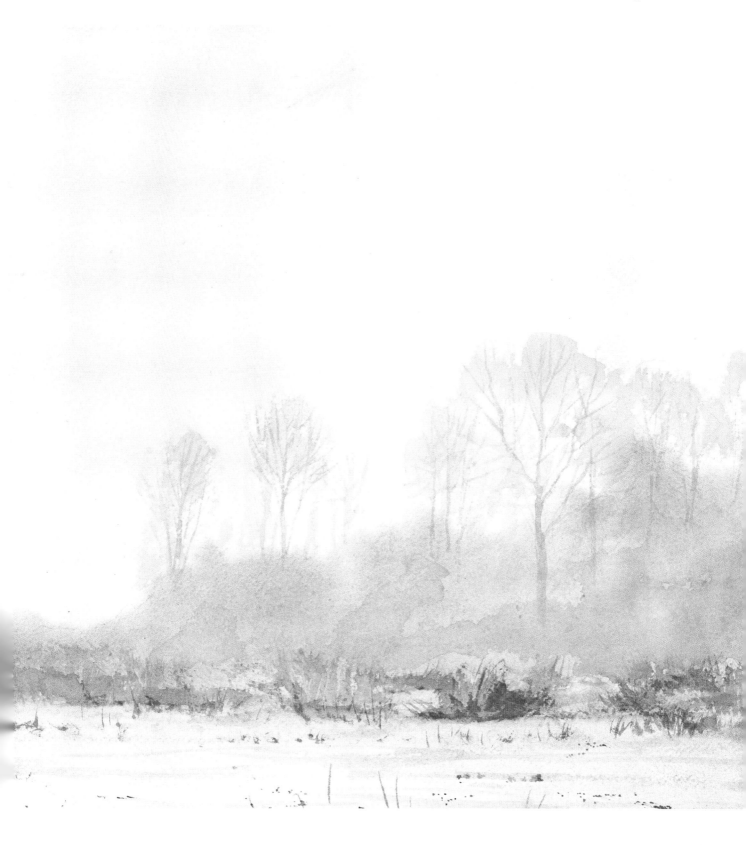

*At sunrise in winter, frost fills the air,
creating a hazy, foggy, softly lit atmosphere.*

Balancing a Cool Foreground and a Warm, Dramatic Sky

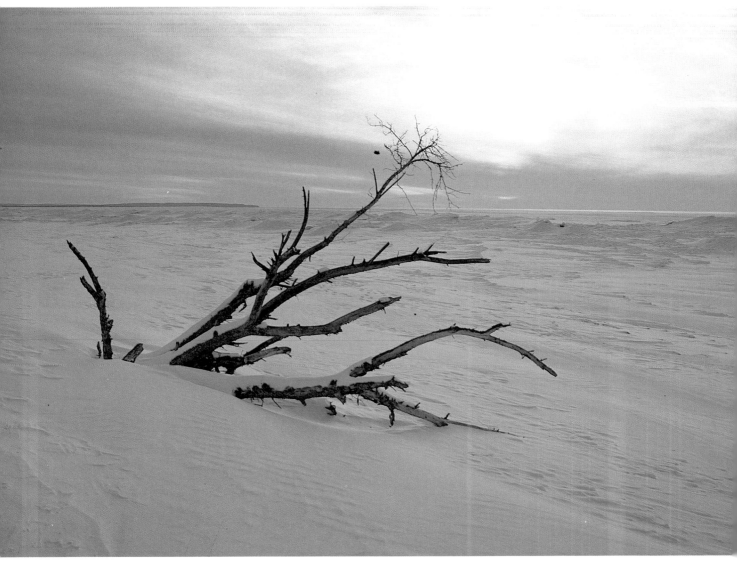

PROBLEM

The snow-covered ground is darker and cooler than the late afternoon sky. Both areas require a special treatment. You'll have to balance the shadowy snow against the warm, colorful sky.

SOLUTION

Develop the sky by working wet-in-wet. Apply a lot of color, and make some areas very pale but warm—otherwise the sky will look overcast. When you turn to the foreground, keep the hues cool and work on dry paper.

☐ Sketch the tree and then draw in the horizon line. Now start with the most difficult part of the painting, the sky. With a natural sponge, moisten the sky area with clear water all the way down to the ground. Let the water evaporate for a minute or two, and then start to drop color into the damp surface. Right in the center of the paper, lay in some new gamboge and yellow ocher.

While the paint is wet, add a little cadmium orange and cadmium red near the horizon. Once the warm colors have been ap-

In midwinter, on the frozen shores of Lake Michigan, branches of a tree swept up during an autumn storm lie covered with snow.

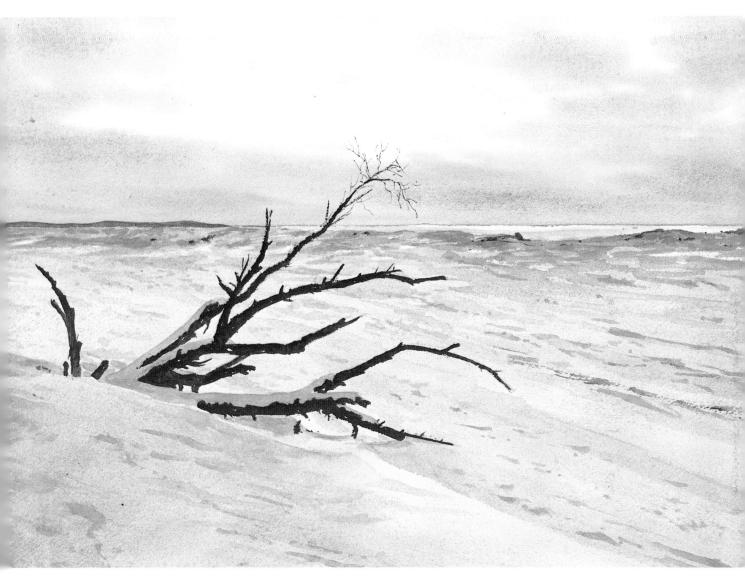

plied, start muting them with cool tones. Here ultramarine, cerulean blue, Davy's gray, and a touch of alizarin crimson are worked in around the bright passages. Because the paper is still wet, the darker tones will merge softly with the warm colors. Right above the horizon, there's a sliver of brilliant orange—don't cover it with the darks.

The snowy ground is very different from the sky. Whereas the sky is fluid and full of color, the ground is monochromatic and still. To capture its cold, solid feel,

work on dry paper. Lay in the ground with ultramarine, cerulean blue, and alizarin crimson. Slightly vary the values to show how the snow lies packed in drifts.

When the paint dries, add details with a slightly darker hue; then run touches of burnt sienna across the paper. Finally, paint the tree: first render the dark branches and later go back to add the snow that lies on them.

In the finished painting, an endless expanse of icy ground seems to move slowly toward the distance to meet the afternoon sky.

DETAIL
The sky is made up of soft, effortless shifts from yellow to orange and from orange to blue. This subtle effect results from working wet-in-wet. Note the sliver of orange that floats along the horizon. This detail, though hard to control on wet paper, is well worth the effort—it makes a strong note in the finished painting.

DETAIL
Cool blues applied to dry paper suggest the still, quiet mood of this winter scene. Slight variations in value sculpt out the contours of the snow drifts, and touches of burnt sienna break up the relentless field of blue.

Working with Subtle Shifts in Color and Value

PROBLEM

Here the quiet beauty of the scene rests on a limited palette. Everything is pinkish and purplish blue. One false note of color will ring out and disrupt your painting.

SOLUTION

When you begin to lay in the sky, keep the area right above the mountains warm; you'll be creating a subtle halo effect. Then, when you turn to the mountains, gradually build up your values.

☐ First sketch the scene. Then begin to paint the sky using light values. Start at the top of the paper with ultramarine, and moving down, shift to cerulean blue. Next turn to mauve; then, alizarin crimson. Carry the crimson to the bottom, making it lighter as you move down. When you add the mountains, the red will spotlight their contours and suggest the rising sun.

For all three mountains, use cerulean blue, ultramarine, and alizarin crimson. Start with the mountain in the distance, using very pale values. Let the paint dry before you move on; this will keep the mountains clearly defined. Next paint the middle slope, increasing the density of your pigments. Again, let the paint dry before you move on.

The mountain in the foreground is the darkest area in the painting. When you work on it, create some texture—use slightly uneven strokes and add some irregular touches on the mountain edge. Unlike the sky and the distant hills, which are flat, the foreground must have enough detail to make it seem close.

Because of the limited palette, the finished painting is a harmonious study of hue and value.

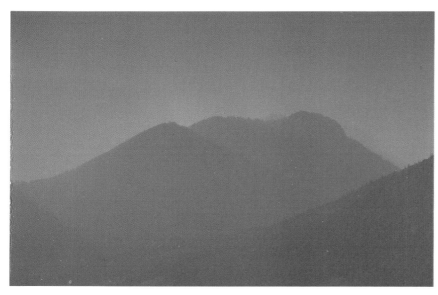

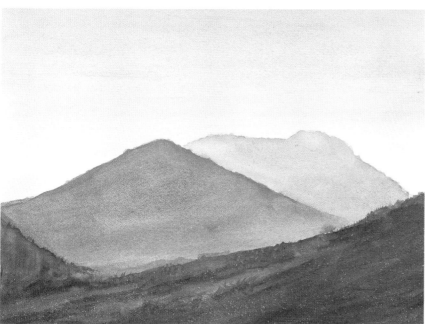

In the Rockies, an early morning rainstorm bathes the sky and land with a cool, purplish tone.

ASSIGNMENT

Try grading a sky primarily with color, not with value. Imagine that the sun is shining in from the left. Begin there with a clear pure yellow. As you move right, across the paper, gradually shift to red and then to blue. Don't let the yellow and the blue mix to form green.

Begin with new gamboge on the far left. Next introduce mauve and then cerulean blue. Practice until you can make the transition between the colors look fresh and spontaneous.

Mastering Strong Contrasts of Lights and Darks

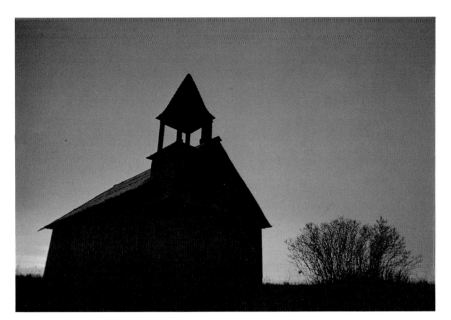

PROBLEM

The church, ground, and trees contrast sharply with the sky. Most of the sky is a medium purple, but near the horizon it's a bright flash of gold. To give your painting power, you'll want to keep the gold vibrant—it has to stand out against the darks.

SOLUTION

The darker the building and the sky, the brighter the patch of light will appear to be. Keep all the values fairly dark except for the area right along the horizon, and make the sky a little lighter around the church to give it emphasis.

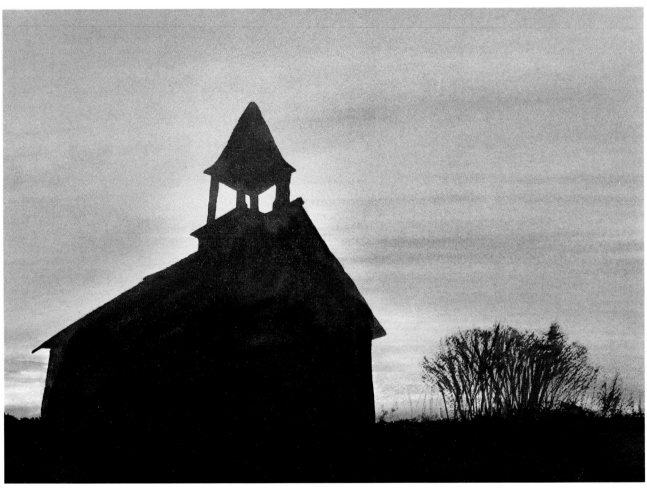

□ The church, viewed at an interesting angle, should be drawn in carefully before you start to paint. The final silhouette has to make sense, and for that a good drawing is vital.

Paint the sky in stages, starting with the warm tones and later adding the cool blues and purples. Right along the horizon, lay in a strong cadmium orange; then add new gamboge and alizarin crimson. Keep the color strong near the ground and then soften the wash over the entire area of the sky. Grade the sky gently, so no hard edge occurs between the bright colors and the softer ones. When the paint is dry, lay in a graded wash of ultramarine and alizarin crimson all the way to the top of the paper. With the same colors, add a few cloud effects near the horizon. The yellow will look even stronger and brighter once these cool touches have been laid down.

The rest of the painting should be easy. Mix a very dark pool of paint—here Prussian blue, alizarin crimson, and sepia—and then add the darks. As you depict the church and the ground, use careful, even strokes. The trees on the right call for a drybrush technique—wispy strokes will summon up the melancholy mood created by trees standing silhouetted against a dark sky.

At dawn, an old church stands silhouetted against a light-streaked sky.

DETAIL (TOP)
The sky moves from a medium purple to a light, radiant rose. Right around the top of the church, the sky is fairly light; it seems even lighter than it is because of the strong, dark color of the building.

DETAIL (BOTTOM)
Painted with a barely moistened brush, the texture of these trees is a welcome contrast to the clean, crisp dark tones that dominate the painting. Behind the trees, bright yellows and oranges spill along the horizon. These strong, pure colors work naturally with the rest of the sky, in part because a wash of those colors is carried over the entire sky before the cool tones are introduced. Until the darks are added, the light tones don't seem nearly bright enough—they need contrast to make them work.

Staining a Painted Sky with Clear Water to Suggest Clouds

PROBLEM

Moonlight is the only illumination here. The snowy ground catches the moon's dim light, brightening the night air. Get the lighting right here—if you don't, your painting won't capture this time of night or the feeling of winter.

SOLUTION

To make the sky and ground work together, use a limited palette. You can get across the feel of a winter evening by streaking the sky near the horizon with water after you've laid in the blue.

☐ In your preliminary drawing, concentrate on the detailed windmill. If its structure is wrong, the whole painting will fall apart.

Now begin the sky. Turn the paper upside down; then work from light to dark. Here alizarin crimson and ultramarine are laid in near the horizon. Slowly shift the color to pure ultramarine and then to a mixture of ultramarine and Prussian blue. When the paint is dry, turn the paper right side up.

The snowy foreground seems warm because of the moonlight that illuminates it, so begin by laying in an underpainting of alizarin crimson. After the underpainting has dried, overpaint it with a slightly darker value of ultramarine and alizarin crimson. Leave a few passages of the underpainting uncovered to indicate the snowdrift in front of the windmill.

Even with the carefully graded wash, chances are that the sky will seem too flat. Try breaking up that large area by washing in water near the horizon. This technique, you'll find, gives a soft feel while creating a sharp edge—an interesting combination. At the same time, you'll see that very little shift in color or value is produced.

Start the foreground by laying in whitish blue gouache along the horizon. Now turn to the details. The windmill requires a steady hand and a fine brush—here it's rendered with sepia and Payne's gray. Add the bits of grass that poke through the snow, and the buildings and trees along the horizon. At the very end, add the crescent moon with white gouache.

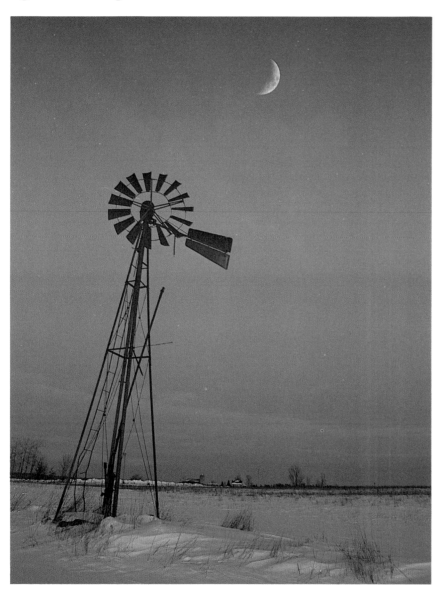

A crescent moon floats above a midwinter landscape, which is punctuated by an old windmill.

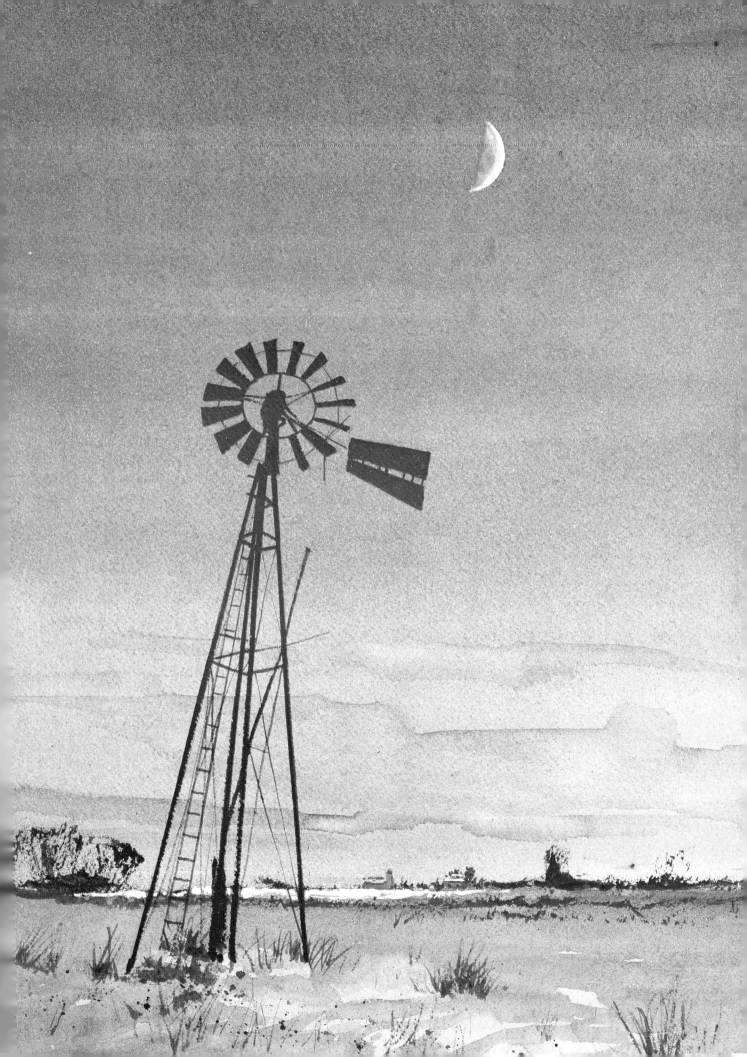

Learning to Paint a Moonlit Scene

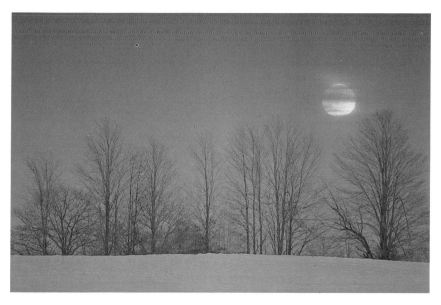

PROBLEM

Painting a moonlit scene is always a challenge, especially in the winter when there's snow on the ground. The snow catches the light cast by the moon, illuminating the landscape; yet the shift in value between the sky and the ground is very slight.

SOLUTION

Paint the golden moon right away; then after it dries, mask it out. When you start to lay in the sky and the foreground, don't use too dark a shade of blue and don't make the two areas contrast too sharply.

☐ Sketch the scene; then paint the moon with new gamboge and touches of alizarin crimson. As soon as it dries, cover the moon with liquid masking solution. Then turn to the sky. Use a graded wash. Here Prussian blue is mixed with ultramarine. For the foreground, try a cooler blue; here it's a blend of cerulean blue and alizarin crimson.

Let the paper dry. Then tackle the trees, rendering them with sepia and Payne's gray. A variety of techniques come into play here: the trunks are done with a small brush loaded with paint; the spidery branches, with a drybrush technique; finally, the masses of twigs, with a light wash laid in over some of the branches.

Now peel the masking solution away from the moon and add the clouds that hover in front of it. Then moisten some areas right around the moon and wipe out the paint there, to suggest clouds which fill the sky.

Finally, turn to the foreground. Give texture to it with a slightly darker mix of cerulean blue and alizarin crimson; then add a few strokes of sepia to suggest the grasses that break through the snow cover.

In February, a full moon rises over
a still, snow-covered landscape.

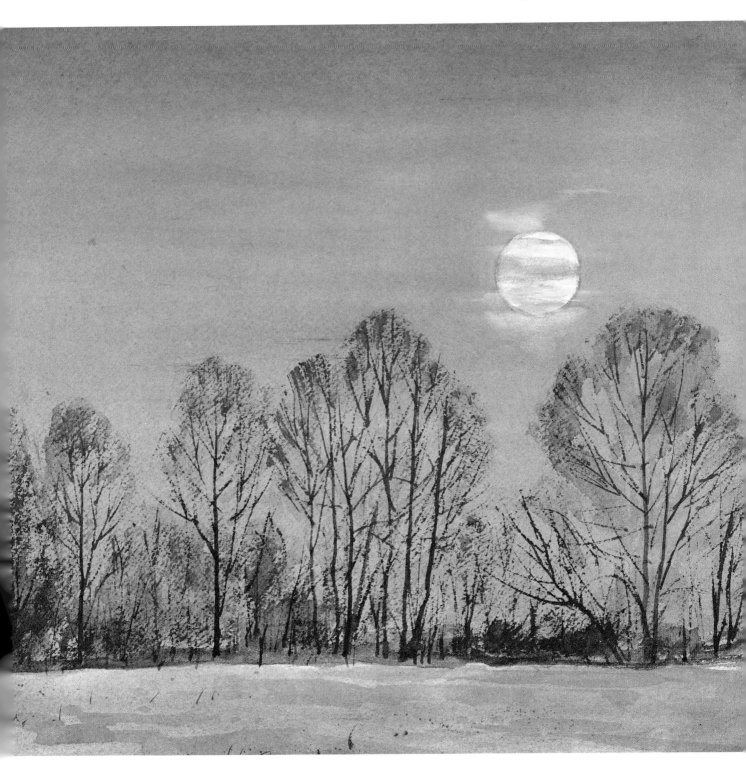

Handling the Contrast Created by a Silhouetted Foreground

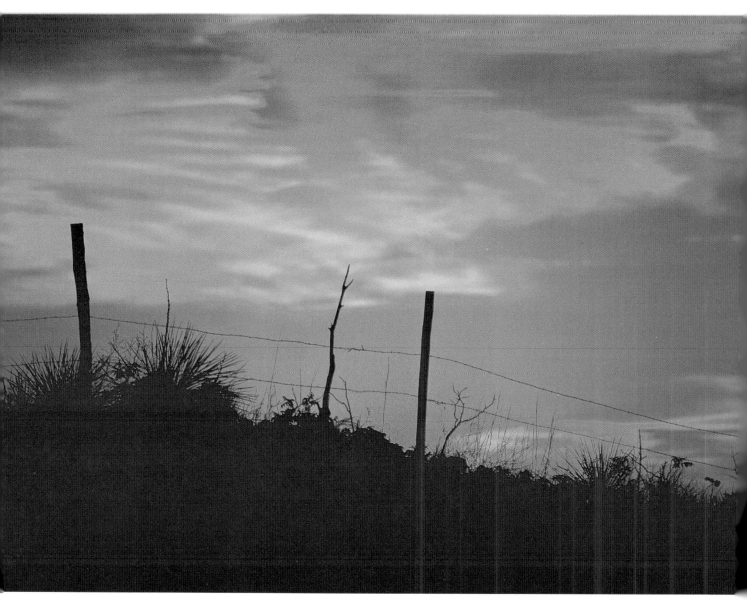

PROBLEM

When working with extreme contrasts, it's easy to end up with a harsh, forced effect. If the sky is either too flat or too garish, the subtle pattern created by the clouds will be lost and with it the gentle, easy touch that distinguishes this landscape.

SOLUTION

Keep the foreground dark and dramatic. When you begin to paint the sky, try rendering it with layers of overlapping light and dark color. You'll break up the masses of strong orange and create a rich, lively pattern.

☐ Carefully sketch all the detail in the foreground—the grasses, fence posts, and barbed wire. Then turn to the sky. Wet it and then lay in a light tone of new gamboge deepened with cadmium orange and alizarin crimson. Let the paper dry. To create the dark streaks that rush across the sky, use a deeper tone mixed from the same colors plus a touch of

A blazing orange sky filled with soft, layered clouds silhouettes a lonely barbed-wire fence and prairie.

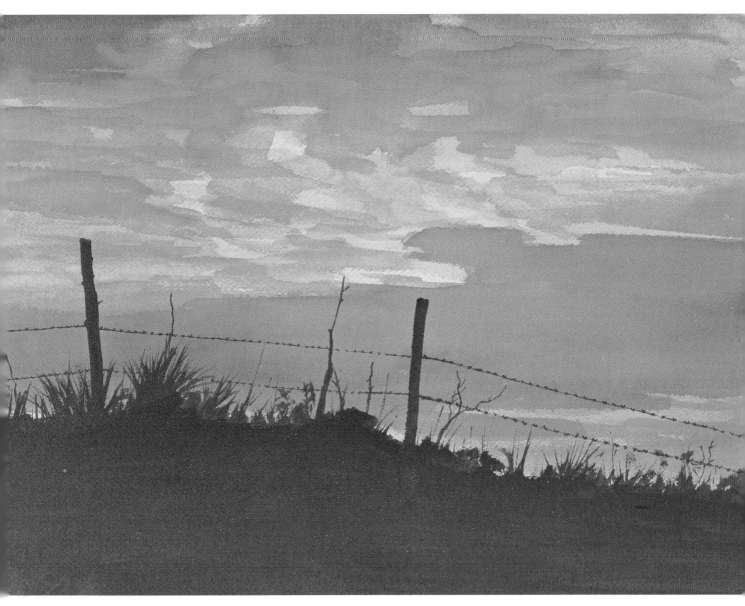

mauve. (Mauve is a good darkening agent for yellow—in small doses, it will change the value of yellow without substantially changing the color.) Work slowly as you add the bands of deep orange. Keep some edges crisp; let others bleed into the adjoining areas of wet paint. Try to follow the general pattern of the clouds. Above the horizon, lay in a bold area of dark paint; then let the paper dry.

The foreground should be a rich dark hue. Here it's carefully painted with ultramarine and sepia. The dark color sets off the yellow, gold, and orange in the sky, making them seem even brighter and more intense.

Working with Strong yet Subtle Contrasts

PROBLEM
The brilliance of the setting sun warms this sky, but the sky's color is only moderately strong. Toward the horizon, the sky becomes almost pure gray and the foreground is very dark.

SOLUTION
Mask out the sun and paint it last. You'll then be able to adjust its brilliant color to blend harmoniously with the muted sky and deep, dark foreground.

☐ Sketch the shapes in the foreground carefully; then mask out the sun. Next lay in the sky with a graded wash, placing the warmest color at the top of the page and a cool gray at the horizon. The gray will form an effective backdrop for the sun when you paint it. Here a mixture of alizarin crimson and new gamboge is applied at the top of the sheet. Gradually mauve is added to the orange, and then the mauve gives way to a combination of mauve and Davy's gray. Near the horizon, the gray is strong and dark.

To render the foreground, use sepia. The tree is executed with careful, even strokes to keep the silhouette strong and powerful. Elsewhere, however, the brushwork is looser, at times even impressionistic, to soften the contrast between the sky and the ground.

Now pull off the masking solution and paint the sun. Here the strength of new gamboge is broken by a touch of cadmium red. The red mixes with the yellow, forming a warm orange tone that relates the sun to the sky above.

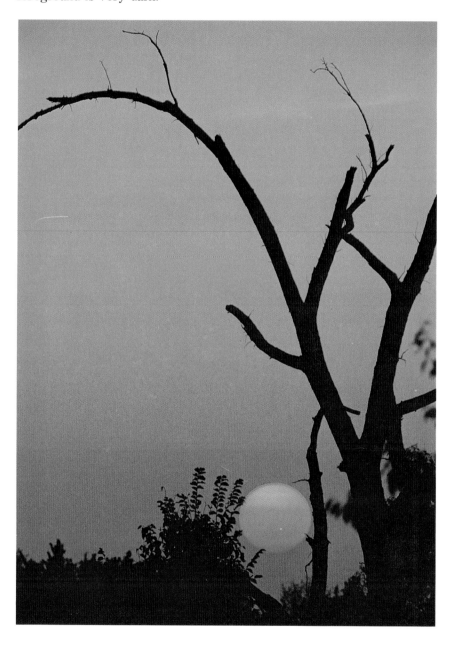

In an early autumn sunset, the skeleton of an old dead elm stands silhouetted against a warm orange sky.

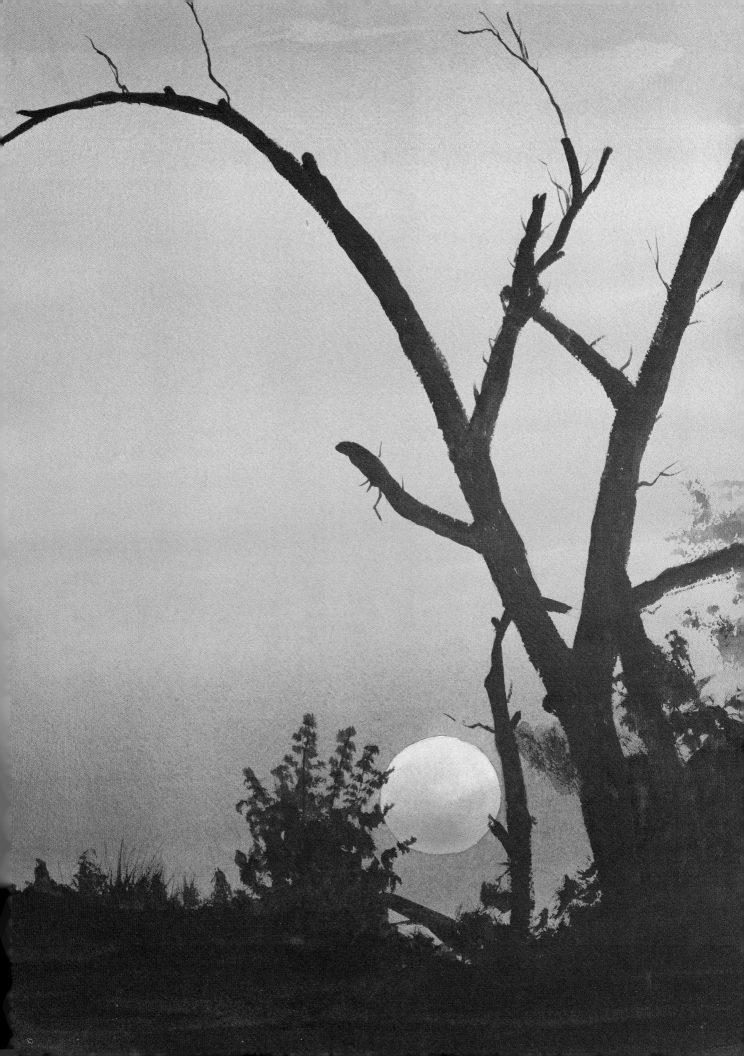

Capturing the Drama of a Sunset

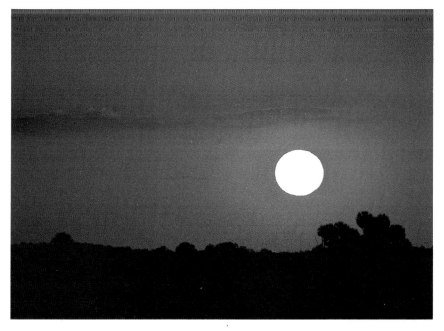

PROBLEM

Taken just at the moment when the still-golden sun was hovering in the sky before setting, this photograph is a study in strong color and contrast. The sun is a special problem: its color is so strong and pure that it could easily look artificial.

SOLUTION

To make the sun fit logically into the picture, show how it lightens the atmosphere immediately around it. Use circular strokes, and as you work outward from the sun, gradually making the sky darker.

☐ Execute a preliminary sketch; then paint the sun with new gamboge. When the paint is dry, cover the sun with masking solution. Now begin the sky.

Here the entire sky is rendered with new gamboge, alizarin crimson, and mauve. The paint is laid down with loose, circular strokes that radiate from the yellow sun. As you move outward, gradually

increase the density of the pigment, and never let the color become too regular. Near the edges of the paper, the yellow and red are strongly tinged with mauve.

Before you begin work on the clouds, let the paper dry. While you're waiting, study the patterns the clouds form: they hover right over the sun and then become fainter farther up in the sky.

For the darkest clouds, use mauve mixed with alizarin crimson. Keep the edges soft; if necessary, run a little clear water on them. As you move upward, use a paler wash of color and don't cover all of the sky that you initially laid in.

Next turn to the ground. Mix a good amount of sepia and ultramarine together, making the color dark and intense—the darker the ground, the brighter and more powerful the sky becomes. Lay the paint onto the paper, keeping the edge hitting the sky lively and full of movement. Finally, peel the masking solution off the sun.

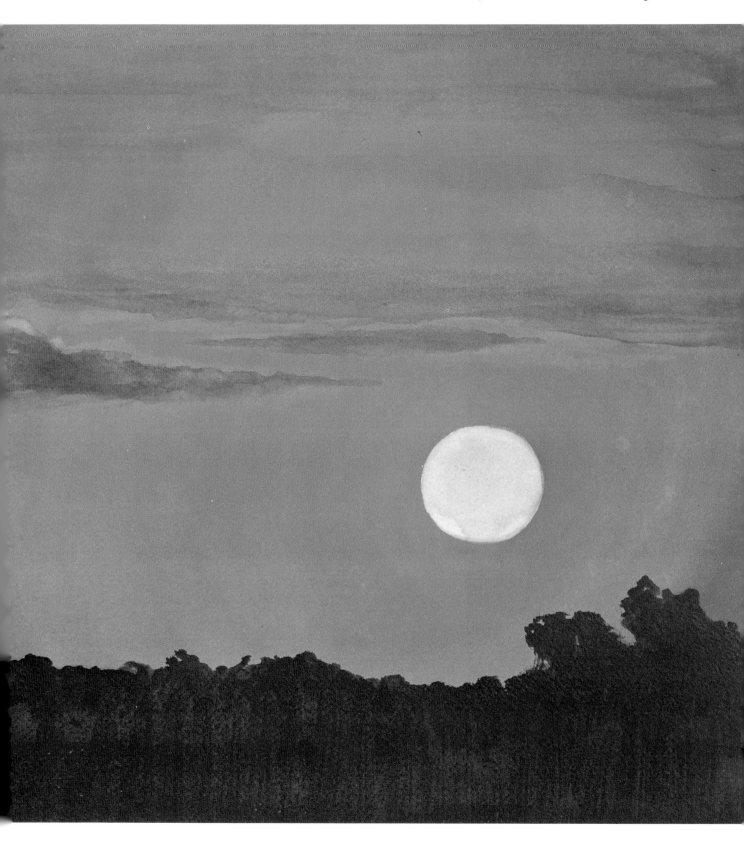

Over a prairie, a brilliant yellow sun slowly sets in a vivid sky.

Laying in a Sky Composed of Delicate Slivers of Color and Light

PROBLEM

This sky is richly patterned with bands of color—so much color that it will be hard to keep the different hues from mixing together and becoming muddy.

SOLUTION

Start by toning the center of the paper with a warm yellowish orange wash. After it's dry, turn to the area near the horizon, where the bands of color are strongest. With a small brush, gradually fill that area with overlapping slivers of color.

☐ Sketch the scene and then begin the underpainting. Near the horizon, lay in a wash of new gamboge; then working upward, gradually add alizarin crimson. As you near the upper fourth of the paper, grade out the crimson until the paper is almost pure white. Now let the paint dry. If the paper is even slightly damp when you move to the next step, you'll lose the effect you're after.

To lay in the streaks of color that fill the sky, use a small round brush. In some areas, keep the edge of your strokes crisp; in other places, let the bands of color mix together. Be very careful not to let the bands cover all the underpainting—that's what pulls the sky together. Near the horizon, use alizarin crimson, cadmium orange, and mauve. In the center of the sky, add ultramarine. For the rich mottled area high in the sky, try ultramarine, Prussian blue, and Payne's gray.

All that's left now is the foreground and tree; they call for a deep, dark tone. Here it's mixed from ultramarine, Payne's gray, and sepia.

In the finished painting, bands of color shoot across the sky, suggesting the sun's last rays playing upon a cloudy sky.

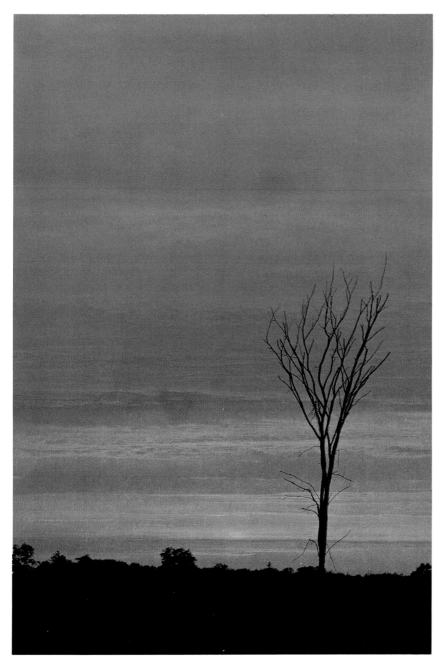

After the sun has set, streaks of red, orange, purple, and blue shift across a cloudy sky.

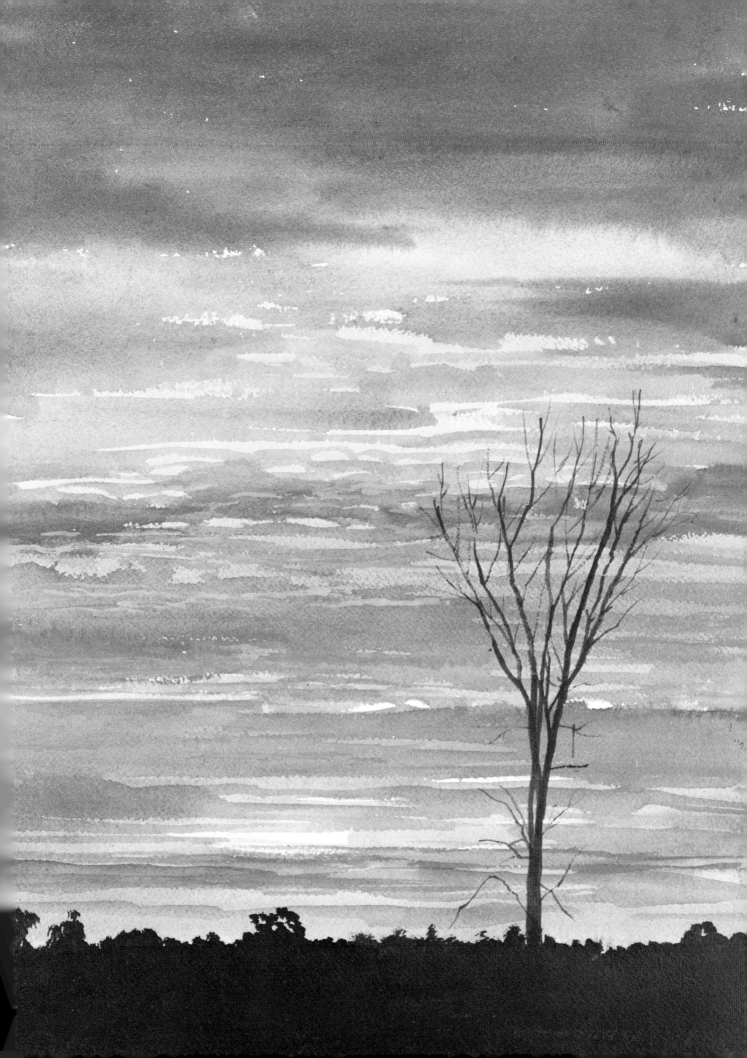

Evoking the Feeling of a Rain-Filled Afternoon Sky

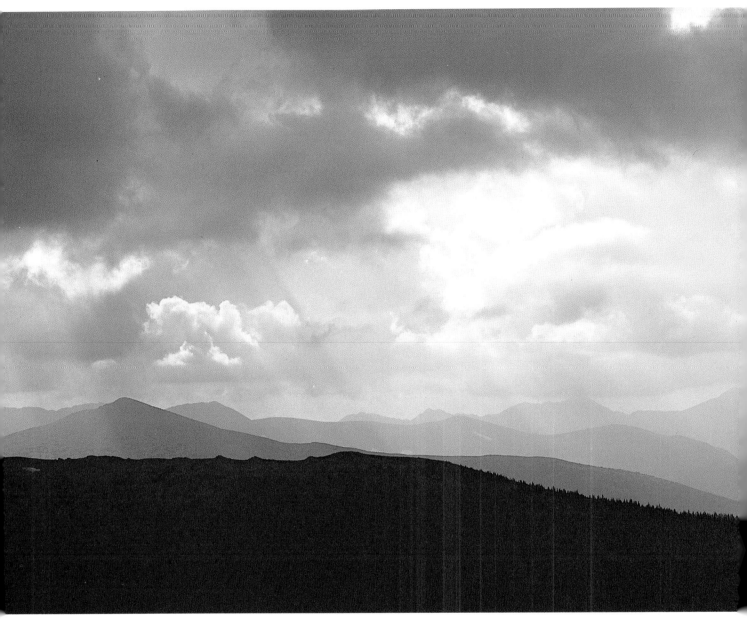

PROBLEM

Three interesting conditions occur here, and for a painting that really works, you'll want to capture all of them. First, there's the strongly patterned, cloudy sky; next, a hazy light bathes the distant mountains; finally, rays of light break through the cloud cover.

SOLUTION

Use a wet-in-wet technique to lay in the sky, indicating the soft patterns the clouds form. To capture the hazy atmosphere, paint the distant hills in very light values. Finally, when everything is dry, rub out the sunbeams with an eraser.

☐ After your initial sketch, sponge down the entire sky. Now drop in cerulean blue, Payne's gray, burnt sienna, and ultramarine. Next, tilt the paper slightly, letting the colors run together. Be careful—keep some areas pure white. As soon as the paint forms a pattern that pleases you, put the paper down to dry.

Now build up the distant mountains, beginning in the back. As each range dries, move on to the

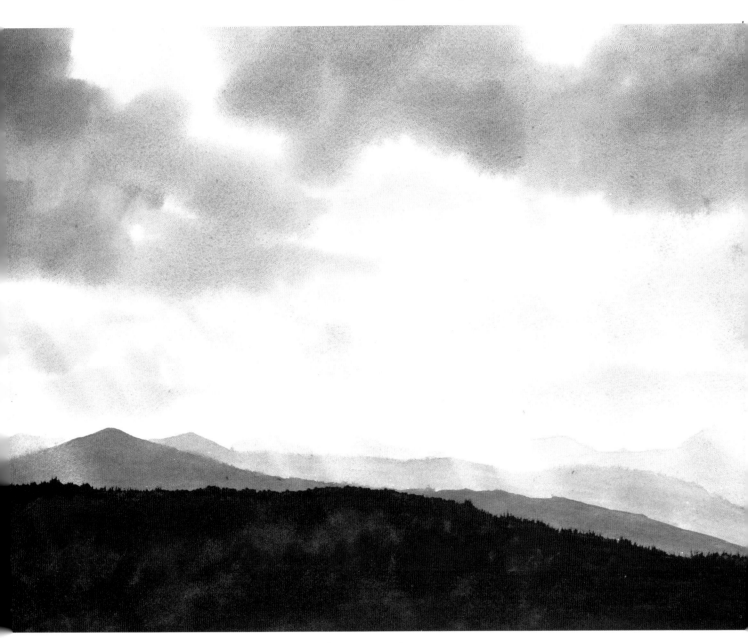

next. Keep the values very light at first, to indicate the hazy, rainy atmosphere. Here the two distant ranges are rendered with cerulean blue and yellow ocher, and the third with ultramarine and burnt sienna.

Before you turn to the foreground, let the paint dry. Then pull out the rays of sun with an eraser. Remember, the paper has to be absoluteiy dry or you'll smudge the paint and ruin your painting. As you run the eraser over the dry paper, pick up just enough paint to suggest the rays; don't try to remove all of the pigment. Note how subtle this effect is—at first it's hardly noticeable because just a little of the paint has been removed.

Finally, paint the foreground. As you lay it in, don't let the color get too flat; uneven application of the paint will make the foreground seem close at hand.

Painting a Dark Sky Set Against a Lush Summer Landscape

PROBLEM
Even though the storm clouds are moving in on the scene, the ground is brightly lit. If the sky is too dark, the flower-filled hillside will look out of place.

SOLUTION
Paint most of the sky with dark, dramatic blues and grays, but leave the area right behind the trees pure white. It will not only make the dark clouds seem to press in on a clear sky, but it will also spotlight the pine trees and make the brilliance of the foreground seem natural.

Tall pine trees separate a moody blue sky from a hillside covered with fresh summer wildflowers.

STEP ONE

Sketch the basic lines of the composition. Then paint the sky quickly, all in one step. The look you want is fresh, soft, and exciting—something you can only capture if you work rapidly. Wet the sky with a natural sponge, and then drop in ultramarine, burnt sienna, cerulean blue, and yellow ocher. Let the colors bleed together, but be sure to leave some areas pure white. Now let the paper dry.

STEP TWO

Turn to the trees. Begin with their trunks and some of the dark branches on the right using a dark mix of cerulean blue and sepia. Next lay in the branches and needles. Start with a light value of green; you'll add the rest of the dark, shadowy areas later. Here the light green is mixed from new gamboge and cerulean blue. Dab the paint onto the paper, keeping your strokes lively and uneven.

STEP THREE

Now finish the dark shadows on the trees, again using a mixture of cerulean blue and sepia. What's left now is the warm, lush foreground. Start by laying in a wash mixed from Hooker's green, sepia, and yellow ocher. Don't try to get the color too even; it will be much more interesting if it shifts from light to dark green.

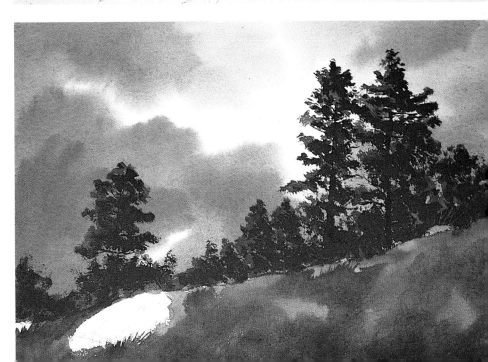

FINISHED PAINTING

Once the foreground dries, spatter bright yellow gouache over it to depict the wildflowers. Finally, paint the rock on the far left using Payne's gray, mauve, and yellow ocher.

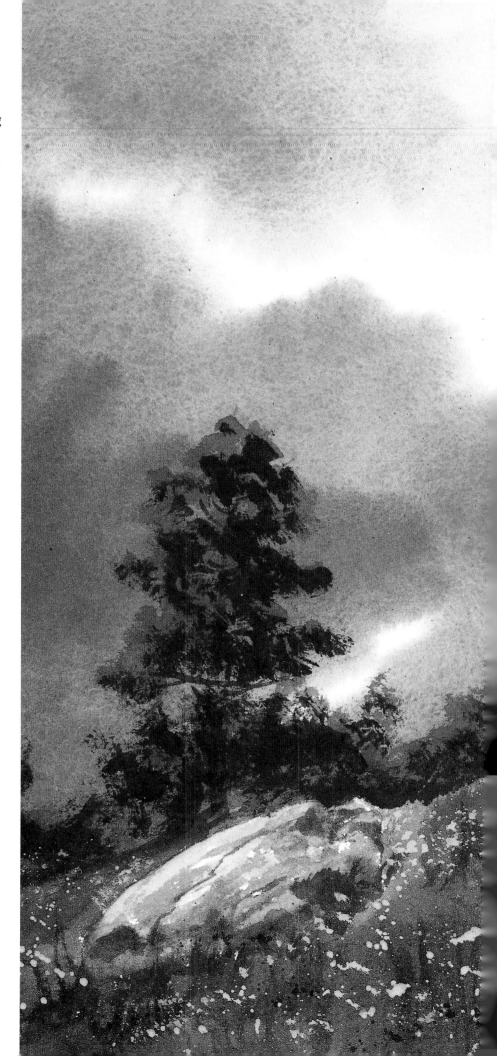

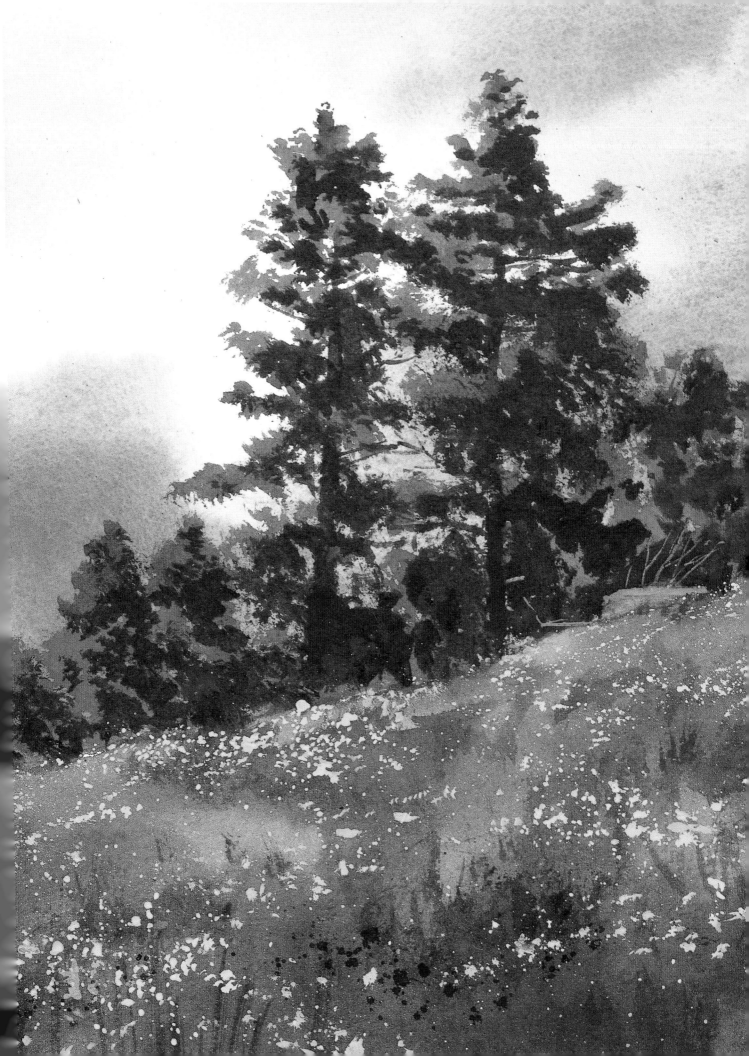

DETAIL
The patch of white sky behind the pines not only breaks up the dark blues and grays that fill the sky but also directs the eye to the pines which dominate the hillside. The white area has a soft, undulating feel, created because the blues which are laid onto the wet paper bleed into the white.

DETAIL
An uneven wash of Hooker's green, sepia, and yellow ocher is the backbone of this foreground. Sometimes dark, sometimes light, the colors suggest sunlight playing on a grassy hillside. The dense gold spattering seems to fill the grass with brilliant wildflowers.

Narrowing in on the Foreground

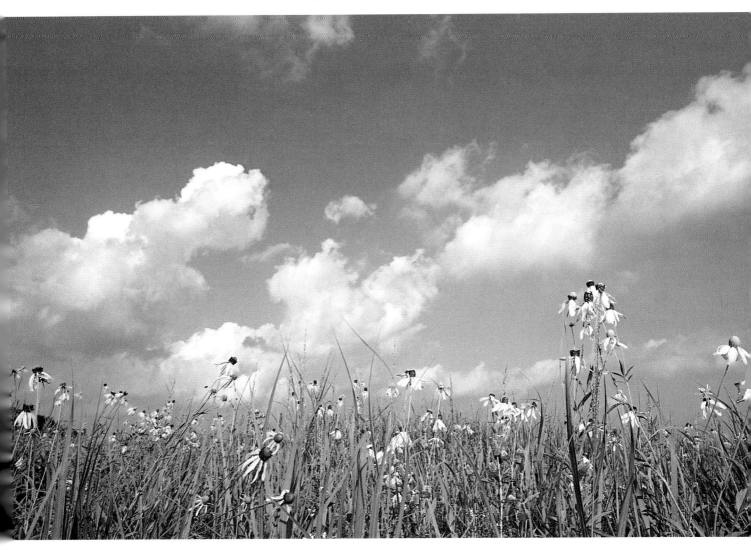

PROBLEM

The field is really the subject here, but the sky is so strongly patterned that it competes for attention. You'll have to balance the two areas.

SOLUTION

Go ahead and treat the sky boldly—if you want, you can even accentuate its drama. Paint the flowers and grass as a final step, with gouache. Because gouache is opaque, you'll be able to work over the sky area and easily adjust the strength of the bright yellows and greens.

A brilliant blue sky forms the backdrop for a field of summer wildflowers.

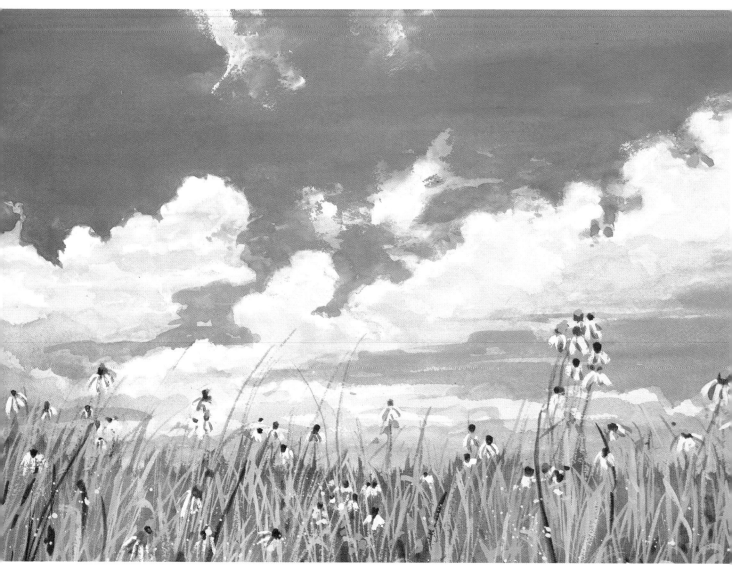

☐ With a rich mixture of ultra-marine and cerulean blue, start to lay in the dark blue sky. At the very top of the paper, drop in a few touches of white gouache and let the drops melt into the blue paint. When you reach the clouds and start to paint around them, shift to cerulean blue and yellow ocher. While the paint is wet, soften some of the edges you've created with clean water. Next, lay in the shadowy undersides of the clouds with a pale mixture of ultramarine, alizarin crimson, Payne's gray, and yellow ocher. Again, soften the edges with clear water as you work.

After the sky has dried, lay in the dark grass with Hooker's green, new gamboge, and Payne's gray. For the light grass and flowers, use gouache; here Hooker's green and new gamboge are blended to form a lively spring green. With dabs of mauve, add the little purple blossoms that grow among the grasses; then spatter touches of yellow over the foreground.

At the very end, the clouds here seem too dark. To make them appear lighter, the top of the sky is darkened with pure ul-tramarine. One shift in value—for example, darkening this sky—can often bring a whole painting into focus.

DETAIL
The shapes of the clouds are etched out by the blue paint; later the blue, gray, and purple shadows that play along their undersides are worked in. The white you see here is the untouched watercolor paper.

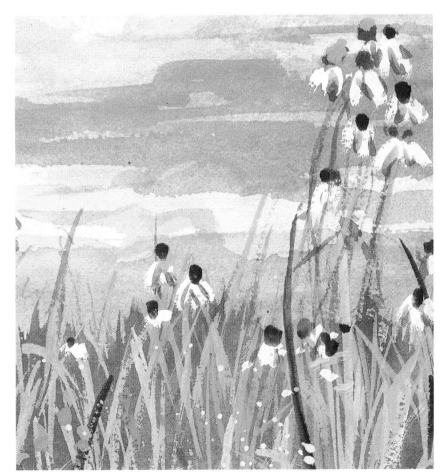

DETAIL
Tall, thin green brushstrokes weave in and out, creating a richly patterned field of grass. The little spatters of yellow added at the very end help pull the foreground forward, animating it at the same time. Touches of mauve further break up the greens and relate the ground to the purple patches of sky near the horizon.

Index

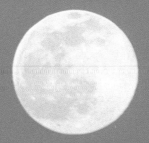

Editorial concept by Mary Suffudy
Edited by Elizabeth Leonard
Designed by Bob Fillie
Graphic production by Hector Campbell
Text set in 11-point Century Old Style